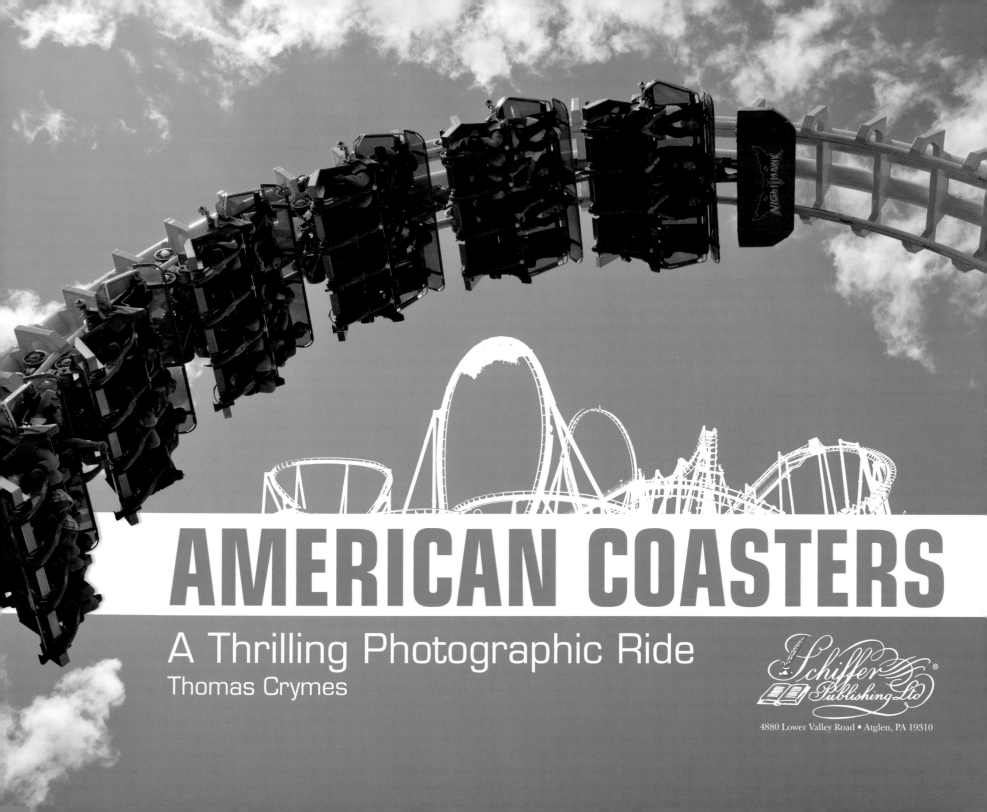

AMERICAN COASTERS

A Thrilling Photographic Ride

Thomas Crymes

Schiffer Publishing Ltd

4880 Lower Valley Road • Atglen, PA 19310

Other Schiffer Books on Related Subjects:

California Theme Parks,
978-0-7643-3478-8, $19.99

Library of Congress Control Number: 2012947661

Designed by Justin Watkinson
Type set in Eurostile LT Std/Zurich BT

ISBN: 978-0-7643-4158-8
Printed in China

Published by Schiffer Publishing, Ltd.
4880 Lower Valley Road
Atglen, PA 19310
Phone: (610) 593-1777; Fax: (610) 593-2002
E-mail: Info@schifferbooks.com

For our complete selection of fine books on this and related subjects, please visit our website at **www.schifferbooks.com**. You may also write for a free catalog.

This book may be purchased from the publisher. Please try your bookstore first.

We are always looking for people to write books on new and related subjects. If you have an idea for a book, please contact us at proposals@schifferbooks.com

In Europe, Schiffer books are distributed by
Bushwood Books
6 Marksbury Ave.
Kew Gardens
Surrey TW9 4JF England
Phone: 44 (0) 20 8392 8585;
Fax: 44 (0) 20 8392 9876
E-mail: info@bushwoodbooks.co.uk
Website: www.bushwoodbooks.co.uk

For those who stand in line perchance to soar, to scream, to dive

Contents

Acknowledgments 5

Introduction . 5

Cedar Point® . 6

Knoebels® . 30

Six Flags New England® 40

Carowinds® . 52

Six Flags America® 64

Kennywood® . 74

Busch Gardens Williamsburg® 84

Kings Island® . 98

Six Flags Over Georgia® 110

Kings Dominion® 124

Dorney Park & Wildwater Kingdom® 134

Six Flags Great Adventure® 148

Best of the Rest 165

Index . 176

Acknowledgments

Many thanks go out to my wife Beth, my family, and friends for their support and encouragement. I'd also like to thank all those who put up my with my incessant picture taking while at the parks, including but not limited to: Greg Kasander, Eric Ebling, Jessica Jett, and Brett Strouse.

Introduction

For more than one hundred years, roller coasters have been a staple of amusement parks throughout America. Many riders clamor for the rush of adrenaline, the jolt of fear found at the bottom of each steep hill. I remember willing myself to be tall enough to ride and basking in the sheer excitement of the dips and flips followed by the mad dash to get back in line.

I still feel that rush to this day.

While these glorious machines provide copious amounts of excitement, they are also works of art, a wonderful marriage of physics and imagination. Infatuated and obsessed, I've been scouring the country for the ride of a lifetime. Along the way I've accumulated a wealth of photos. The following pages provide a photographic tour of the most beautiful roller coasters I've had the privilege of riding.

Enjoy.

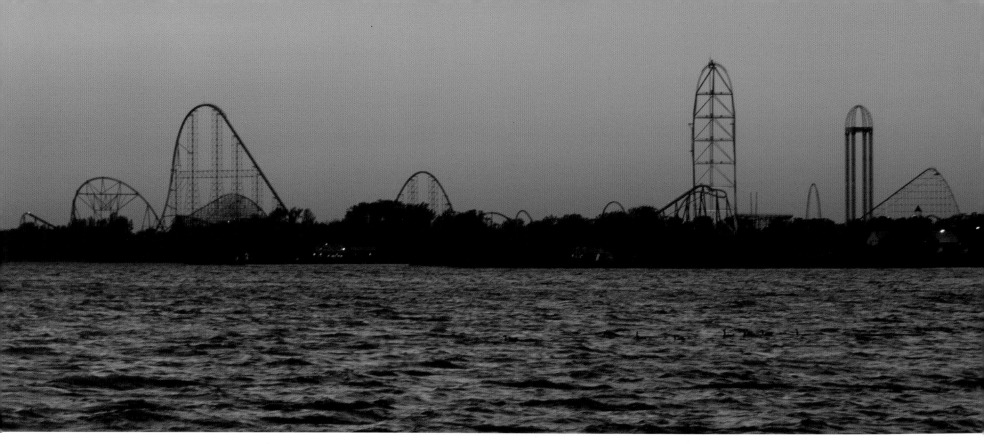

The Cedar Point skyline as seen from the causeway leading to the park.

Cedar Point
Sandusky, Ohio

If the multitude of amusement parks throughout the land formed a nation, its capital would be Cedar Point. This is where the modern rebirth of the roller coaster began and where it continues today. Magnum XL-200™ was the first 200-foot-tall coaster. Millennium Force™ was the first 300-foot-tall, full-circuit coaster, and Top Thrill Dragster™ was the first to eclipse 400 feet. Located on the shores of Lake Erie, the park has an astounding 17 coasters and an assortment of flat rides and water rides. It's extremely busy, so don't bother visiting on the weekends unless you enjoy spending the bulk of your time inching through lines.

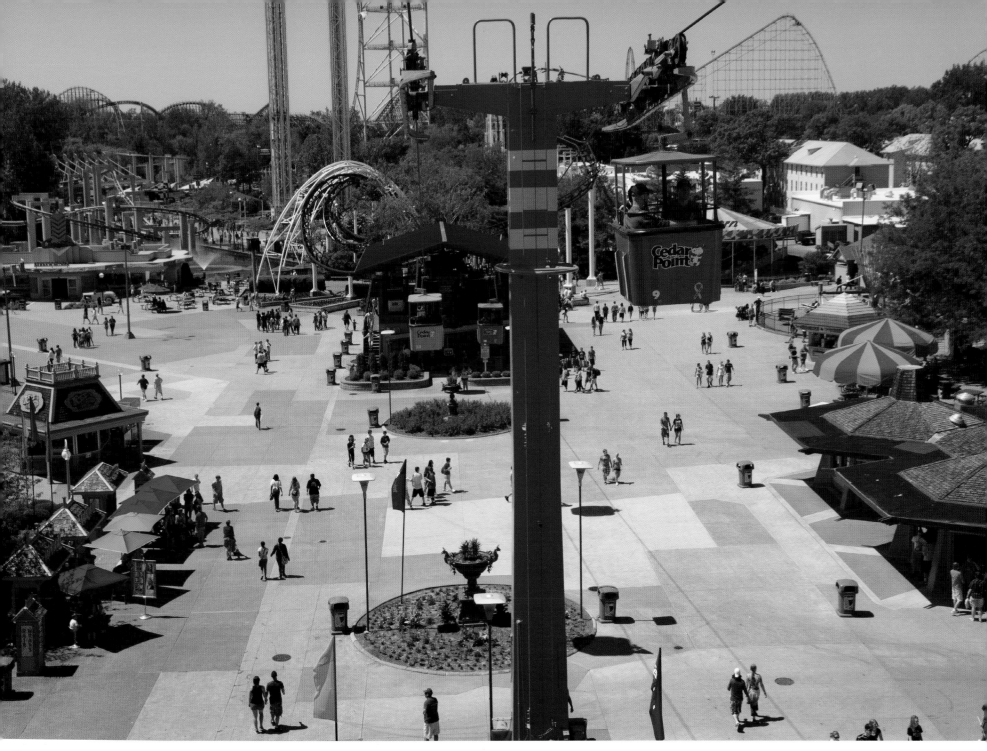

The Sky Ride™ spans the midway and gives patrons an excellent view of the front of the park.

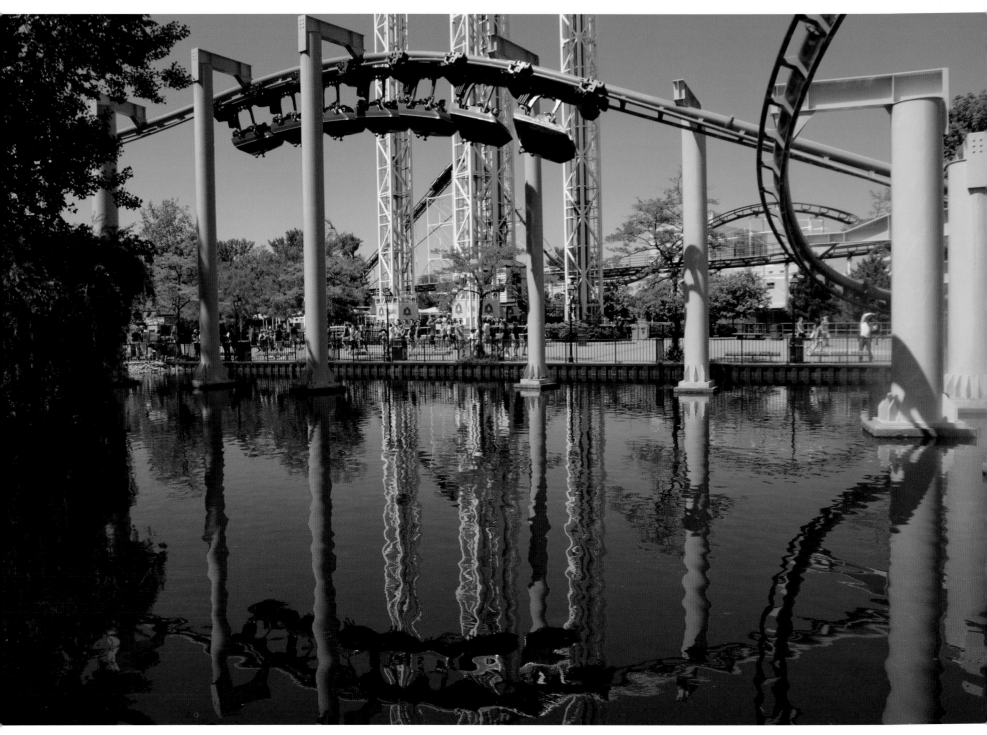

Iron Dragon™ is a suspended coaster that travels primarily over water.

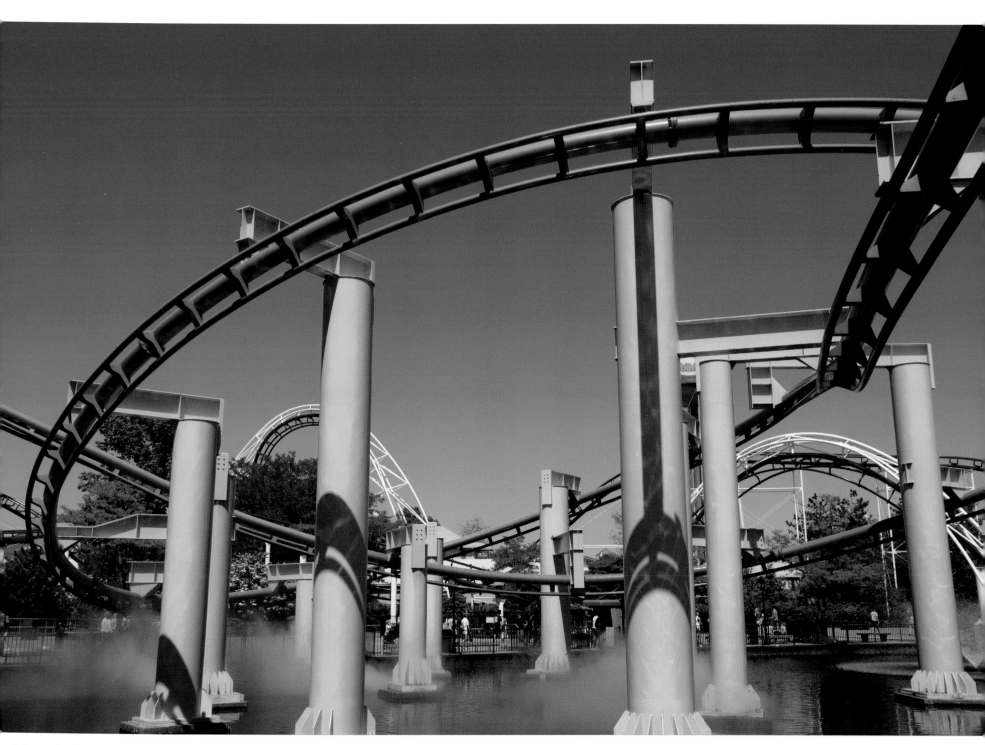

A fine mist is continually pumped out, providing some added drama.

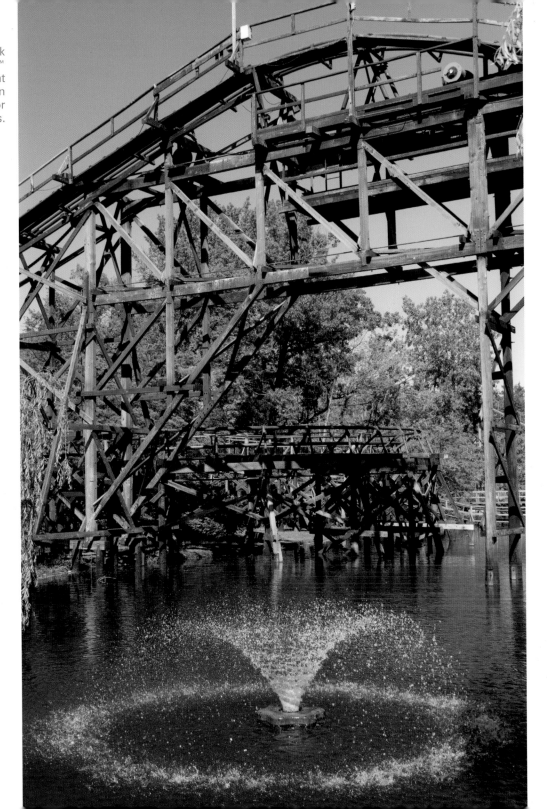

Cedar Creek Mine Ride™ is a great introduction for junior riders.

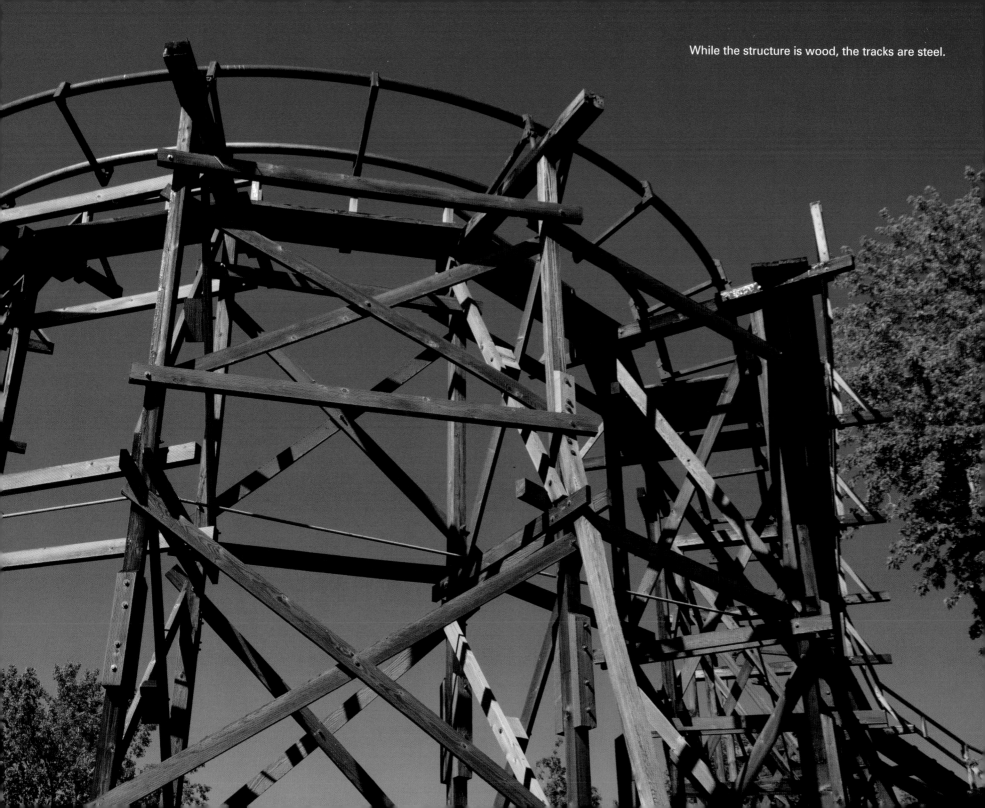

While the structure is wood, the tracks are steel.

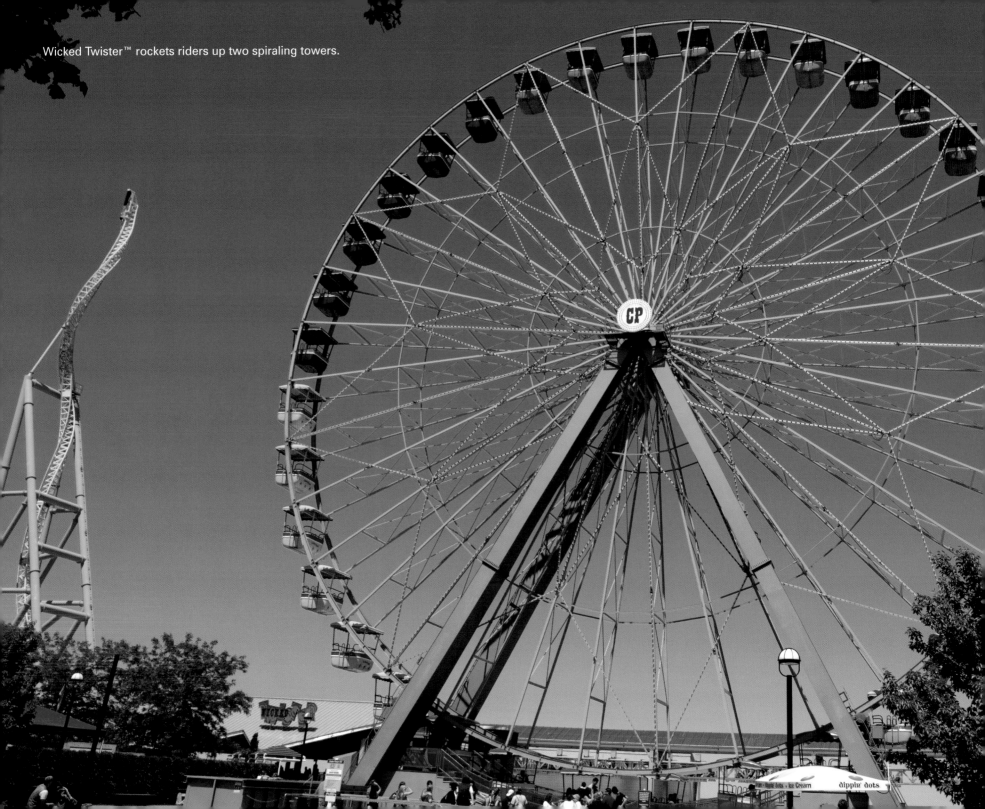

Wicked Twister™ rockets riders up two spiraling towers.

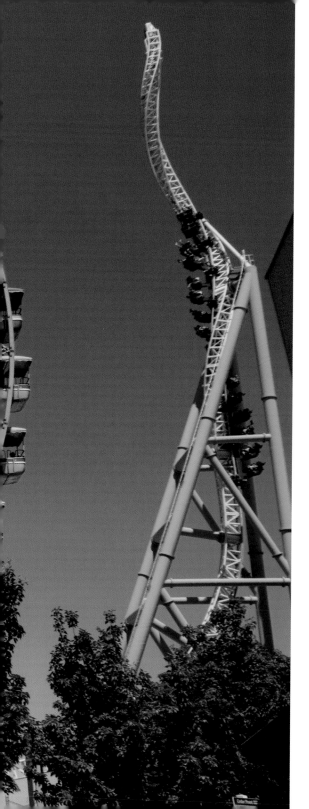
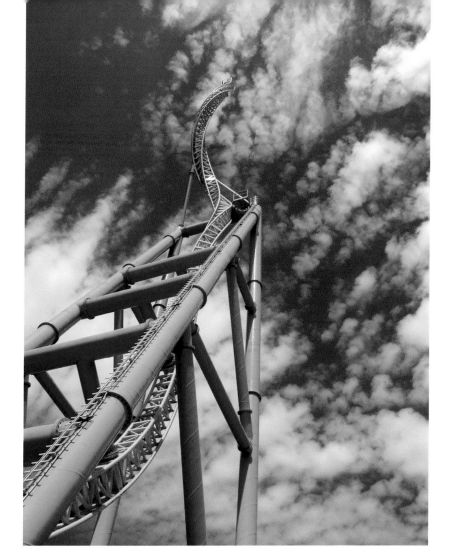

The twisted track rises 215 feet into the air.

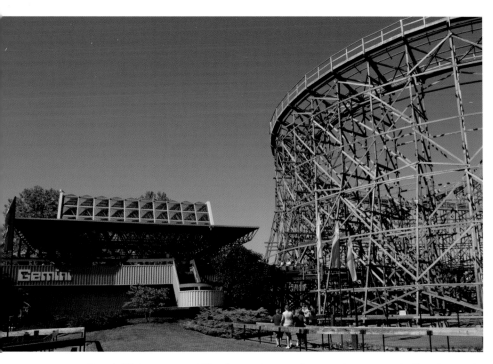

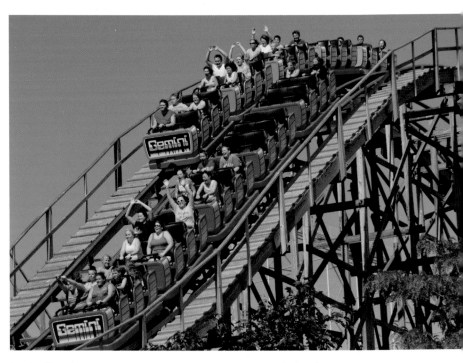

Gemini™ has a great 70s vibe going on. Its wood structure belies the eerily smooth steel track it rests on.

Looks like the red train has the advantage in this epic battle.

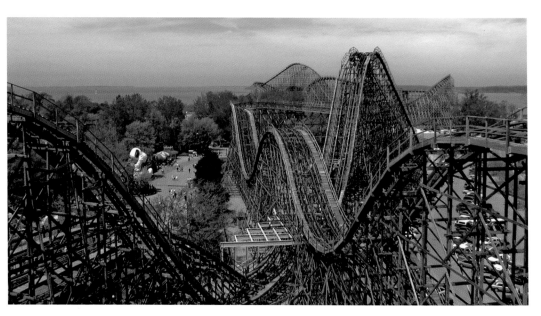

The two tracks run parallel for nearly the entire ride.

Maverick™ features a drop that exceeds ninety degrees and two different launch sections.

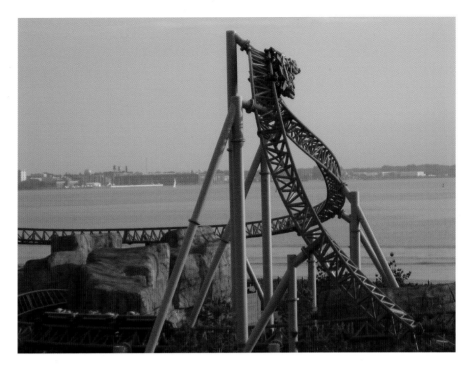

What this ride lacks in height it makes up for in speed and acrobatics.

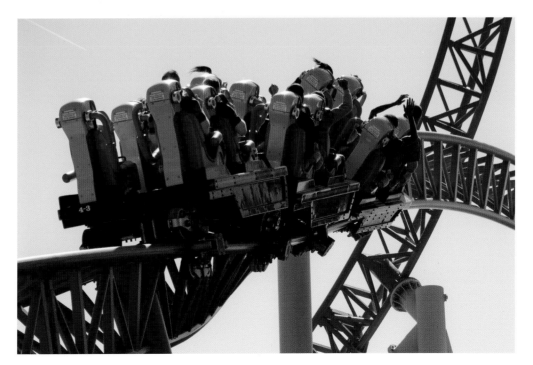

The short trains are quite nimble.

Gone but not forgotten: Removed before the 2012 season, WildCat™ was a wild-mouse-like roller coaster that featured small cars and sharp turns.

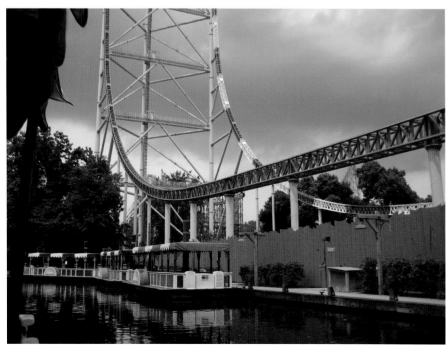

Riders race up and down the massive tower at speeds near 120 miles per hour.

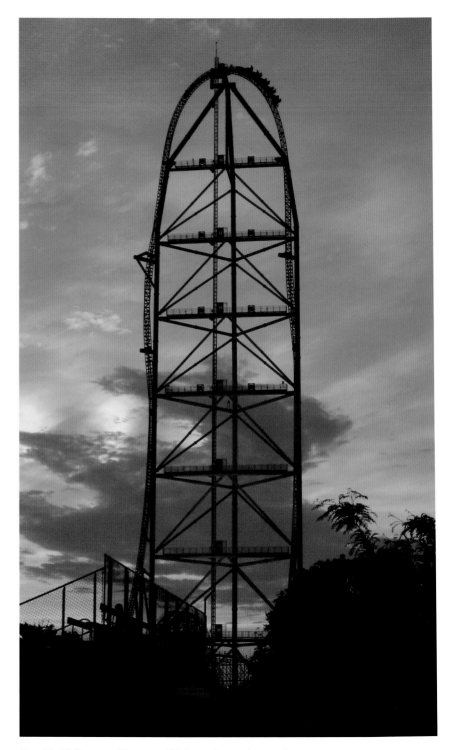

Top Thrill Dragster™ soars 420 feet above the earth.

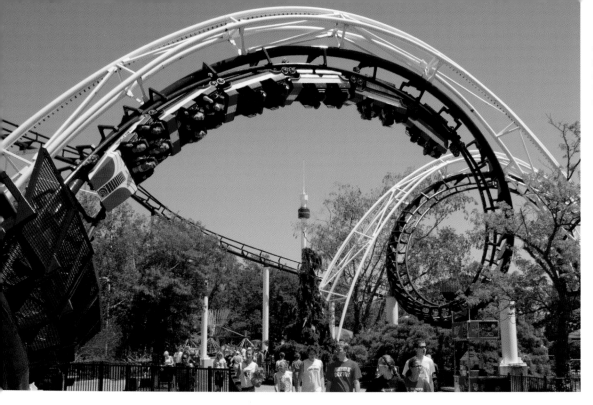

Corkscrew's™ signature move spans a main thoroughfare of the park.

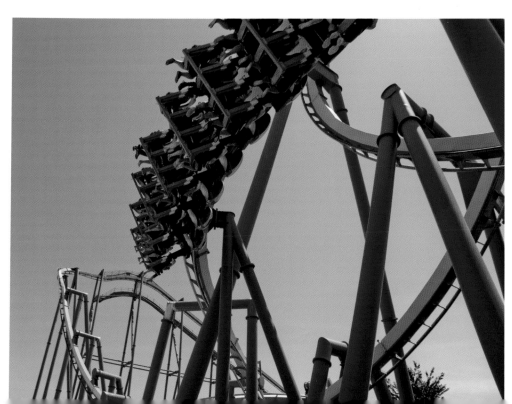

Raptor™ was the first inverted coaster to have a "cobra roll" element.

Blue Streak™

OPENING DATE: May 23, 1964
DESIGNERS: Frank F. Hoover,
John C. Allen
BUILDER: Philadelphia Toboggan
Coasters, Inc.
MAX HEIGHT: 78 feet (72-foot drop)
LENGTH: 2,558 feet
MAX SPEED: 40 mph
DURATION: 1:45
INVERSIONS: 0

The oldest active coaster in the park, its distinctive cupola and classic out-and-back design hearkens back to a simpler time. While many of the older woodies can rattle out fillings, Blue Streak is smooth and graceful, offering some of the best air time in the park.

FACING PAGE
TOP: Blue Streak's smooth lines are accentuated at night.
BOTTOM LEFT: One final bunny hill before the train arrives back at the station.
BOTTOM RIGHT: In the distance is the signature cupola that sits atop the lift hill.

The train climbs a hill before turning around to head back to the station.

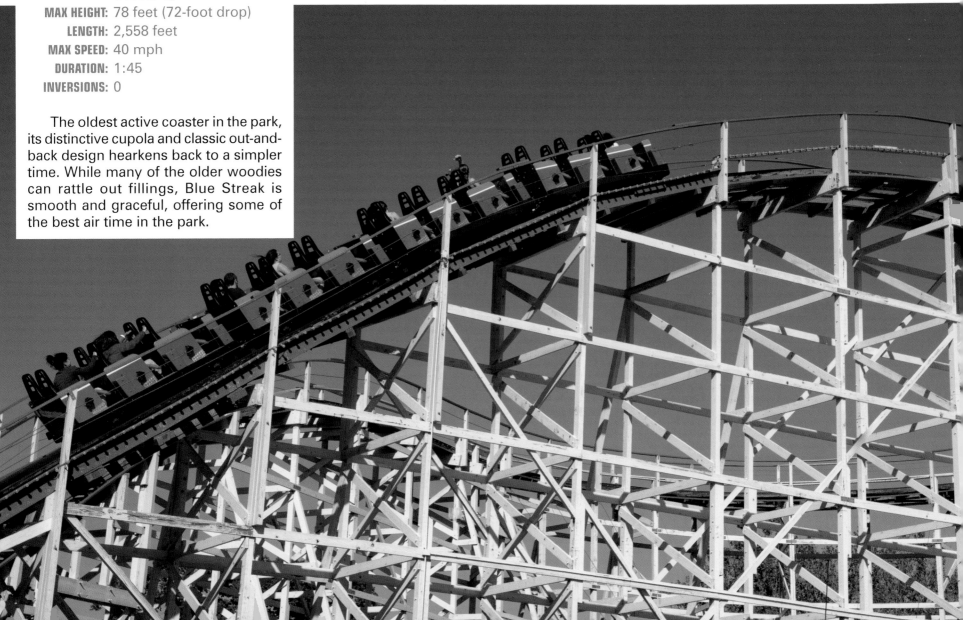

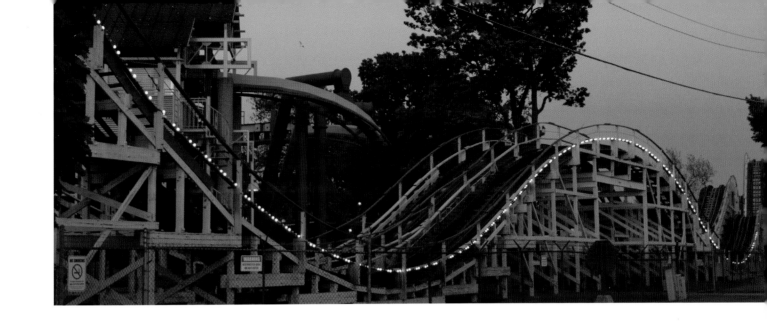

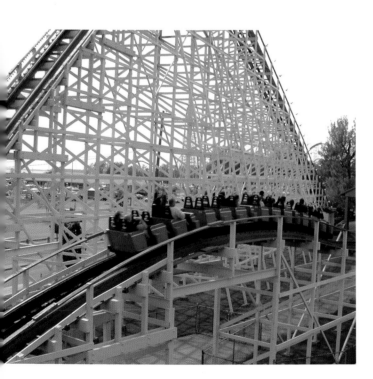

Mantis™

OPENING DATE: May 11, 1996
MAKE: Bolliger & Mabillard
MAX HEIGHT: 145 feet (137-foot drop)
LENGTH: 3,900 feet
MAX SPEED: 60 mph
DURATION: 2:40
INVERSIONS: 4

Mantis is Cedar Point's stand-up roller coaster. It's a beauty to behold, but somewhat of a beast to ride. If you look at it the wrong way, this ride will bite you, but once you understand its nuances, you can coax a decent ride out of it.

FACING PAGE

TOP LEFT: The inclined loop is one of the more beautiful ride elements.
BOTTOM LEFT: After the first drop, riders are thrust into a 119-foot vertical loop.
RIGHT: Fun Fact: Mantis was originally (and briefly) called Banshee™.

Riders zip around a tight turn.

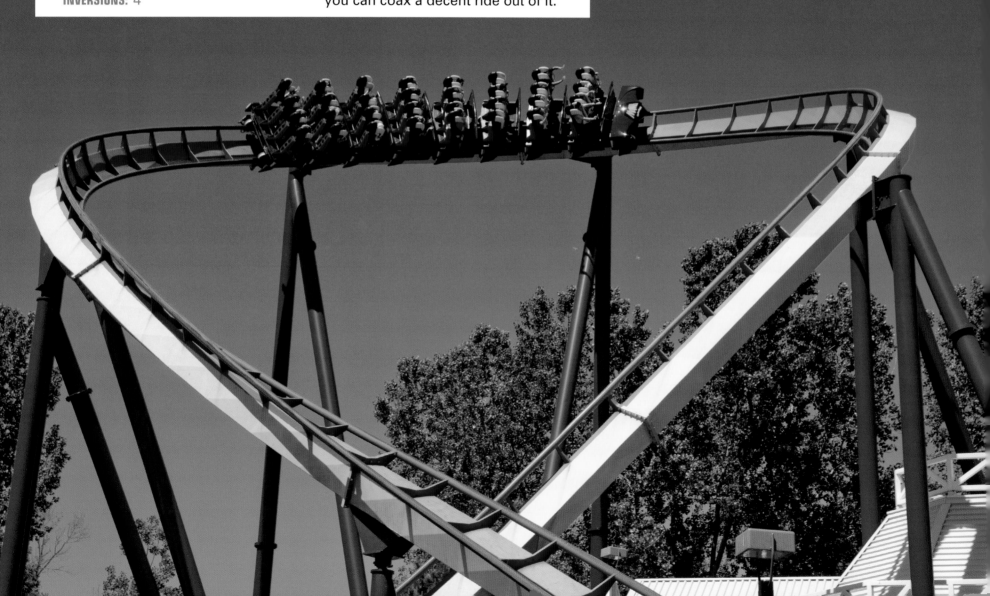

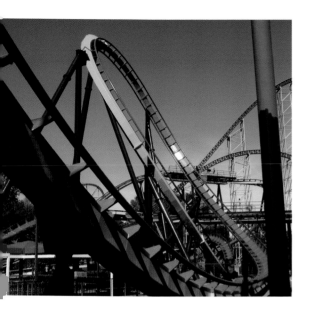

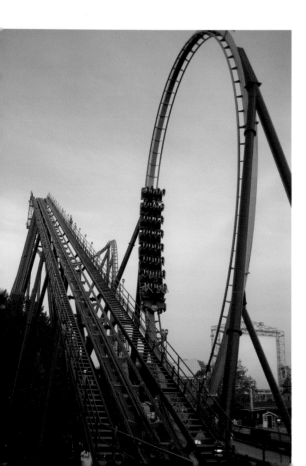

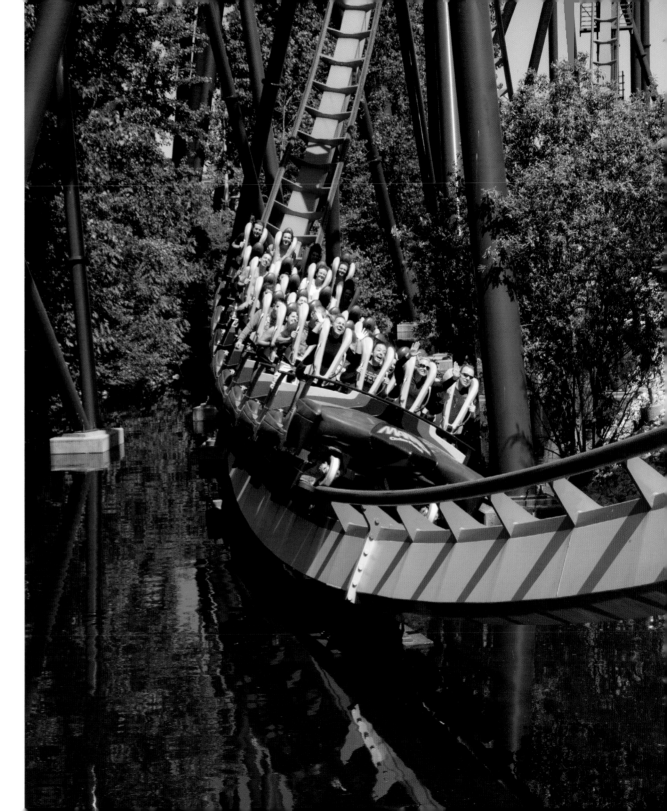

Magnum XL-200

OPENING DATE: May 6, 1989

MAKE: Arrow Dynamics

MAX HEIGHT: 205 feet (195-foot drop)

LENGTH: 5,106 feet

MAX SPEED: 72 mph

DURATION: 2:00

INVERSIONS: 0

With its rocket-ship shaped front car, this coaster ushered in the new age of roller coasters. It was bigger and faster than those that came before and captured the imagination of a new generation of riders. While it has since been eclipsed by others, Magnum XL-200 remains a strong contender filled with great air time and a creative track layout.

FACING PAGE

TOP LEFT: The outer reaches of the track skirt a beach on the lake.

TOP RIGHT: Ominous clouds make it that much more intimidating.

BOTTOM LEFT: In 1989, the towering 205-foot lift hill broke records and maybe soiled a few undies.

BOTTOM RIGHT: One of Mangum's majestic hills.

The train has a distinctive angular design.

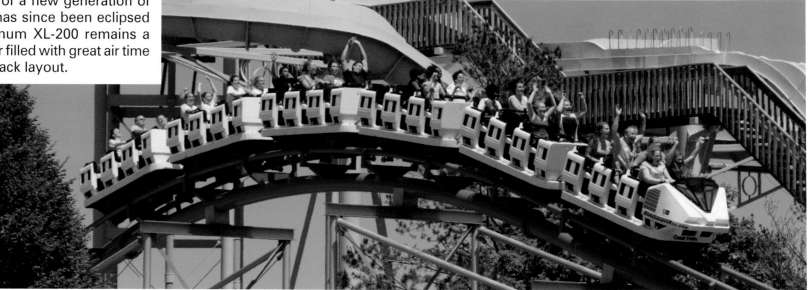

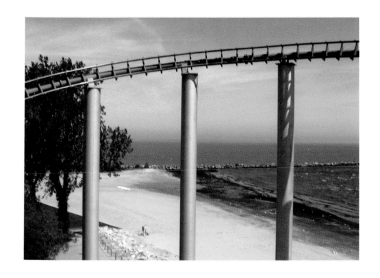
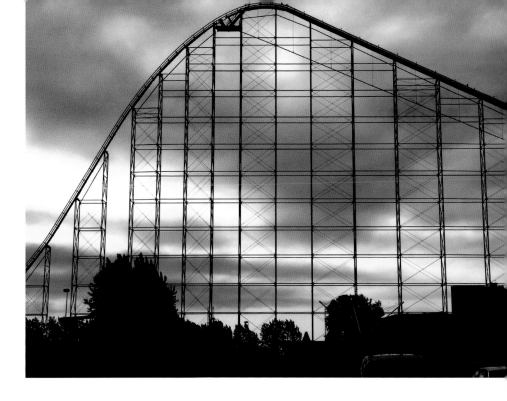
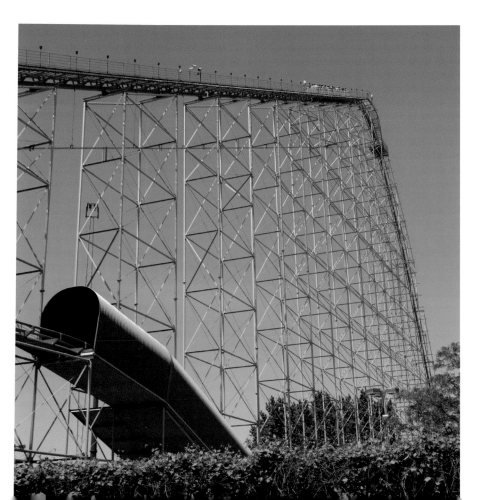
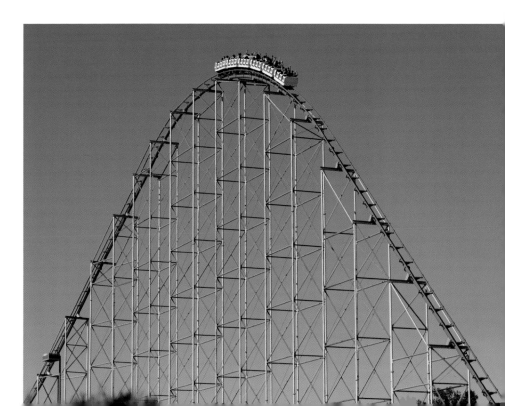

Mean Streak is one of the tallest, fastest, longest wooden coasters in the world.

Mean Streak™

OPENING DATE: May 11, 1991
DESIGNER: Curtis D. Summers
BUILDER: Dinn Corporation
MAX HEIGHT: 161 feet (155-foot drop)
LENGTH: 5,427 feet
MAX SPEED: 65 mph
DURATION: 3:13
INVERSIONS: 0

Make an appointment with your chiropractor before getting on this one. There is no false advertising here. This ride will punch you in the stomach and run off with your lunch money. That doesn't mean it isn't fun. With more than a mile of track, it starts at a furious pace and doesn't let up. It's also a breathtaking structure to behold. Situated on the edge of the park, it offers a great view of Lake Erie as you crest its larger hills. If you want to minimize the rough nature of the ride, be sure to sit in the front seat of a car near the front of the train.

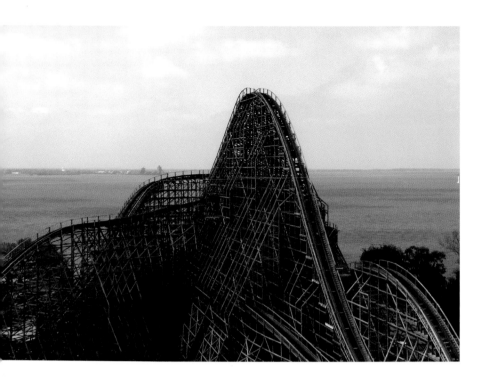

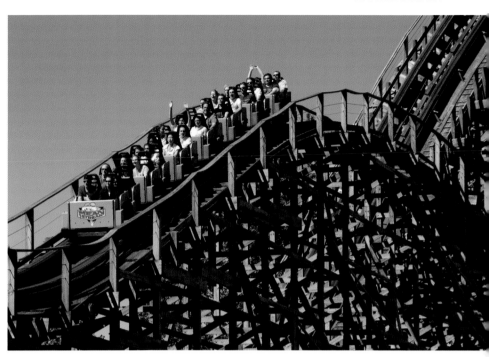

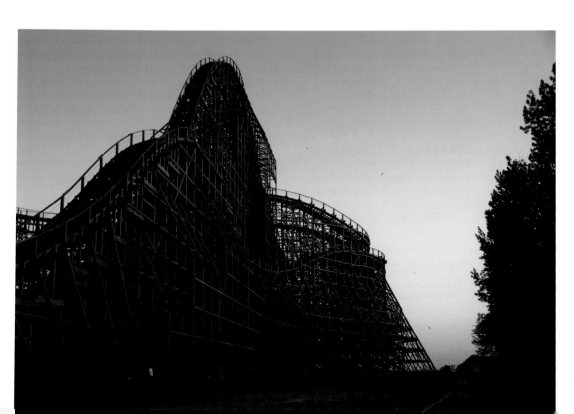

Millennium Force

OPENING DATE: May 13, 2000
MAKE: Intamin AG
MAX HEIGHT: 310 feet (300-foot drop
LENGTH: 6,595 feet
MAX SPEED: 93 mph
DURATION: 2:20
INVERSIONS: 0

Nothing quite compares to a ride on the front seat of Millennium Force. Moments before plunging down the 300-foot, near-vertical first drop, time stops. With the back of the train still making its way over the hump, you hang there looking down, the ground impossibly far away.

Then the entire weight of the train surges from behind, thrusting you through the first dip at more than 90 miles per hour. Primal urges transform what would be an ear to ear grin into a throaty roar as you rocket through its many twists and turns before cresting the final banked turn at near 60 miles per hour.

With more than a mile of track, this coaster delivers on nearly every front imaginable. There are taller and there are faster, but scant few as exhilarating. Millennium Force should be on every coaster enthusiast's bucket list.

FACING PAGE

TOP LEFT: If the thrilling hills and mind-numbing speed aren't enough, riders get to traverse two tunnels.
TOP RIGHT: Millennium Force is a star amidst the coaster landscape of Cedar Point.
BOTTOM: The train maintains a high speed all the way back to the station.

Riders navigate the final banked curve at speeds faster than the top speed of most other roller coasters.

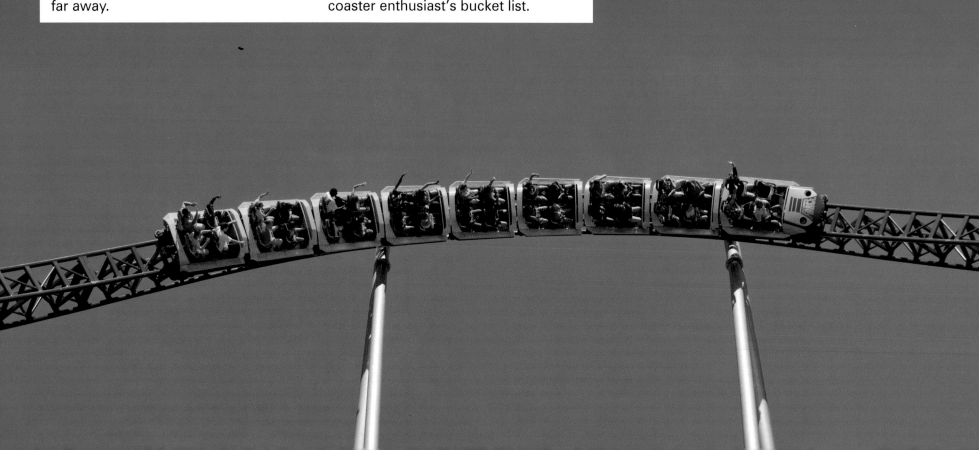

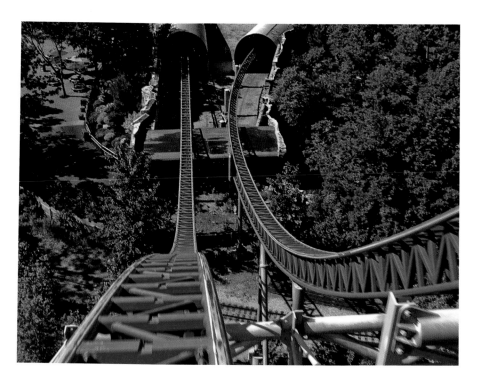

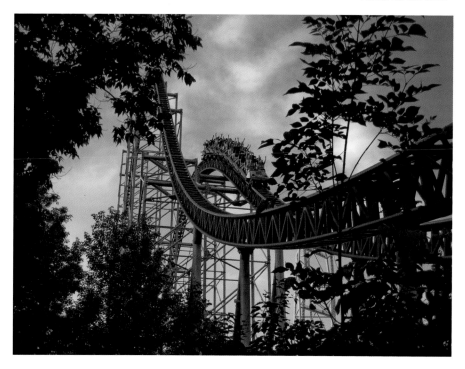

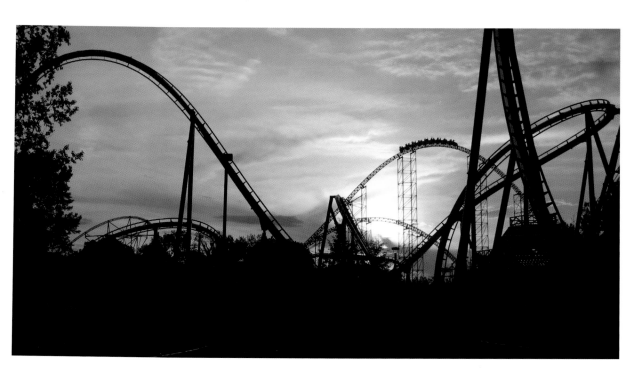

At sunset this iconic
structure is a bold
statement.

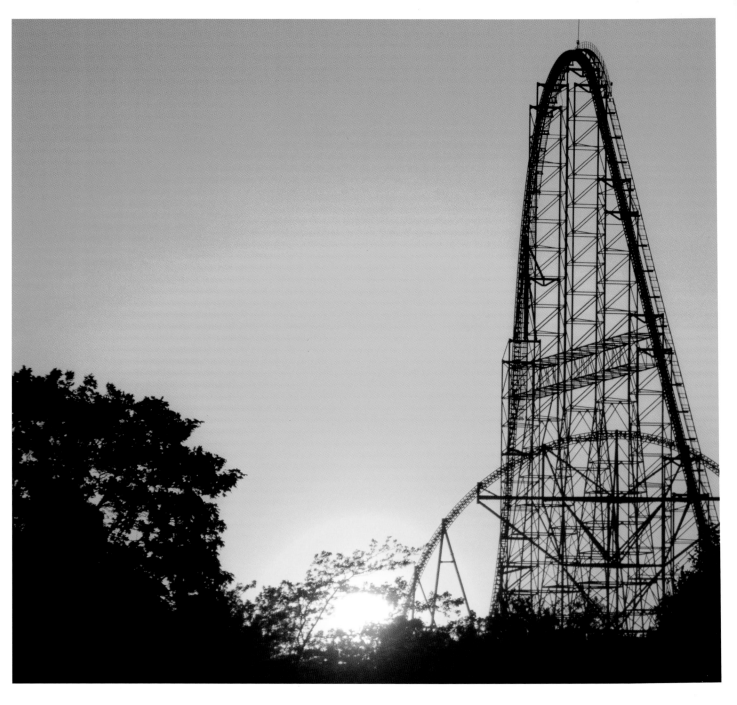

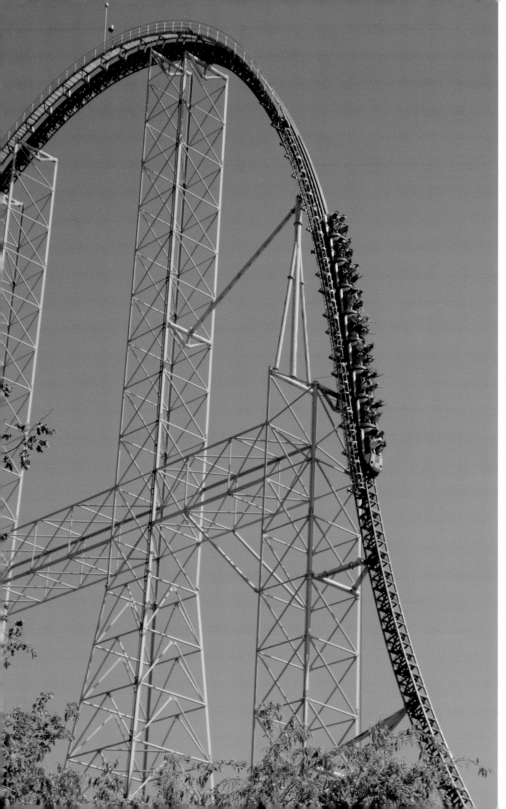

The 300-foot, near-vertical first drop
is one of the most thrilling coaster
experiences, period.

The park has a carnival-like atmosphere.

Knoebels
Elysburg, Pennsylvania

If you detest the sanitized, corporate shell that seems to define most major amusement parks, then you'll enjoy Knoebels Amusement Park. This family-owned park doesn't charge for parking. Admission is free. The food is even reasonably priced. You pay for what you ride. While you won't be riding the latest and greatest mega coasters, you won't feel like you were held up at gunpoint either.

The park specializes in resurrecting rides long forgotten. The Looper™ is the single best flat ride anywhere (if you like spinning end over end until up seems down) and the bumper cars are said to be tops. All this and it has one of the top-ranked wood roller coasters in the world.

Bottom line: If you are looking for a good old-fashioned park, Knoebels is the place to be.

The park is laid back and easy going. There are even private residences inside the park's perimeter.

There are plenty of rides for the wee ones.

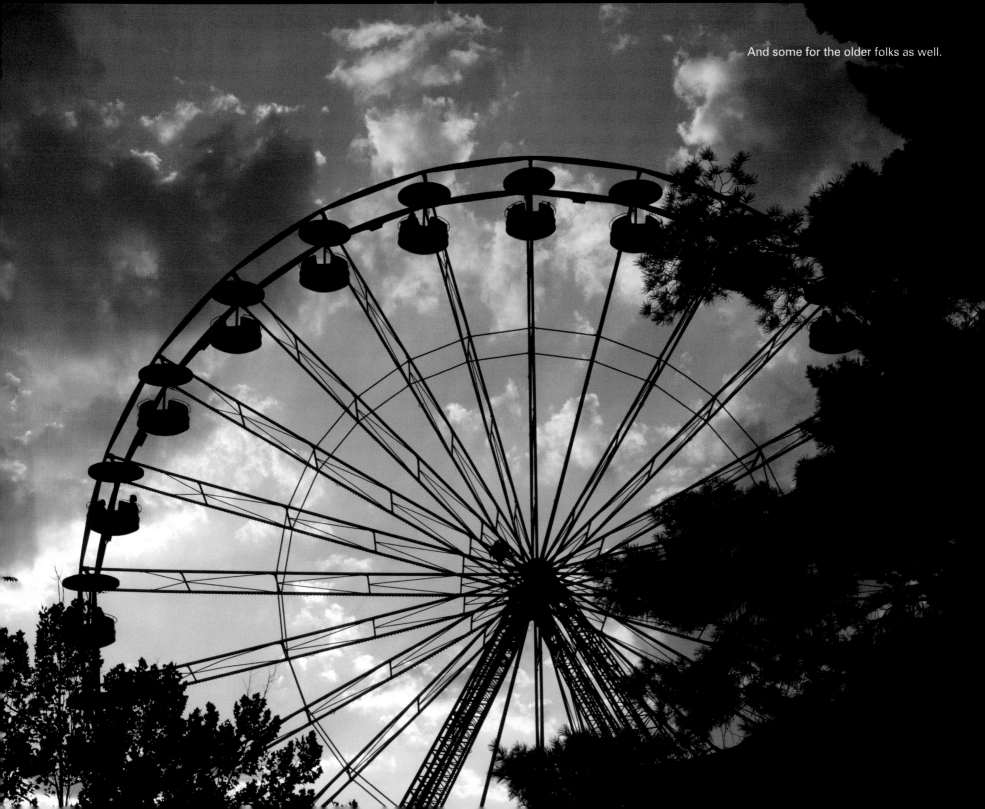

And some for the older folks as well.

Phoenix™

OPENING DATE: June 15, 1985

DESIGNER: Herbert Paul Schmeck

MAKE: Philadelphia Toboggan Company

MAX HEIGHT: 78 feet (72-foot drop)

LENGTH: 3,200 feet

MAX SPEED: 45 mph

DURATION: 2:00

INVERSIONS: 0

This might be the scariest roller coaster in the country. Current roller coasters, no matter how big or fast, are built with an overabundance of safety in mind. For good or bad, in today's world, riders are stapled in place. Fortunately, Phoenix doesn't have seat belts and features some of the most impressive air time of any coaster, old or new— wood or steel. At certain times during the ride you'll find yourself reflexively splaying your legs in an effort to hang on even though there is no real danger of harm.

Originally built in 1947 and operated as "The Rocket" at Playland Park in San Antonio, Texas, until 1980, Knoebels had the entire coaster transported (each part numbered on site) and rebuilt, even though the original blueprints were long gone. It's this dedication to preservation that puts Knoebels in a class by itself.

FACING PAGE

TOP LEFT: Phoenix's signature cupola awaits riders at the top of the lift hill.

TOP RIGHT: Night rides are simply exhilarating.

BOTTOM LEFT: The train rounds a turn, a brief respite before the exciting finish.

BOTTOM RIGHT: Phoenix is built right up to the edge of the forest.

Riders begin their journey on this wonderful roller coaster.

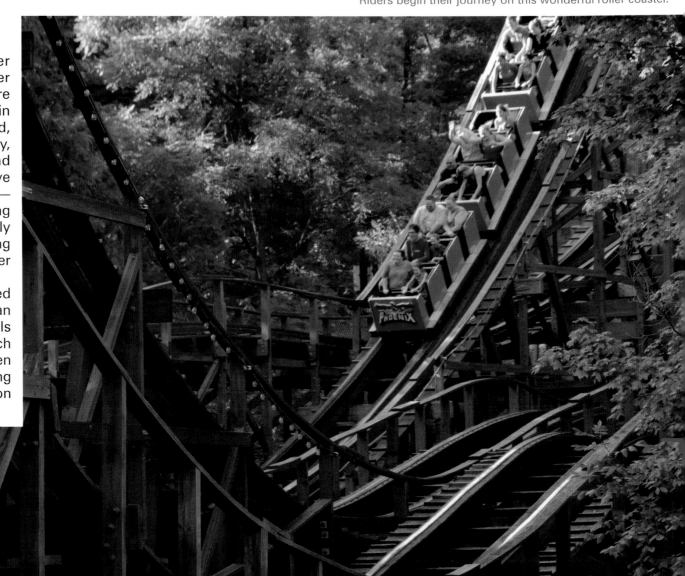

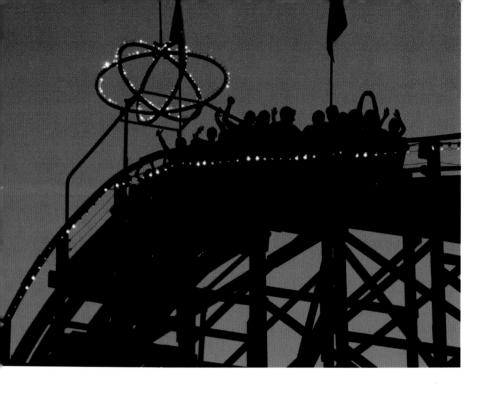
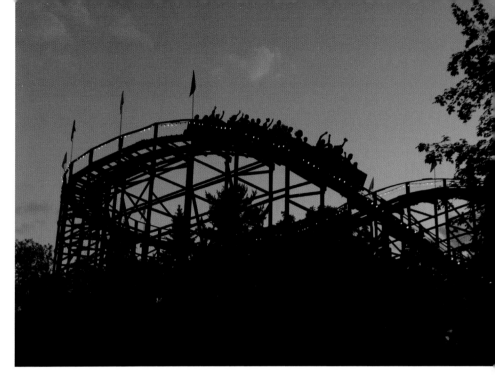
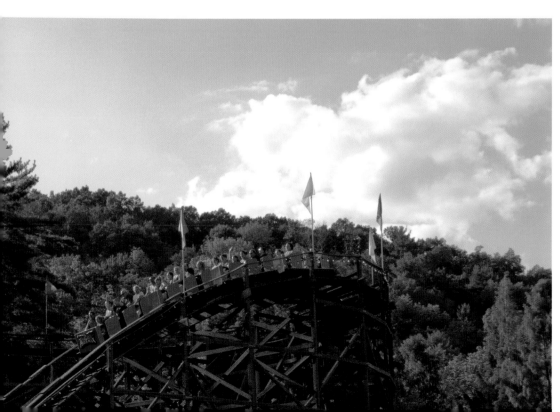
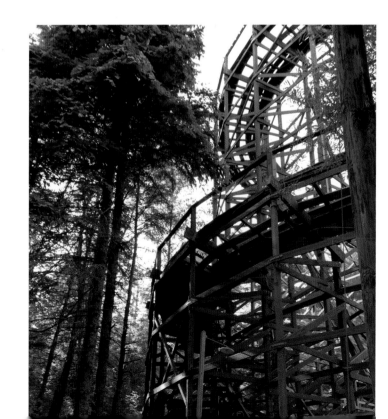

Twister™

OPENING DATE: July 24, 1999

DESIGNER: John Fetterman
(from John C. Allen's
Mister Twister design)

MAX HEIGHT: 102 feet (90-foot drop)

LENGTH: 3,900 feet

MAX SPEED: 52 mph

DURATION: 2:10

INVERSIONS: 0

Like Phoenix, Twister has an interesting past. When it became impossible to transplant the original Mister Twister™ ride as it stood, Knoebels bought the blueprints and modified them to fit within the park, taking pains to preserve the unique elements that the original featured.

Its unique layout features a double helix that encircles the loading station. While Twister can be a bit bumpy, if you give it a few rides the soul of this coaster will eventually shine through.

FACING PAGE

LEFT: The train enters the double helix.

RIGHT: To maintain this curve at the top of the lift hill, it was actually split into two lift sections.

The track appears to be overlapping as it wraps around the station.

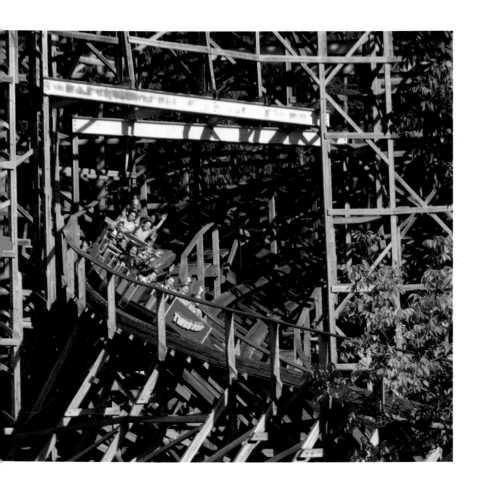

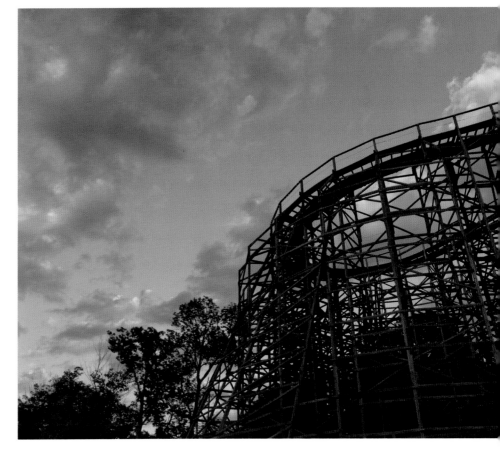

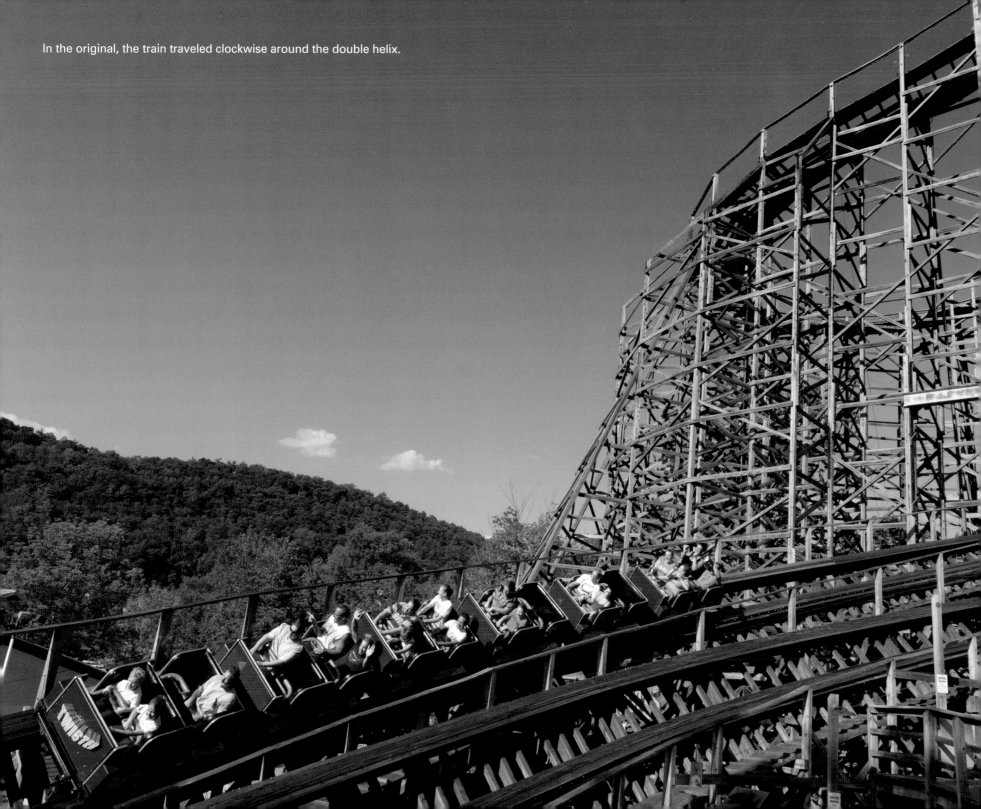
In the original, the train traveled clockwise around the double helix.

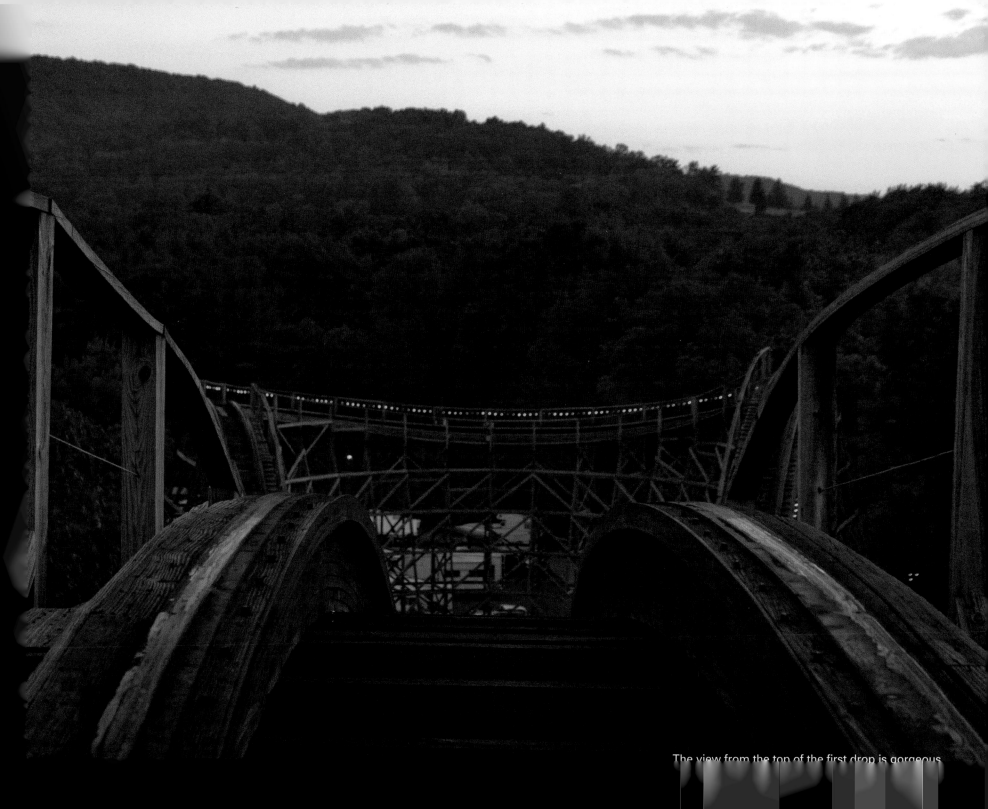

The view from the top of the first drop is gorgeous.

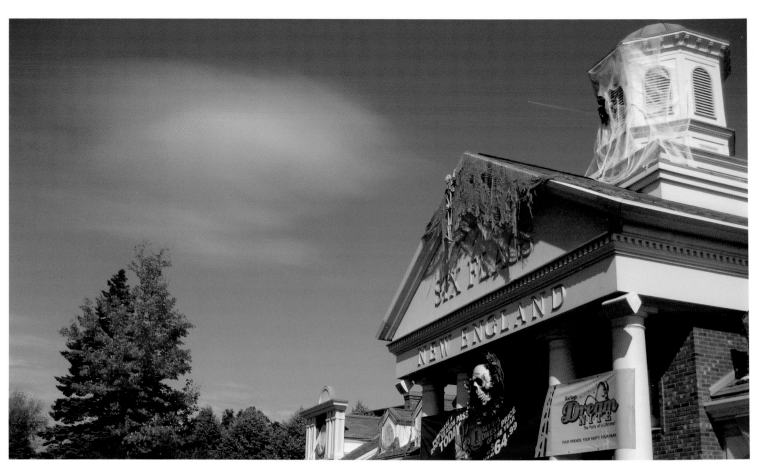

The entrance is decorated for Halloween festivities.

Six Flags New England
Agawam, Massachusetts

A few hours north of New York City, inches from the Connecticut/Massachusetts border, lies Six Flags New England. It's the largest park in its area and features, at its heart, a coaster that has won many accolades. Even though it became a Six Flags property in 1998, this old soul dates back prior to 1900, under the name Riverside Park.

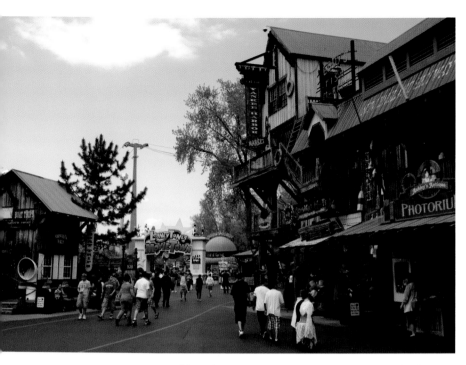

Many interesting buildings dot the park's landscape.

Gotham City Gauntlet Escape from Arkham Asylum™ is one of the few wild-mouse coasters that is easy on the eyes.

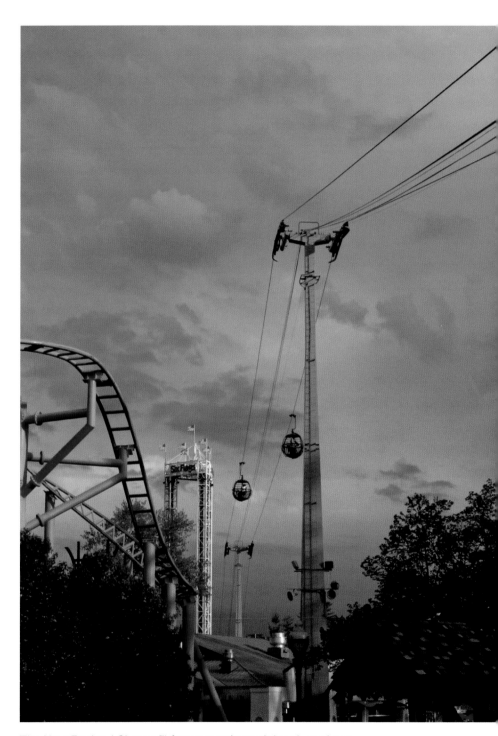

The New England Skyway™ features unique globe-shaped cars.

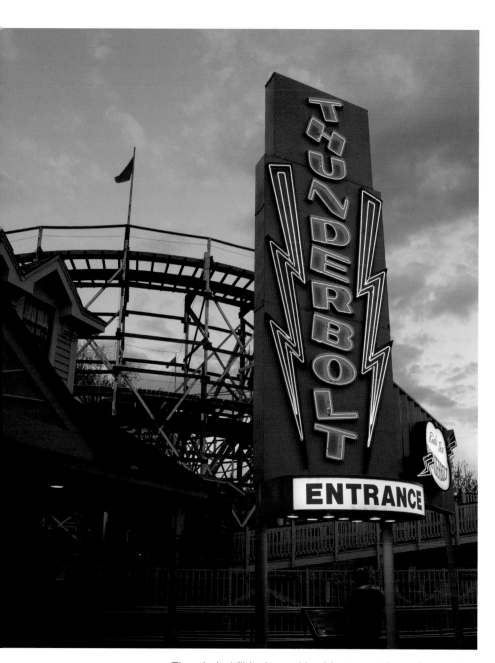

Thunderbolt™ is the park's oldest operating roller coaster.

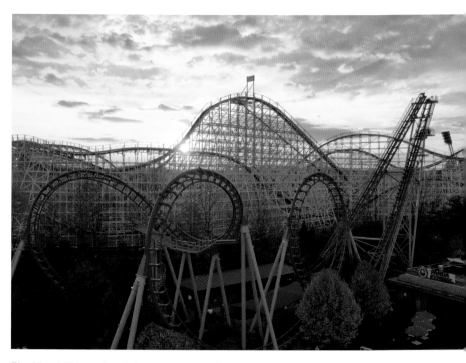

Flashback™ is a classic boomerang-style coaster that lives in the shadow of the Cyclone™.

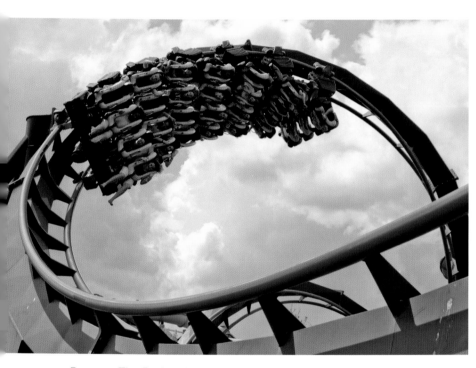

Batman: The Dark Knight™ is a floorless roller coaster that performs many acrobatic feats.

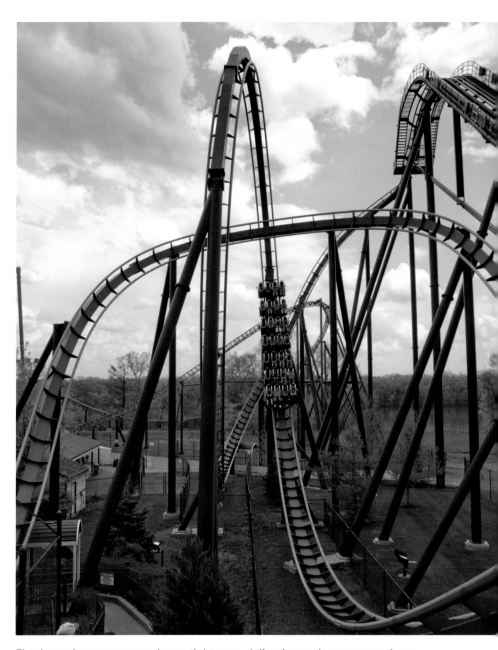

Five inversions are woven into a tight area, delivering an intense experience.

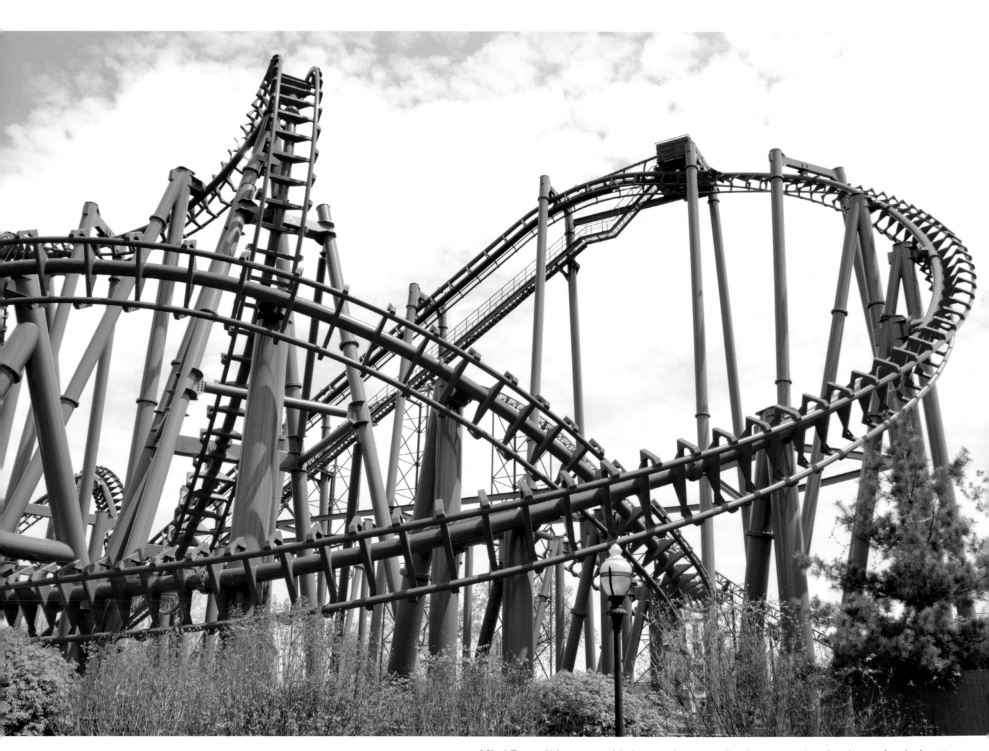

Mind Eraser™ is a two-aside inverted coaster that has more than its share of turbulent turns.

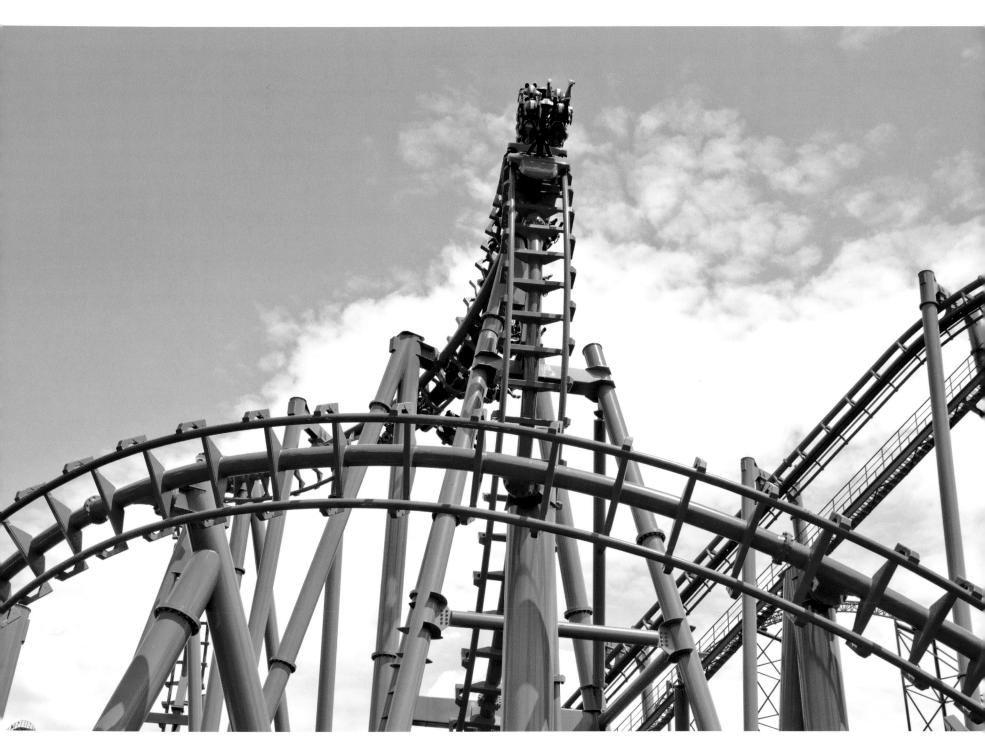

This is one of five inversions. Try to anticipate turns and rolls to prevent it from tossing you around.

Cyclone

OPENING DATE: June 24, 1983
BUILDER: William Cobb & Associates
MAX HEIGHT: 112 feet (90-foot drop)
LENGTH: 3,600 feet
MAX SPEED: 45 mph
DURATION: 2:40
INVERSIONS: 0

Originally opened as the Riverside Cyclone, the name was changed after Six Flags purchased the park. It is based on the Coney Island Cyclone, but was squeezed into a smaller space, resulting in some hard turns.

FACING PAGE
LEFT: It features a few memorable dips that set it apart from other Coney Island derivatives.
RIGHT: A tight turning radius requires this tower and chains for added support.

Cyclone is in the perfect spot for great pictures at sunset.

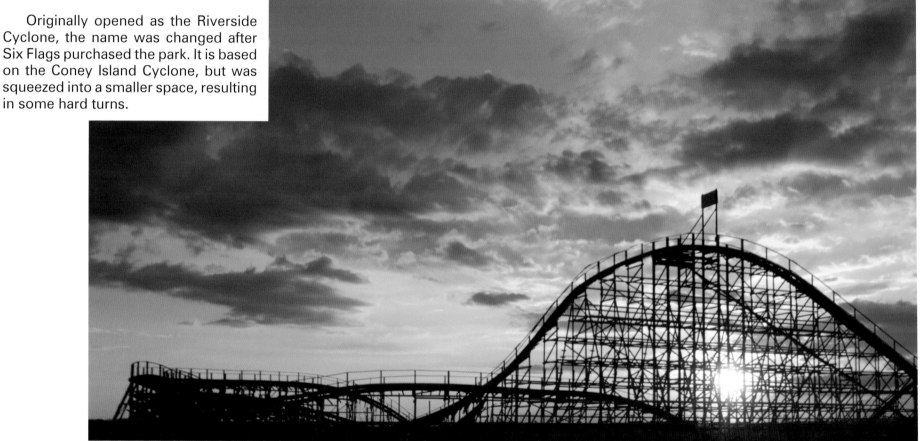

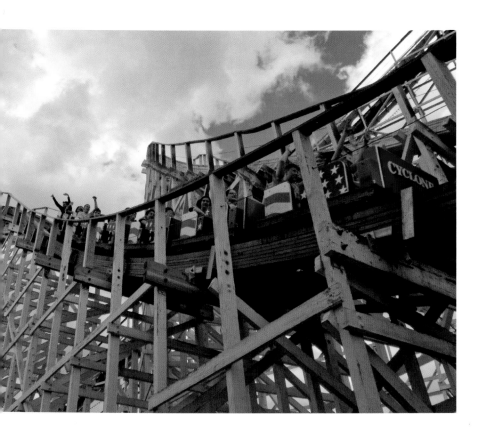

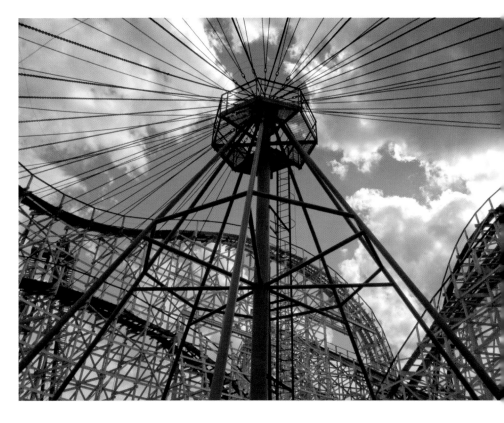

The train crests a hill before entering a tunnel.

Bizarro™

OPENING DATE: July 5, 2000
MAKE: Intamin AG
MAX HEIGHT: 208 feet (221-foot drop)
LENGTH: 5400 feet
MAX SPEED: 77 mph
DURATION: 2:35
INVERSIONS: 0

Previously known as Superman: Ride of Steel™, it was renamed Bizarro in 2009 as part of a major re-theming. Riders now are accompanied by a soundtrack as they fly through mist and around structures. But in the end, it adds little if anything to a roller coaster that is repeatedly named the best steel coaster on the planet. The first half is filled with large loping hills followed by a series of furious turns that will demand you dash back to the line for another go.

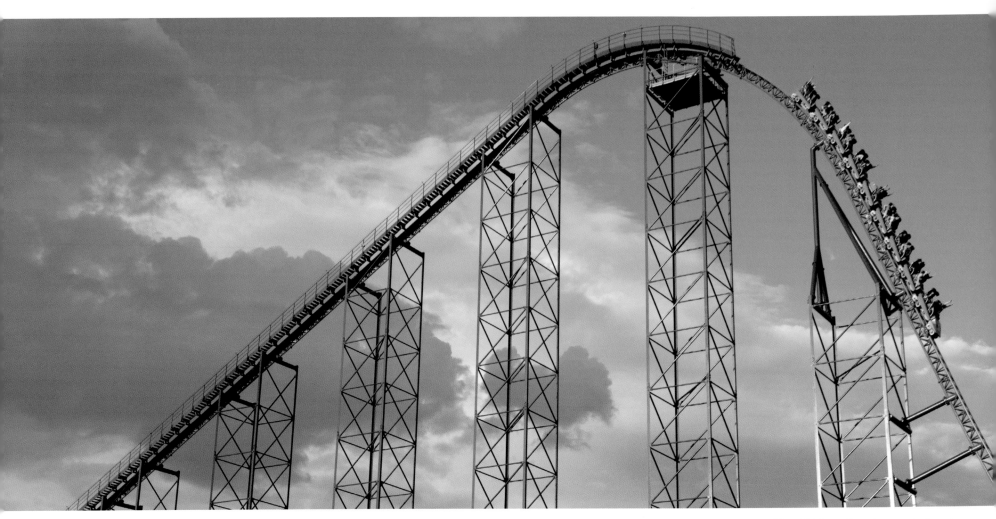

The 221-foot first drop sets the stage.

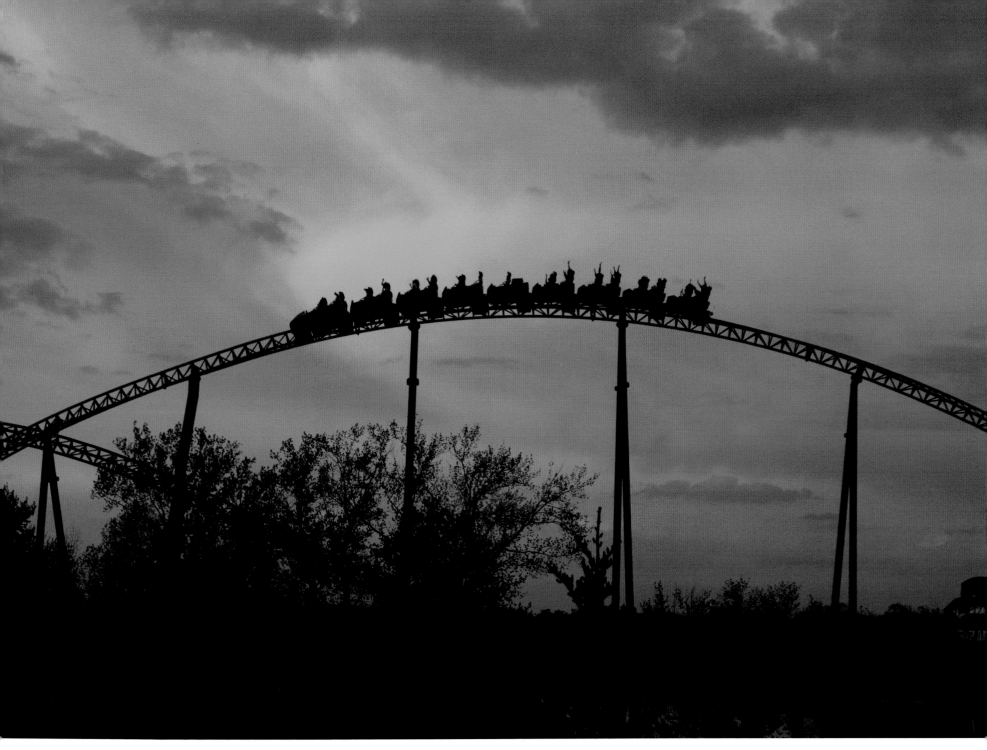

A night ride on Bizarro is the perfect ending to a day at Six Flags New England.

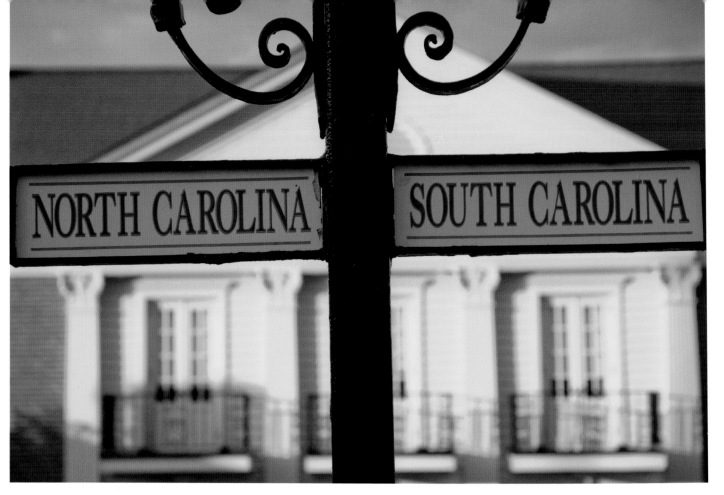

This sign indicates the states' borders within the park.

Carowinds

Charlotte, North Carolina

Fort Mill, South Carolina

If you want to ride roller coasters in two different states on the same day, then you're in luck. Carowinds straddles North and South Carolina and contains ten legitimate coasters plus three more for the younger crowd. Standing, flying, looping, wooden, among others: Carowinds has a nice portfolio of roller coasters that aim to scratch your coaster itch.

Bunting conjures up images of old town U.S.A.

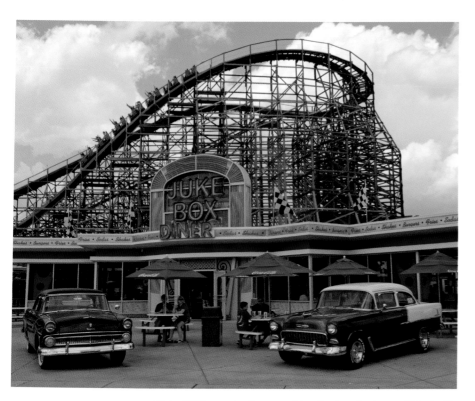

This 1950s-style diner resides in the shadow of Hurler™.

Even though it lost its ties to the Wayne's World® movies, Hurler was able to retain its name when Cedar Fair Entertainment Company bought all Paramount® Parks, including Carowinds, in 2006.

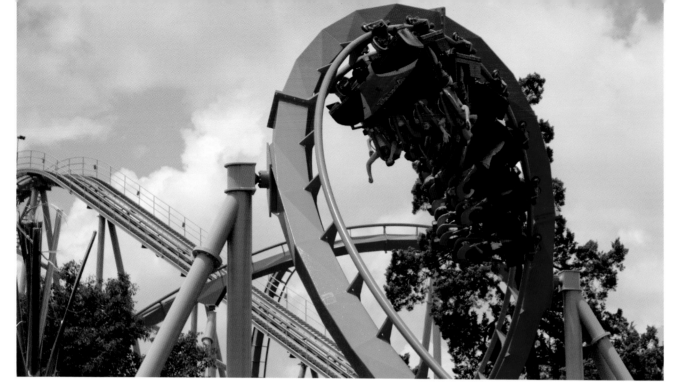

Vortex™ is Bolliger & Mabillard's third roller coaster, one of a new breed of stand-up coasters when it opened in 1992.

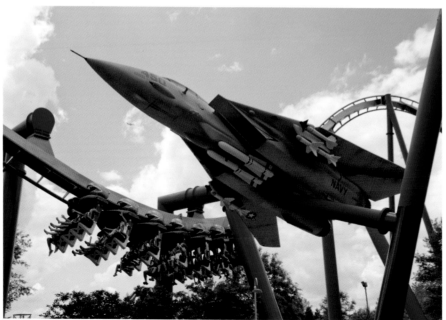

Introduced in 1999, Afterburn™ still arguably produces the greatest thrill of any roller coaster in the park.

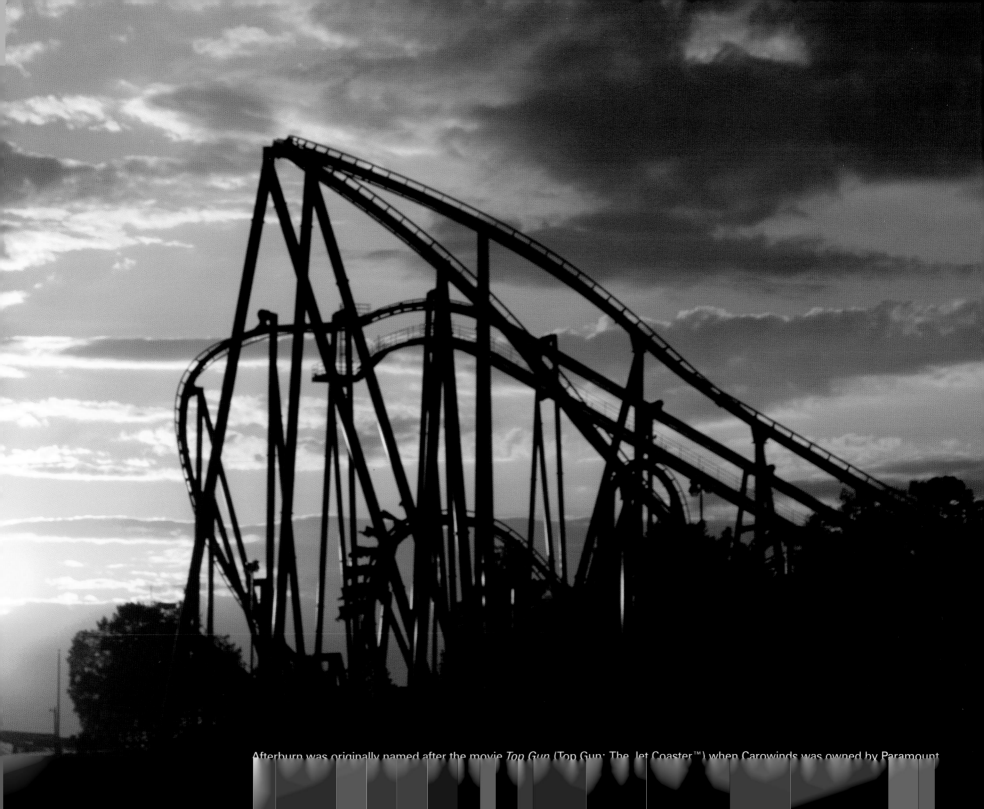

Afterburn was originally named after the movie *Top Gun* (Top Gun: The Jet Coaster™) when Carowinds was owned by Paramount

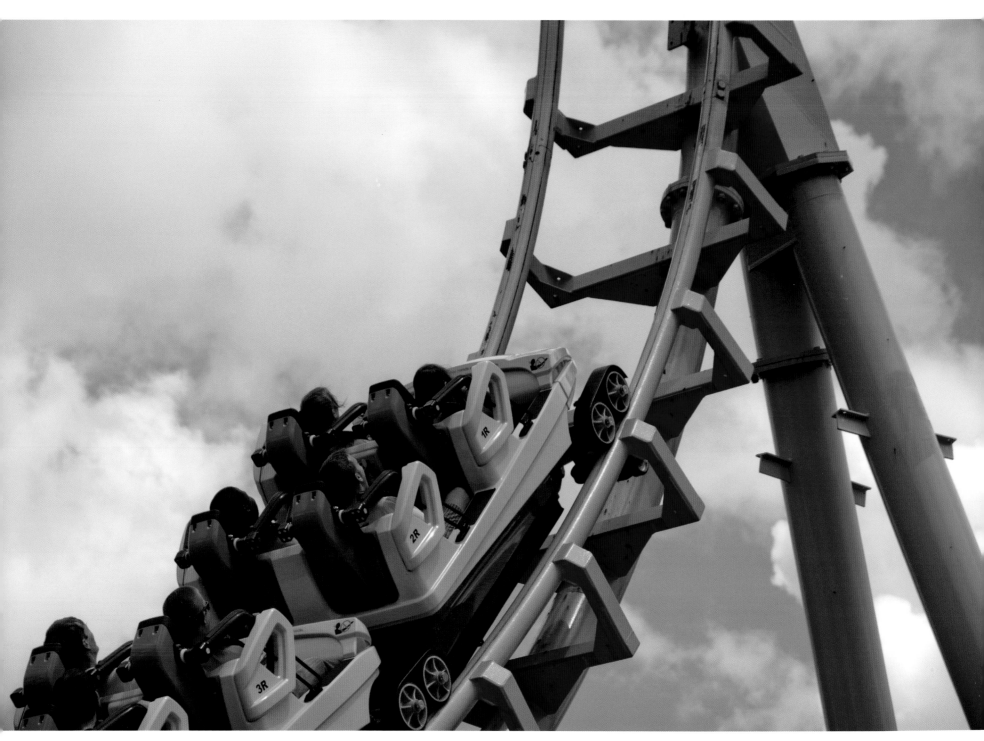

Carolina Cobra™ is Carowinds' boomerang coaster. Just about every park seems to have one of these.

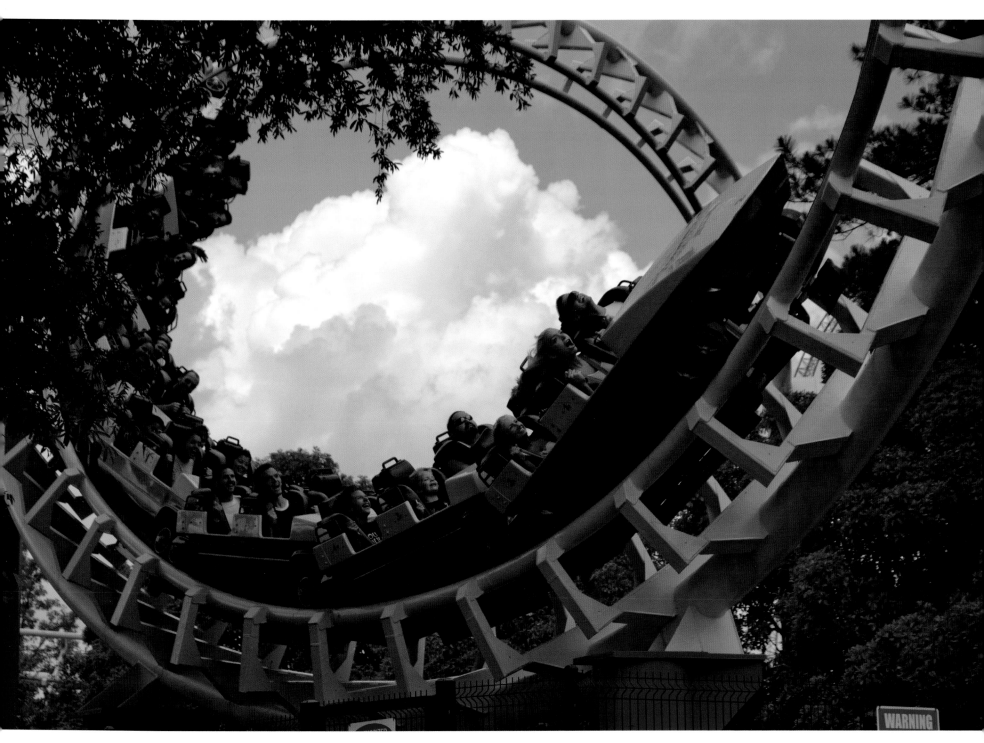

Opening in 1980, the Carolina Cyclone™ was the premier roller coaster of the park for more than a decade.

Nighthawk™

OPENING DATE: March 20, 2004
MAKE: Vekoma
MAX HEIGHT: 115 feet
LENGTH: 2,766 feet
MAX SPEED: 51 mph
DURATION: 1:50
INVERSIONS: 5

Nighthawk started life as Stealth™ at California's Great America®. It was the first flying coaster built by Vekoma. Riders are lowered onto their backs before the train leaves the station, but once the train starts its descent down the first hill, it rolls over to put riders in the flying position. Flying coasters have notoriously long load times and the Vekoma examples are the worst of them. Ride it when the line is short and you'll come out with a better opinion.

FACING PAGE

LEFT: A nice corkscrew twists through the trees.
TOP RIGHT: A fresh paint job helps even a pedestrian section of track stand out.
BOTTOM RIGHT: Nighthawk integrates with the surrounding landscape in interesting ways.

Nighthawk is located in a picturesque portion of the park.

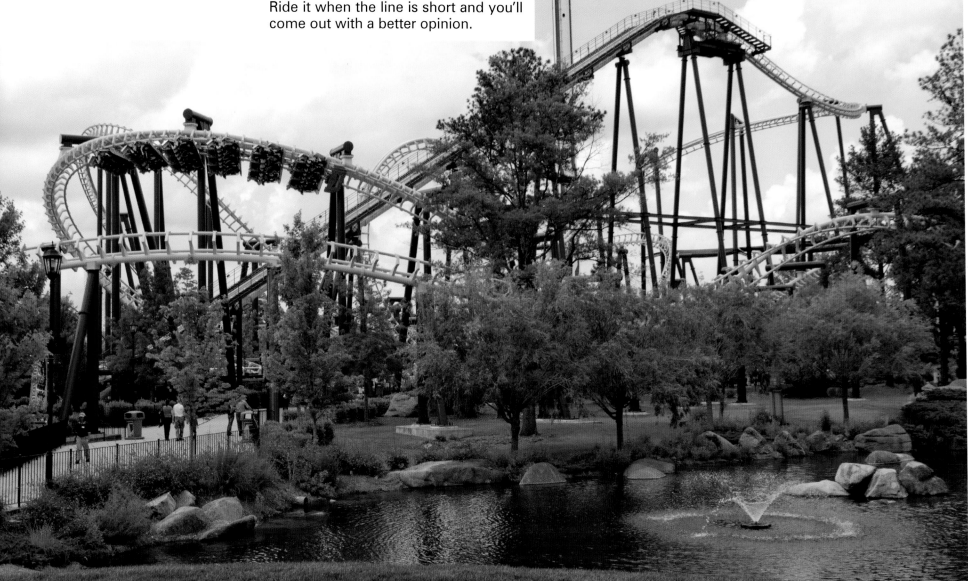

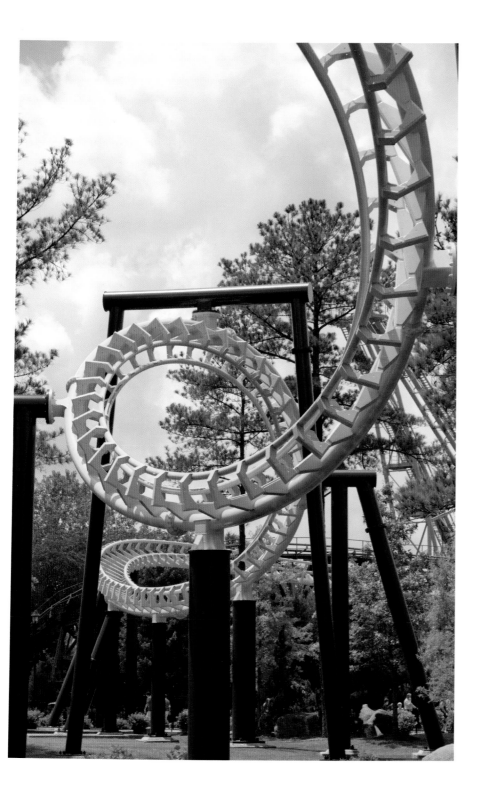

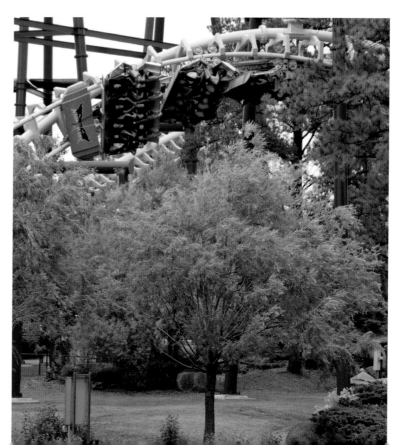

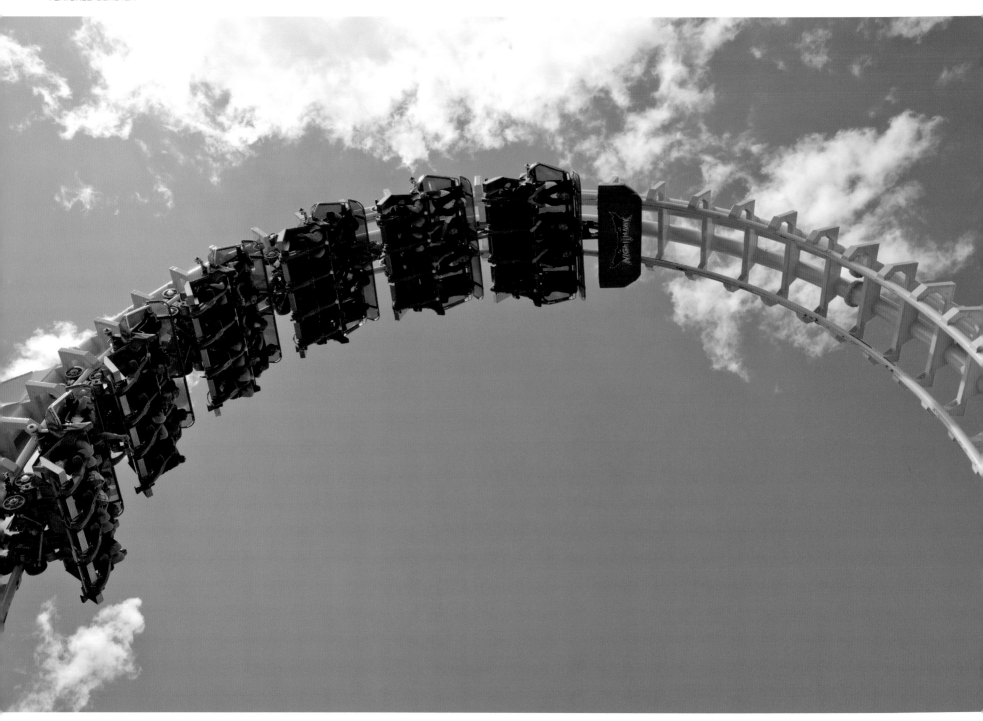

Riders power through Nighthawk's tall loop.

Intimidator™

OPENING DATE: March 27, 2010
MAKE: Bolliger & Mabillard
MAX HEIGHT: 232 feet (211-foot drop)
LENGTH: 5,316 feet
MAX SPEED: 75 mph
DURATION: 3:33
INVERSIONS: 0

Intimidator gets its name from the nickname of late NASCAR® driver Dale Earnhardt. There are two Intimidators (The other one is called Intimidator 305™ at Kings Dominion). This one is built by Bolliger & Mabillard and features oodles of airtime. Even if you generally prefer the front seat, give the back a try. It's something special. But don't take my word for it. Experimenting is fun!

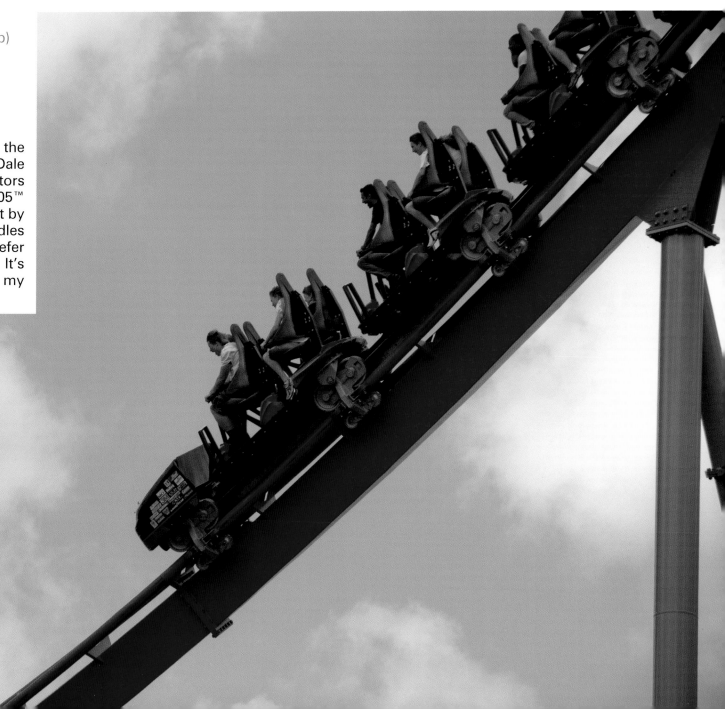

Riders plunge down one of the steep hills.

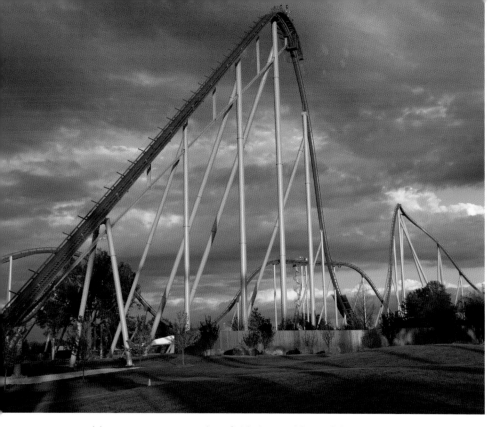

It's easy to get a gander of this beast. Most of the track is front and center.

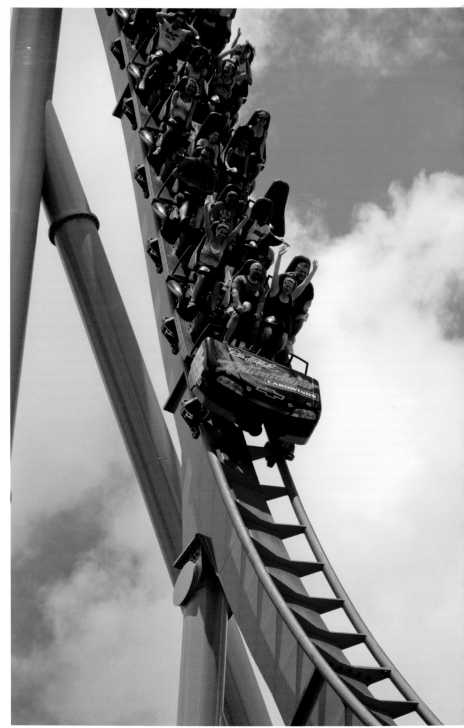

The front of the train makes you feel like you are zooming around a race track in top gear.

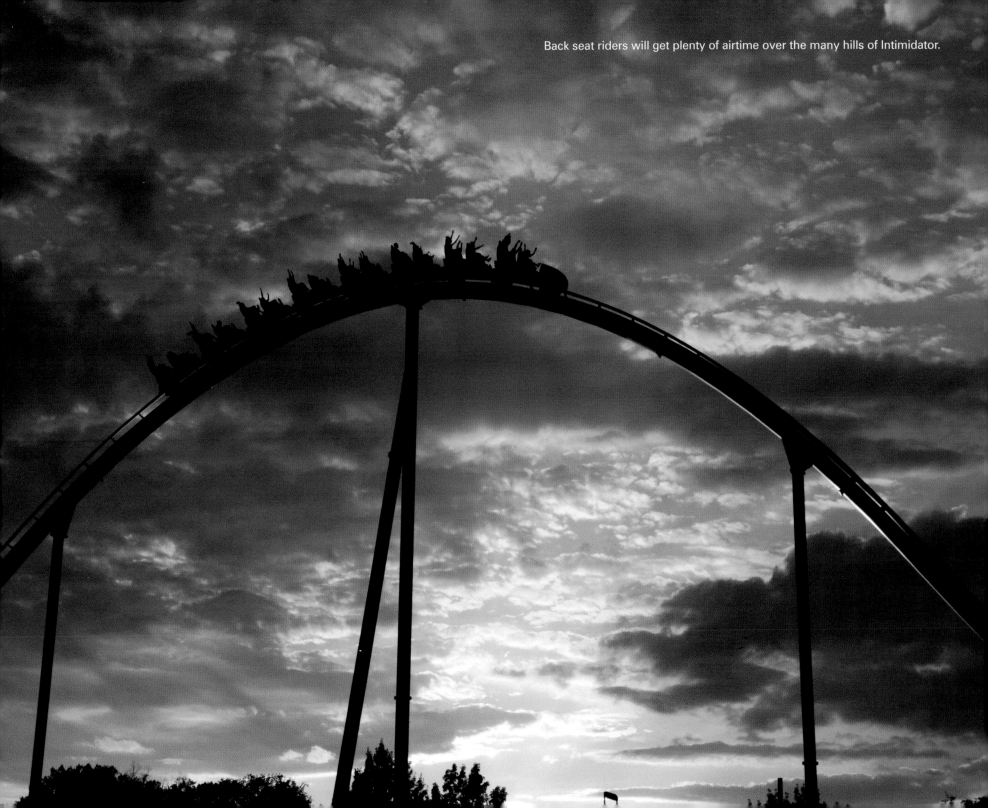

Back seat riders will get plenty of airtime over the many hills of Intimidator.

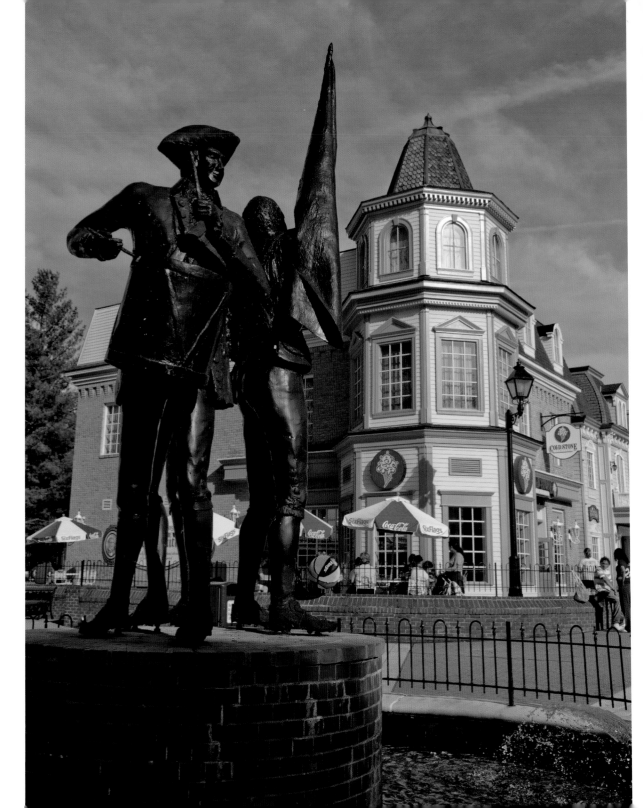

The statue of the Revolutionary War soldiers is the centerpiece of a fountain at the front of the park.

Six Flags America

Mitchellville, Maryland

Nestled between heavy hitters like Six Flags Great Adventure and Kings Dominion, this small park just outside Washington, D.C., is easy to overlook. Those who find their way into the park will find one of the oldest roller coasters in the country, as well as a steel coaster that measures up with the best of them.

Batwing™ is the park's flying coaster.

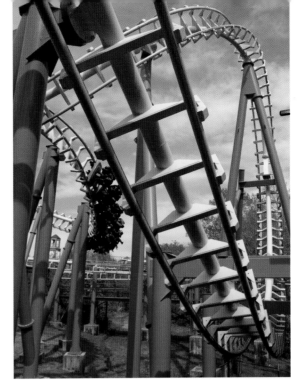

Mind Eraser™ is a two-a-side inverted that will scramble your brains if you aren't careful.

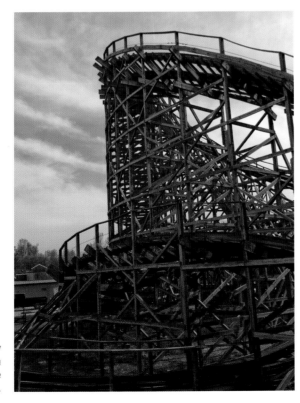

Roar™ is one of the new breed of thrilling wooden coasters that burst onto the scene in the mid-nineties.

This roll is one of five inversions.

Wild One™

OPENING DATE: 1986
BUILDER: Dinn Corporation
MAX HEIGHT: 98 feet (88-foot drop)
LENGTH: 4000 feet
MAX SPEED: 53 mph
DURATION: 1:52
INVERSIONS: 0

How is a coaster that opened in 1986 one of the oldest in the country? Originally opened in 1917 as The Giant Coaster™ at Paragon Park™ in Nantasket Beach, Massachusetts, this coaster endured fires and redesigns before it was bought by Wild World™ (now Six Flags America) and restored to its original design. It's a smooth-riding woodie with some decent airtime and only one distinct rough spot. In other words: a pleasant surprise.

FACING PAGE

LEFT: The train navigates some bunny hills on the way back to the station.

RIGHT: Wild One is integrated closely with other rides, including the train.

Wild One has a classic out and back style.

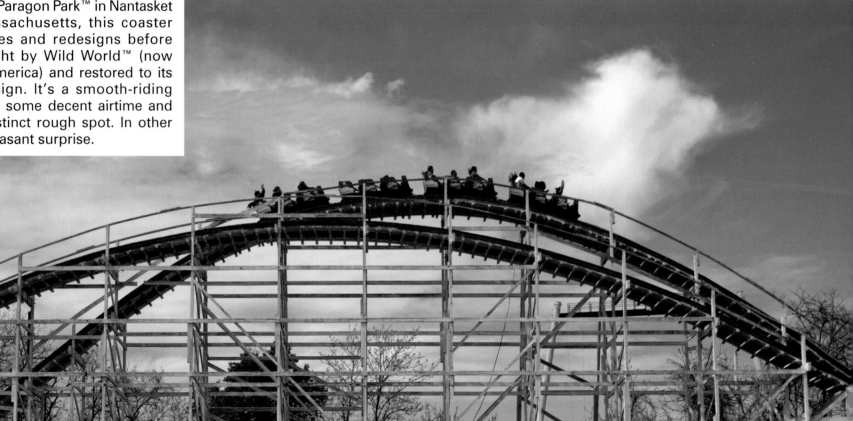

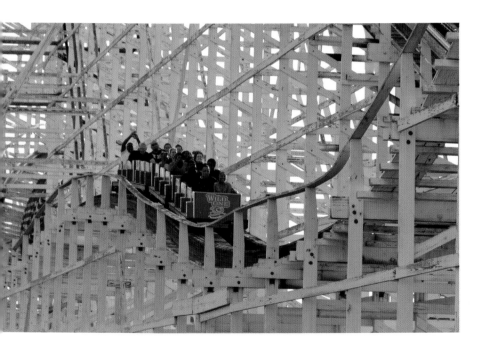

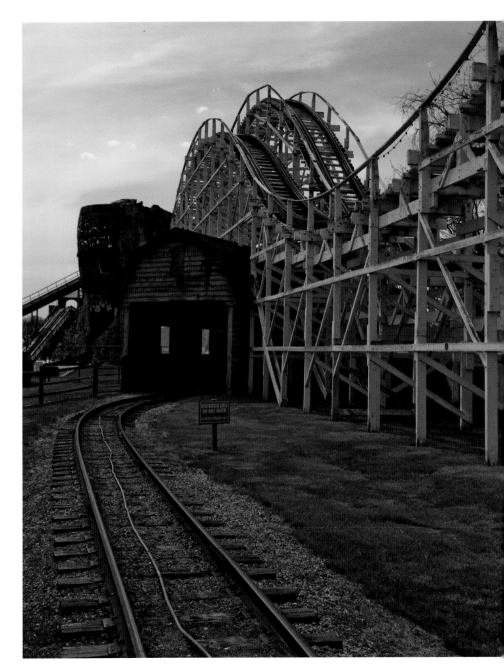

The tight helix makes for a great ending.

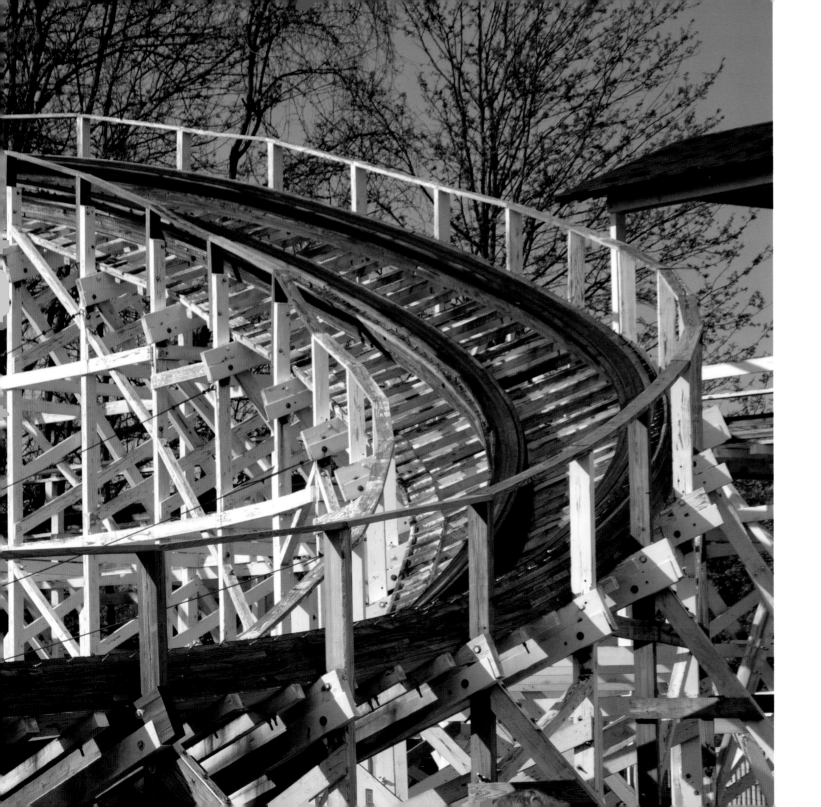

Joker's Jinx™

OPENING DATE: May 8, 1999
MAKE: Premier Rides
MAX HEIGHT: 79 feet
LENGTH: 2,705 feet
MAX SPEED: 60 mph
DURATION: 0:56
INVERSIONS: 4

This coaster is a jumbled tangle of track, an odd puzzle still seeking a solution. Riding through the maze is exhilarating. Launch coasters like this rarely deliver the goods, but Joker's Jinx is a rare exception. One can't help but think that this ride was intended to be enclosed, similar to Flight of Fear™. Leaving it exposed gives you a rare glimpse behind the curtain.

FACING PAGE
LEFT: The train finds its way out of that mess every single time.
RIGHT: The ride is deceptively smooth, despite all its twists and turns.

The train spirals through its final inversion before the brake run.

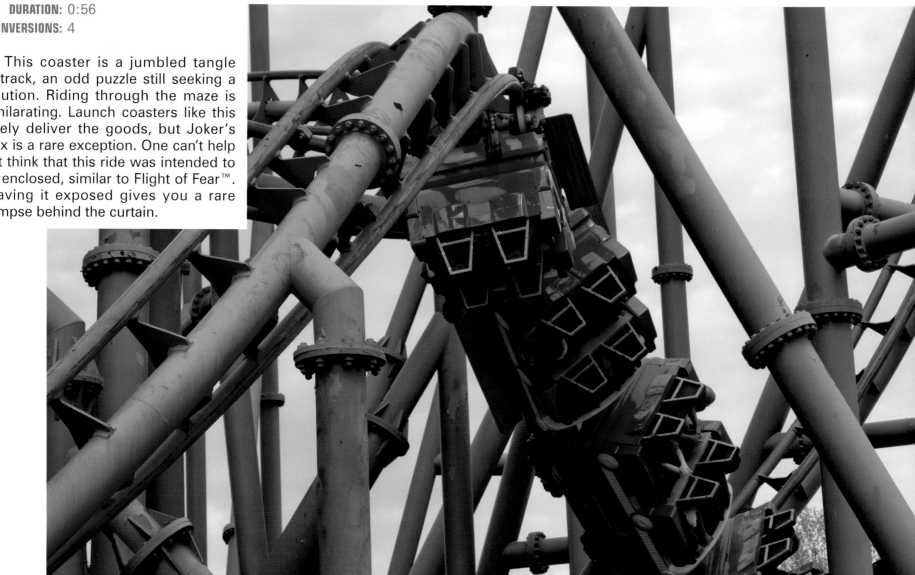

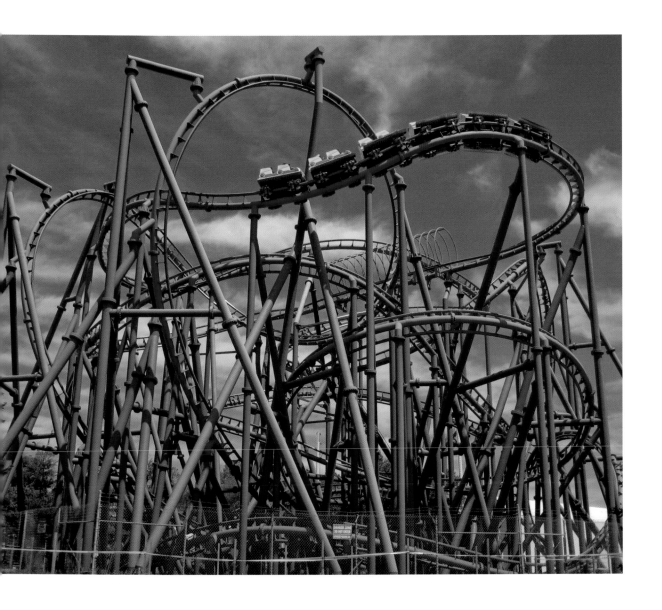

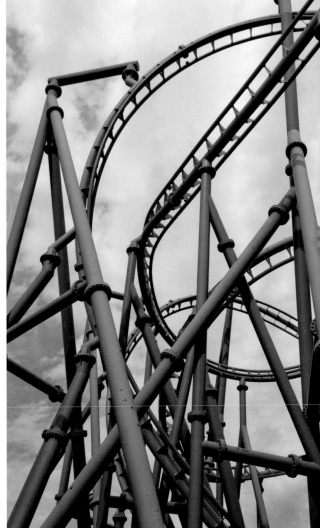

FACING PAGE

TOP LEFT: The 205-foot first drop is a thing of beauty.

BOTTOM LEFT: The train screams into the final double helix.

RIGHT: The 68-degree first drop gets riders traveling 73 miles per hour.

Superman: Ride of Steel™

OPENING DATE: May 13, 2000

MAKE: Intamin AG

MAX HEIGHT: 197 feet (205-foot drop)

LENGTH: 5,350 feet

MAX SPEED: 73 mph

DURATION: 2:10

INVERSIONS: 0

If any ride embodies Superman, it's this one. The design of this coaster accentuates speed at every moment. Yes, there are faster and there are taller, but those comparisons fade away once you pull out of the first of two huge double helixes blazing towards the next hill faster than a speeding bullet.

To really drink in Superman: Ride of Steel, the front seat is the place to be, with your hands outstretched like you are knifing through the sky.

Awesome.

The train glides over bunny hills before arriving back at the station.

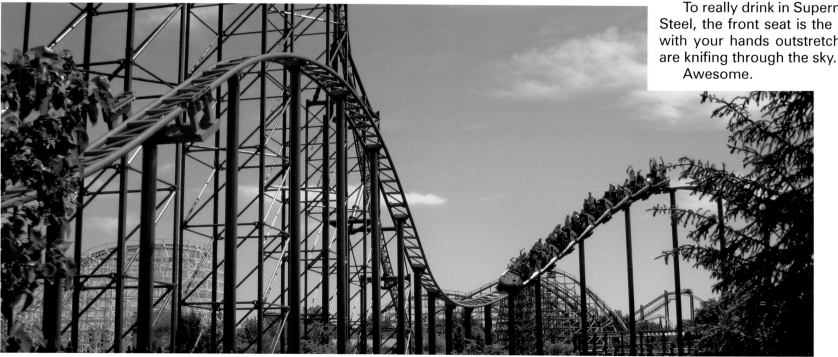

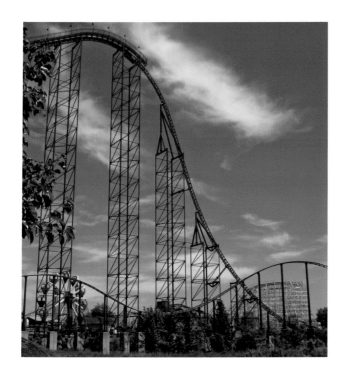

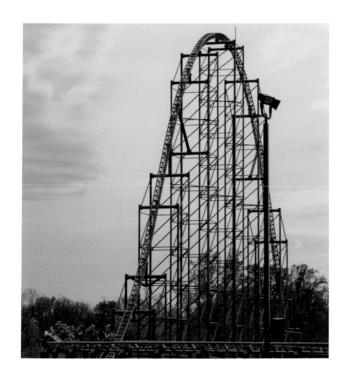

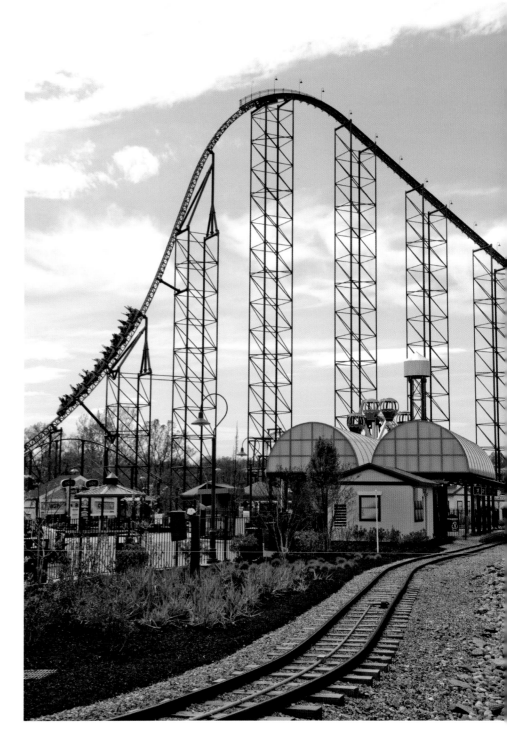

A carousel horse fountain located in front of the ticket offices.

Kennywood

West Mifflin, Pennsylvania

A family-owned park until recently, Kennywood maintains its down-home charm with its classic coasters, several of which date back to the 1920s. Situated in the middle of an industrial town, it has an underlying authentic grit that separates it from the polished veneer of the major corporate parks. It also has some of the best theme park food in the country.

The park features many well-landscaped areas perfect for taking a break throughout the day.

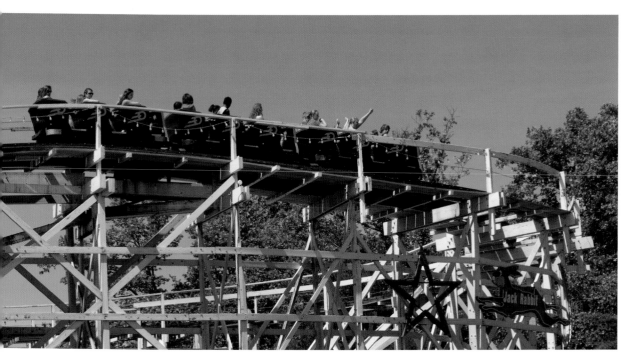

Operating since 1920, Jack Rabbit™ is the oldest roller coaster in the park.

Jack Rabbit utilizes undulating terrain to great effect.

Racer™

OPENING DATE: 1927
DESIGNER: John A. Miller
BUILDER: Charlie Mach
MAX HEIGHT: 76 feet (50-foot drop)
LENGTH: 2,250 feet
MAX SPEED: 40 mph
DURATION: 1:35
INVERSIONS: 0

It's a coaster and a mind game all in one. Two trains launch at once. Riders from the left side return on the right, but the trains never cross each other. How is this possible? The answer lays half way. It's a pleasing jaunt on a piece of roller coaster history.

FACING PAGE
LEFT: The trains run side by side for nearly all of the circuit.
RIGHT: Try and figure out how you leave one side and return on the other without the tracks crossing over.

Its rusty color gives it a distinctive appearance.

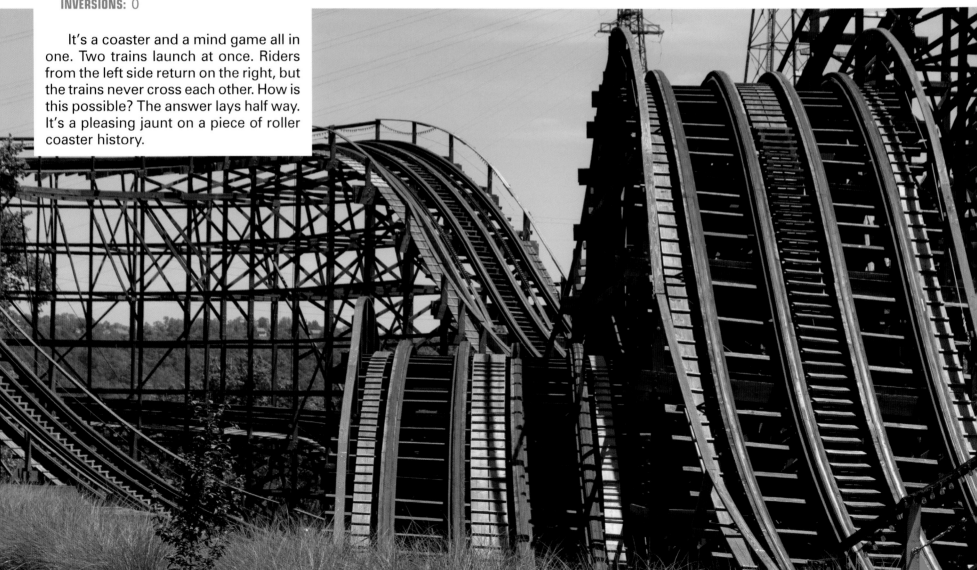

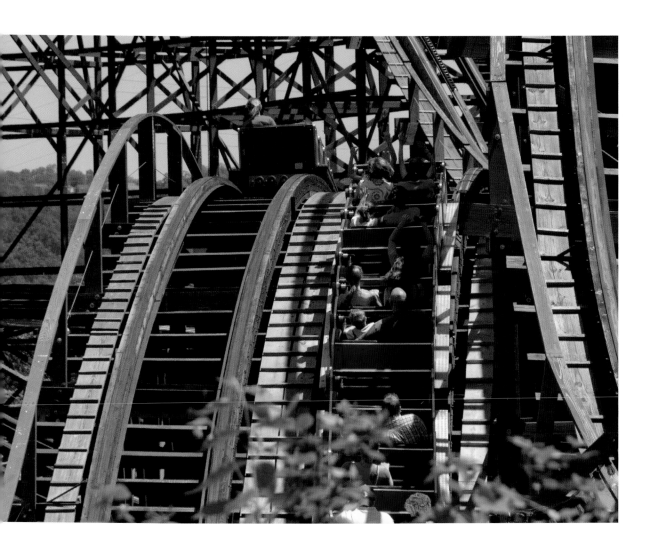

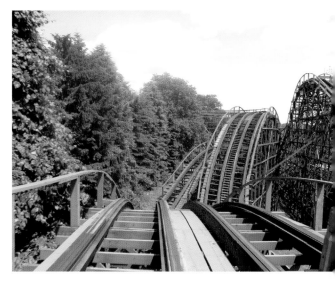

Phantom's Revenge™
(formerly Steel Phantom™)

OPENING DATE: May 19, 2001 (Original opening date: 1991)

MAKE: Arrow Dynamics (redesigned by Morgan)

MAX HEIGHT: 160 feet (228-foot drop, 225 feet before redesign)

LENGTH: 3,200 feet (3,000 feet before redesign)

MAX SPEED: 85 mph

DURATION: 1:57 (2:15 before redesign)

INVERSIONS: 0 (4 before redesign)

Phantom's Revenge looms large over the steel town. This popular coaster is intertwined with one of the park's older coasters and provides a picturesque view of the park and surrounding area. It's uncannily smooth for an older steel coaster, making for an enjoyable ride into and out of a ravine within the park. It originally had four inversions (a first for a coaster that tall) that were removed because they jostled the rider too much. Rough or not, I'm sad I never got a chance to experience them.

FACING PAGE

TOP LEFT: The train bounds down one of the many hills while prospective passengers wait their turn to ride.

TOP RIGHT: There's not a bad seat on the train. Even the middle provides a distinct and stellar experience.

BOTTOM LEFT: The sweeping first drop isn't something you come across every day; it exerts some interesting forces on the rider.

BOTTOM RIGHT: A looming presence, Phantom's Revenge dominates the park's topography.

Phantom's Revenge dominates the landscape of the park.

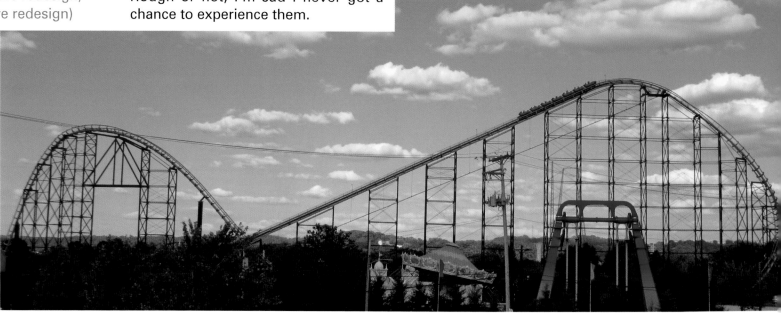

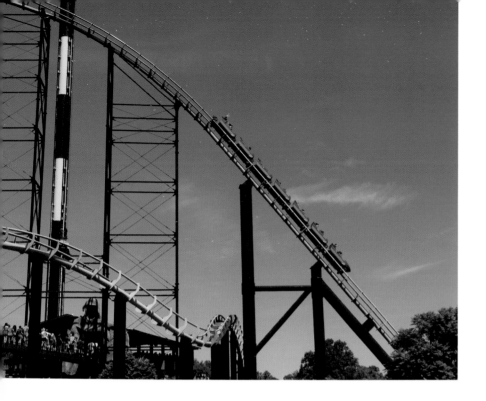

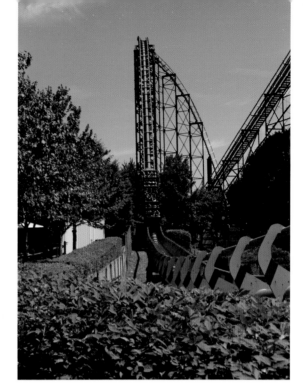

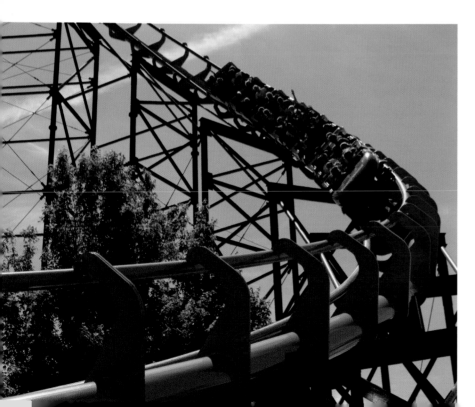

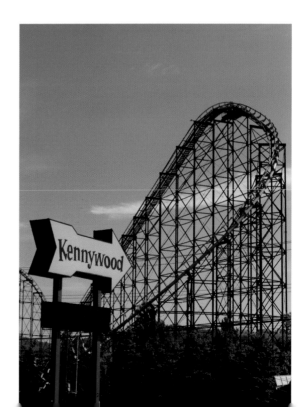

Sky Rocket™

OPENING DATE: June 29, 2010
MAKE: Premier Rides
MAX HEIGHT: 95 feet
LENGTH: 2,100 feet
MAX SPEED: 50 mph
DURATION: 1:00
INVERSIONS: 3

It's an interesting name for a roller coaster that is neither high nor fast, but I guess Ground Hog isn't a very sexy coaster name. Despite being vertically challenged and slower than traffic, it manages to deliver the fun. It has several acrobatic elements, but oddly enough, the one that intrigues the most is the "surf curve." You'll know it when you feel it.

They put a lot of track into a tight spot.

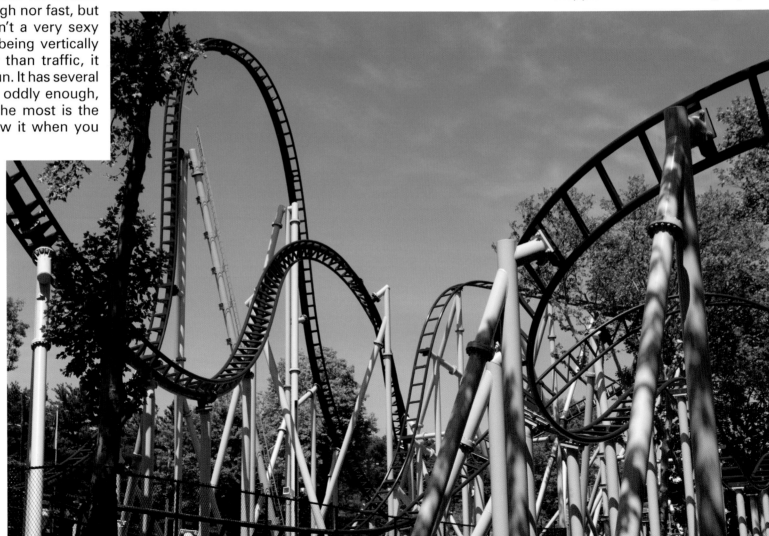

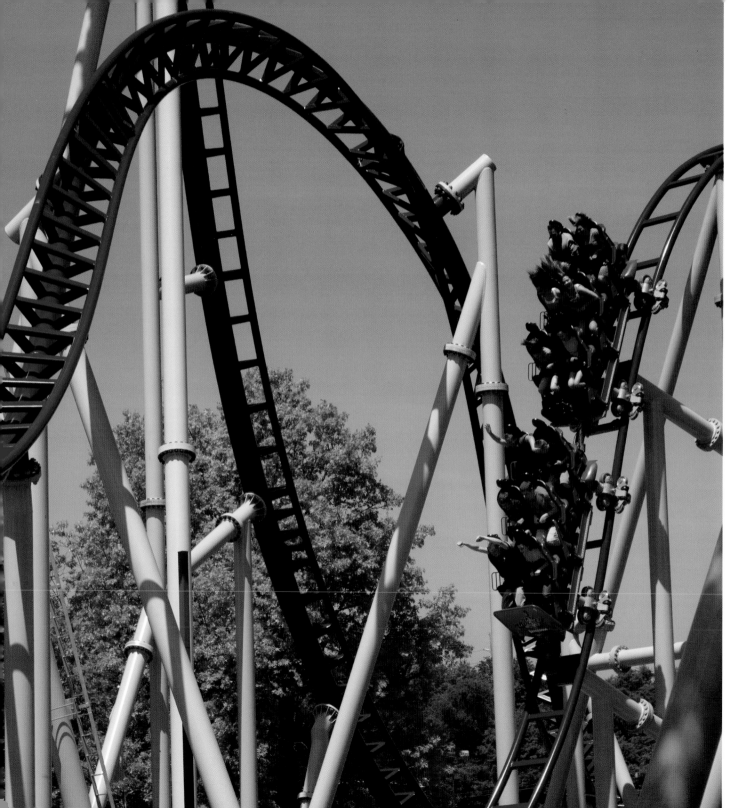

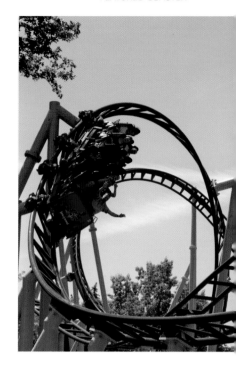

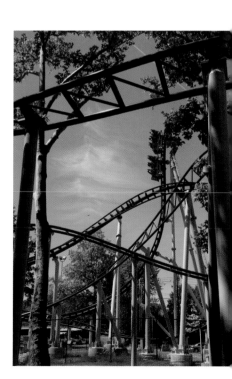

FACING PAGE

TOP LEFT: The structure was modified to accommodate Steel Phantom and again for Phantom's Revenge.

BOTTOM LEFT: While the meager first drop is nothing special, the ride makes up for it with great airtime elsewhere.

RIGHT: Thunderbolt has plenty of right turns so the heavier of the two riders is encouraged to sit on the left.

Thunderbolt™
(Pippin™ before redesign)

OPENING DATE: March 27, 1968 (original opening date: 1924)

BUILDER: Andy Vettel (John A. Miller before redesign)

MAX HEIGHT: 70 feet (95-foot drop)

LENGTH: 2,887 feet

MAX SPEED: 55 mph

DURATION: 1:41

INVERSIONS: 0

Thunderbolt is a wooden coaster that has scored high marks from riders for more than forty years. Part of its charm is its lack of a seat divider between riders. If you don't know your riding partner, you'll be real close afterward, so it's best to ride with someone in your own weight class to prevent being squashed. Loners need not apply. Single riders are not allowed on Thunderbolt, but they'll pair you up with someone.

Everything about Tunderbolt is a blast from the past.

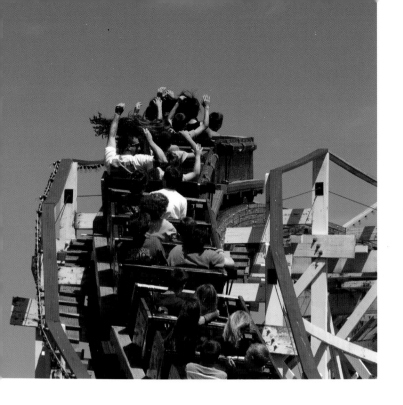

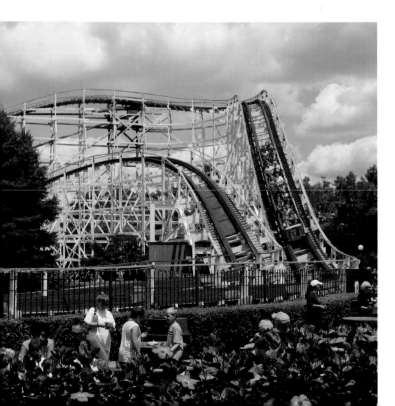

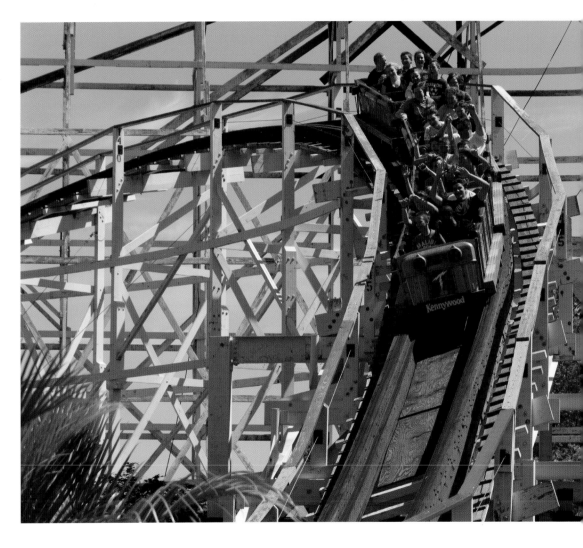

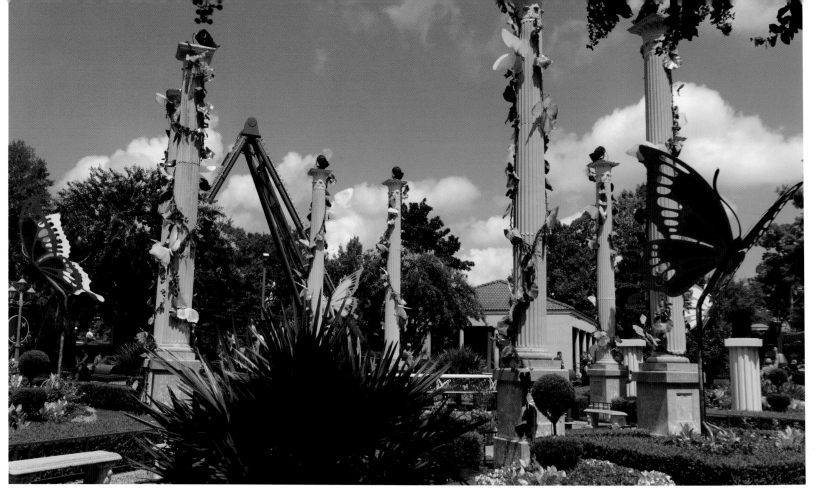

The Italy section of the park has beautiful columns and a fountain.

Busch Gardens Williamsburg

Williamsburg, Virginia

Routinely praised as one of the most well-maintained parks in the country, Busch Gardens Williamsburg is as beautiful as it is clean. Each section of the park painstakingly recreates a different European country. There is also a small animal habitat, including a bald eagle sanctuary. While the park isn't stuffed with roller coasters, the few it has offer a distinct and memorable experience.

River cruises and train rides offer a relaxing ride and beautiful scenery.

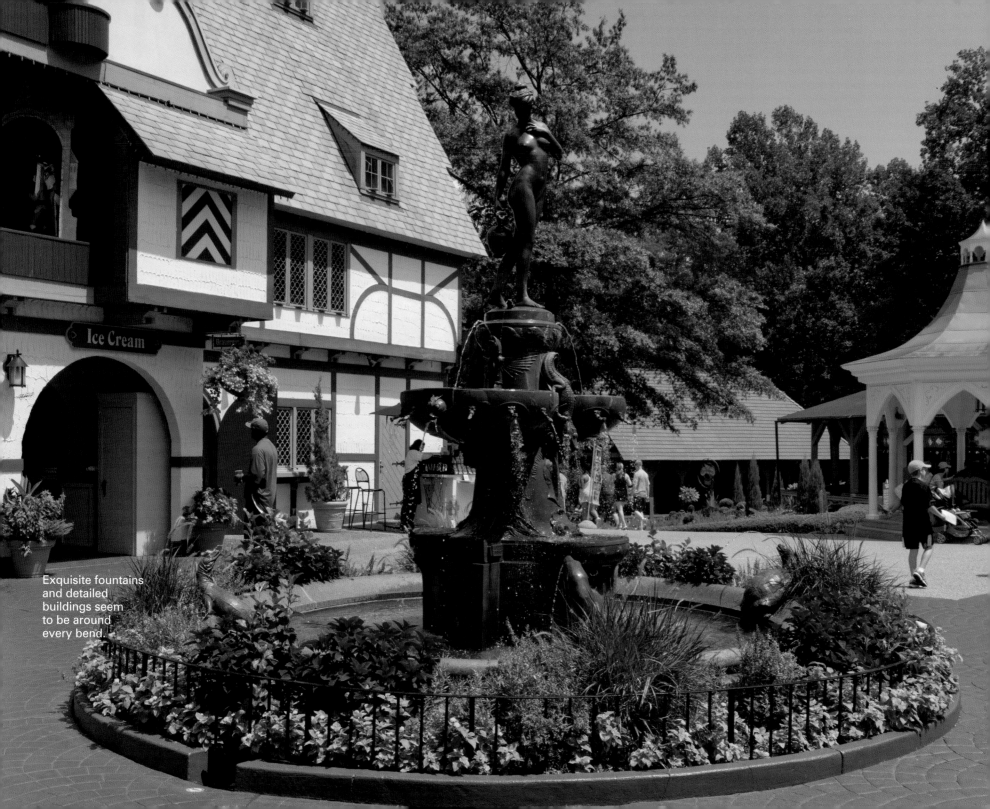

Exquisite fountains and detailed buildings seem to be around every bend.

The varied flora and fauna throughout the park create a relaxed atmosphere.

Children often climb in this whimsical tree in the Ireland section of the park.

Apollo's Chariot™, a B&M mega coaster, whips through the forest.

At 73 miles per hour there isn't a lot of time to admire the scenery.

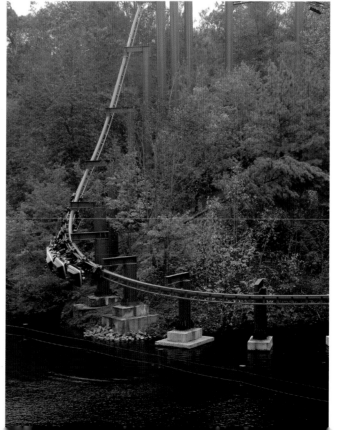

Once an icon of the park the Big Bad Wolf™ was removed from the park to make way for Verbolten™, a new roller coaster that opened in 2012.

Griffon™

OPENING DATE: May 18, 2007
MAKE: Bolliger & Mabillard
MAX HEIGHT: 205 feet
LENGTH: 3,108 feet
MAX SPEED: 71 mph
DURATION: 3:00
INVERSIONS: 2

At first glance, Griffon seems like a gimmick ride with its ten-across seating and its signature ninety-degree dives, but it takes just one ride to brush all preconceptions aside. More than just a few vertical plunges, it's a thrilling mixture of drops, hills, and sweeping turns. With no track below you, riding on or near the end of a row delivers feelings of being carried through the sky as if clutched in the talons of the mythical beast. With three rows, and ten riders per row, riding in the front is no longer reserved for those willing to wait a fortnight to ride.

FACING PAGE

TOP LEFT: The train swoops as if in flight on its way to another perilous dive.
TOP RIGHT: The Griffon's crest greets riders as they enter the station.
BOTTOM LEFT: Just before starting their descent, riders are held for a moment, dangling above the drop looking down.
BOTTOM MIDDLE: The two seats at the ends of each row get an experience unlike just about everything else in the coaster world.
BOTTOM RIGHT: There are two, ninety-degree drops during the course of the ride.

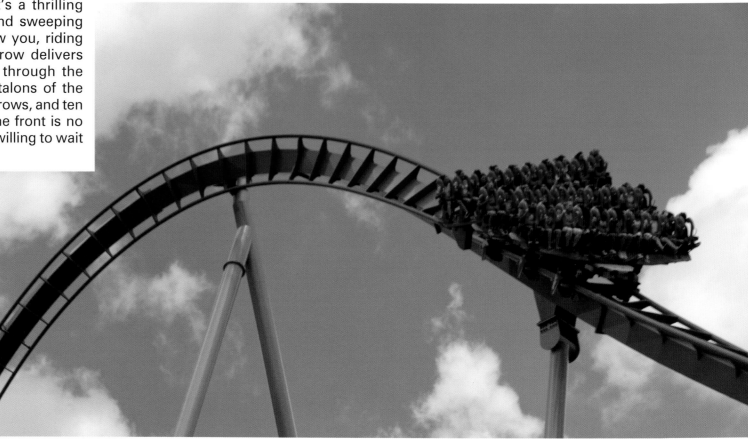

Thirty riders are crammed into three rows; it makes for an odd sight while the train soars through the air.

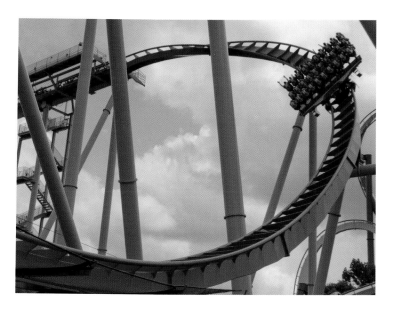
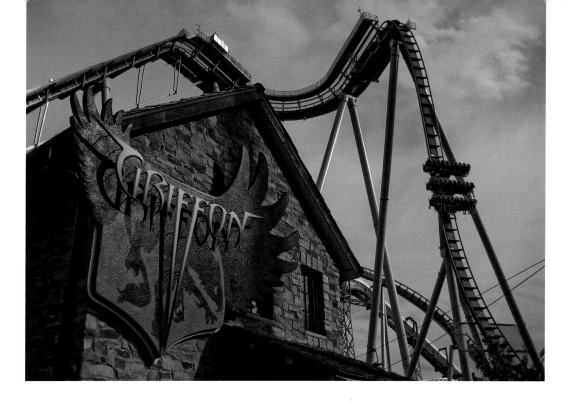
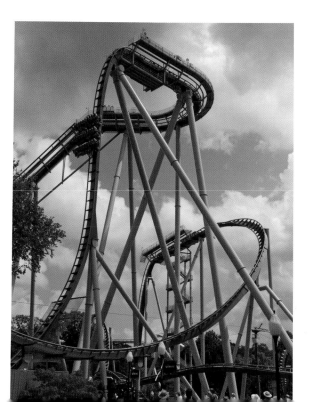
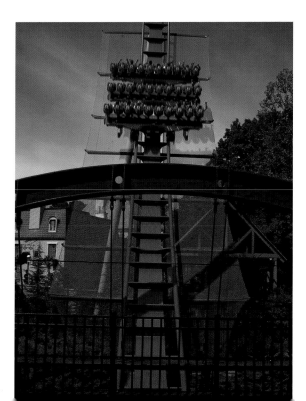
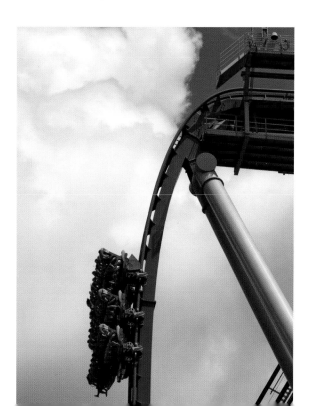

One of several roll elements throughout the ride.

Alpengeist means "ghost of the Alps" in German, a fitting name for a ride themed on a runaway ski lift.

Alpengheist™

OPENING DATE: March 22, 1997
MAKE: Bolliger & Mabillard
MAX HEIGHT: 195 feet (170-foot drop)
LENGTH: 3,828 feet
MAX SPEED: 67 mph
DURATION: 3:10
INVERSIONS: 6

A brilliant combination of speed and acrobatics make this one of the top inverted coasters. Themed on a fast and furious skiing run down a treacherous mountain slope, the spot-on Busch Garden's theming elevates this ride to another level.

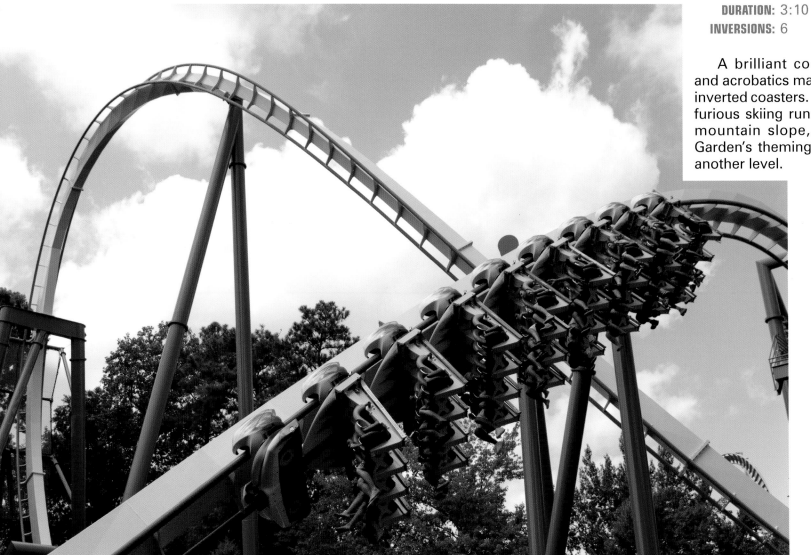

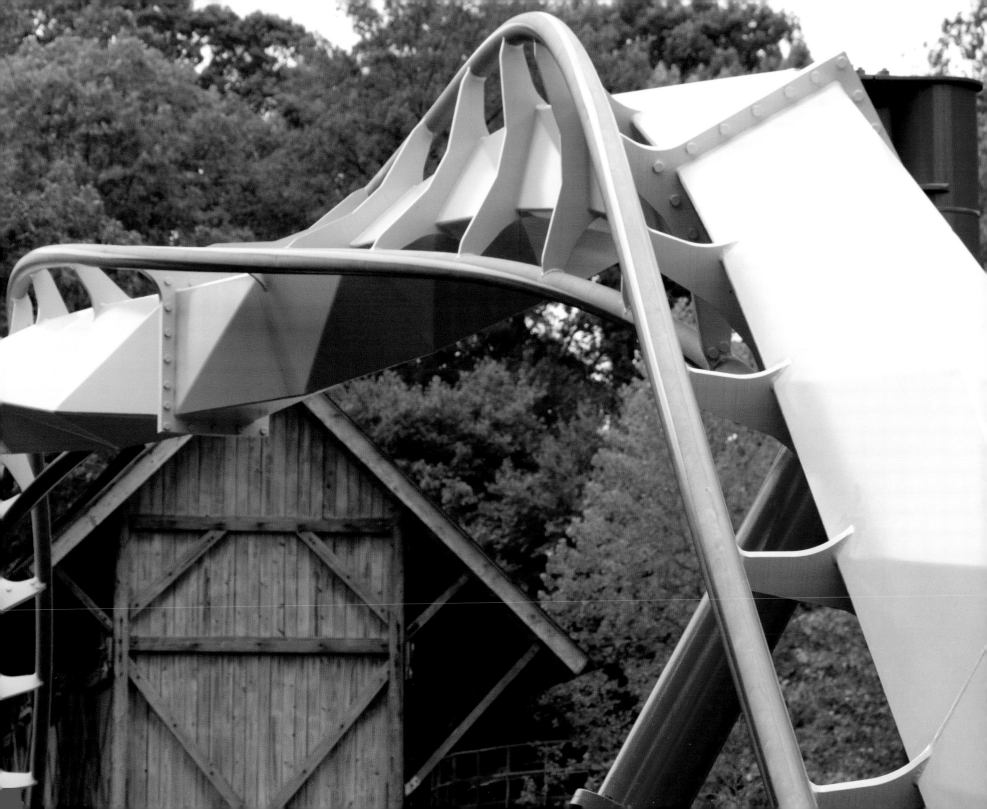

The train screams through a chalet.

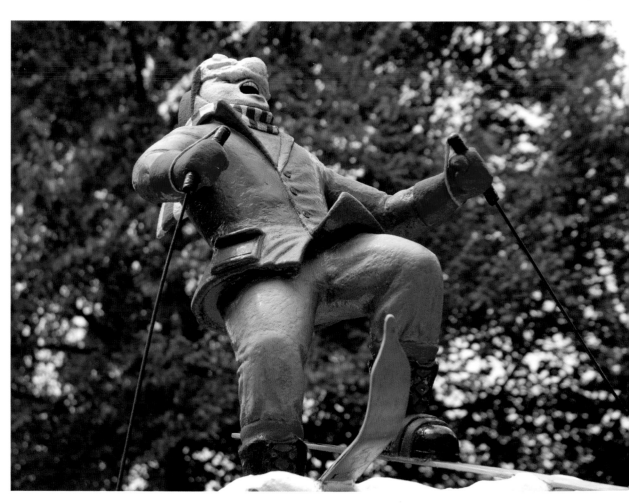

This whimsical statue greets riders as they enter the line.

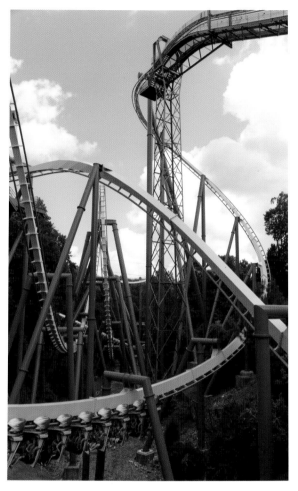

The first drop is an S-curve that mimics a skier carving down the side of a hill.

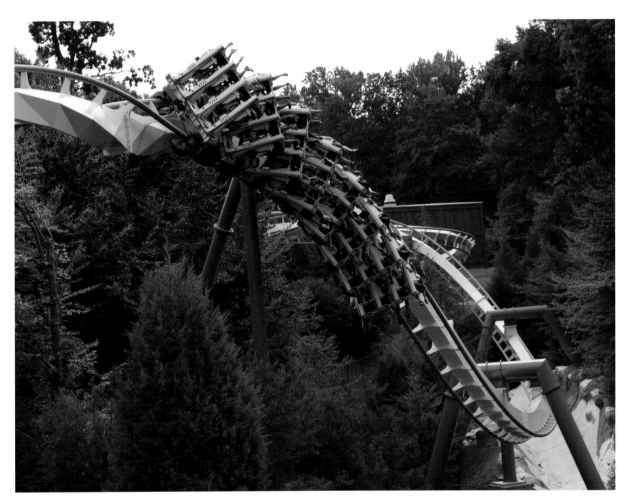

The train passes over simulated snow-covered rocks creating an immersive experience.

Loch Ness Monster™

OPENING DATE: 1978

MAKE: Arrow Dynamics

MAX HEIGHT: 130 feet (114-foot drop)

LENGTH: 3,240 feet

MAX SPEED: 60 mph

DURATION: 2:10

INVERSIONS: 2

It was the tallest roller coaster in the world when it opened and the first to have interlocking loops. Today it's the last operating coaster with interlocking loops, making it one of a kind. Loch Ness Monster is a classic. It may no longer be the most comfortable ride in the world, but what it lacks in innovative thrills it makes up for in uniqueness and historical value.

FACING PAGE

TOP LEFT: The serpentine track layout features slithering hills and a spiraling tunnel.

BOTTOM LEFT: Many roller coasters at Busch Gardens utilize the landscape, and Loch Ness Monster is no different.

RIGHT: Tight, interlocking loops provide awe-inspiring visuals. If the timing is just right, you'll see trains looping around each other.

Grimm's Landung features a wooden walkway that gives visitors a great view of Loch Ness Monster's interlocking loops.

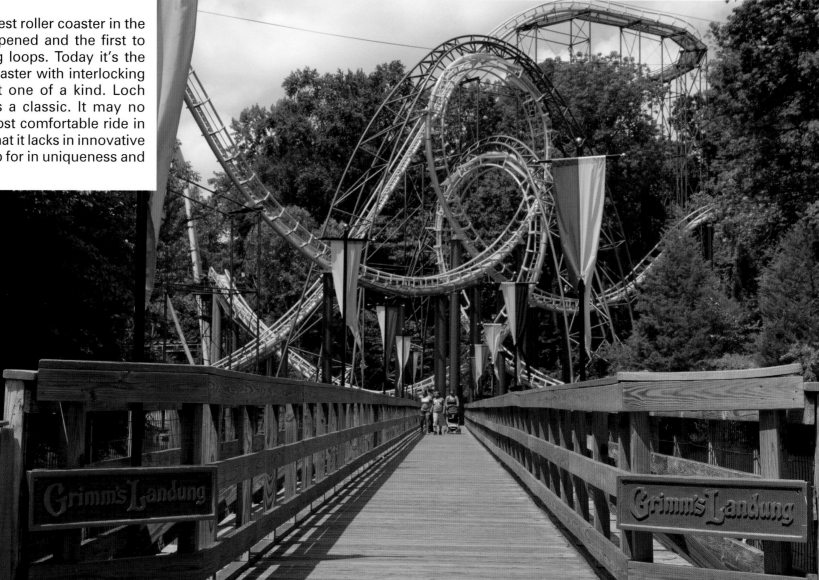

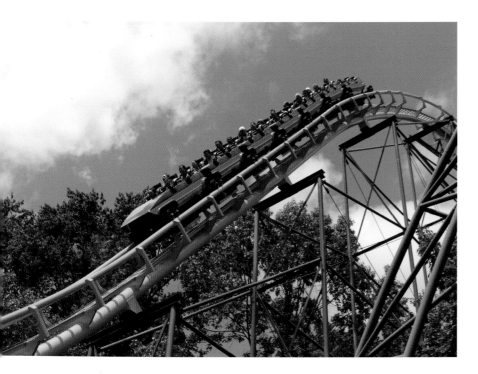

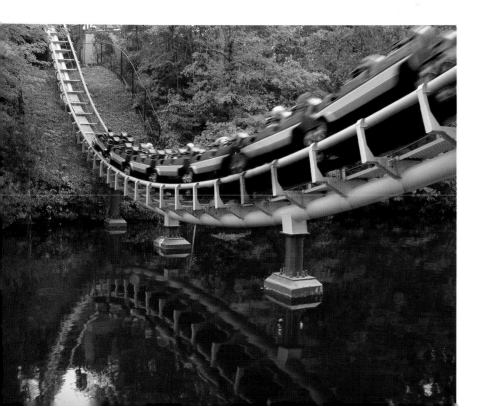

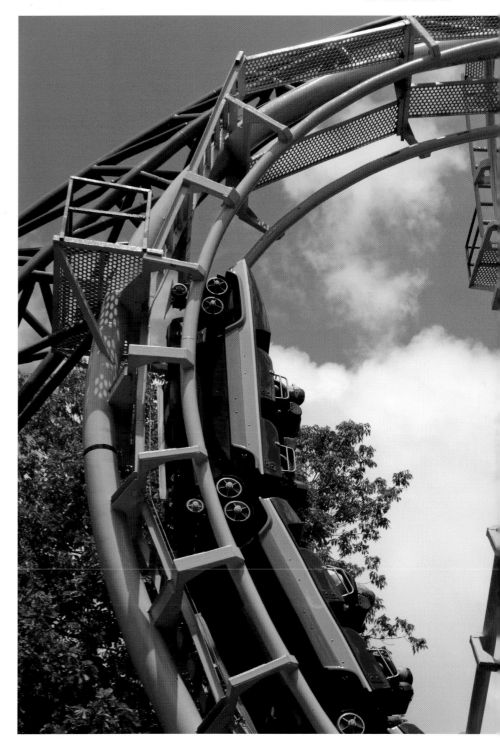

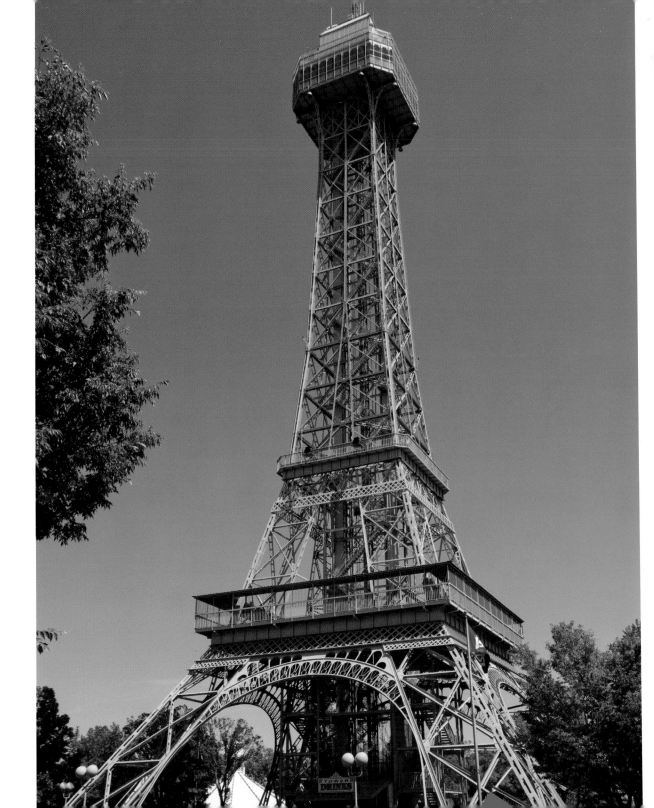

This one-third scale replica of the Eiffel Tower gives guests a great vantage point to see the entire park from above.

Kings Island

Kings Mills, Ohio

This 364-acre powerhouse of the Midwest had the biggest attendance (~3.1 million) of any seasonal park in the United States in 2010. At its heart is a one-third scale replica of the Eiffel Tower. Formerly owned by Paramount Studios, many areas have been re-themed and rides renamed in an effort to cleanse the park of the movie studio's presence. What remains is a park that is struggling to find an identity. Fortunately, this park is home to a plethora of roller coasters to thrill and delight, one of which is among the best in the world.

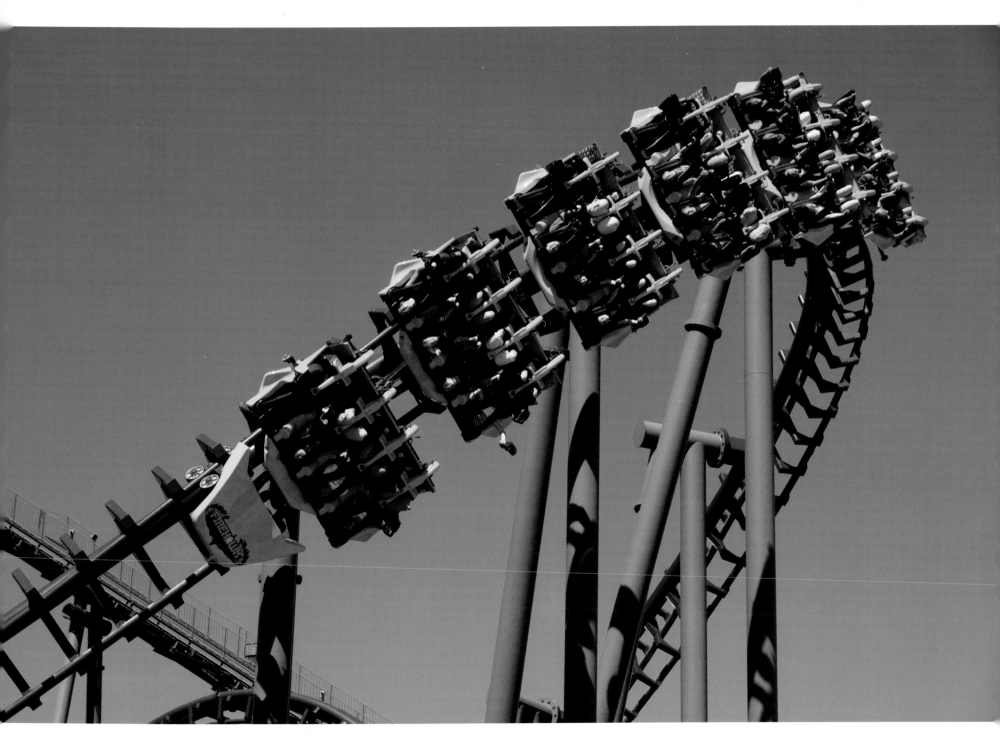

Firehawk™ is a Vekoma flying coaster that was relocated from Geauga Lake near Cleveland, Ohio.

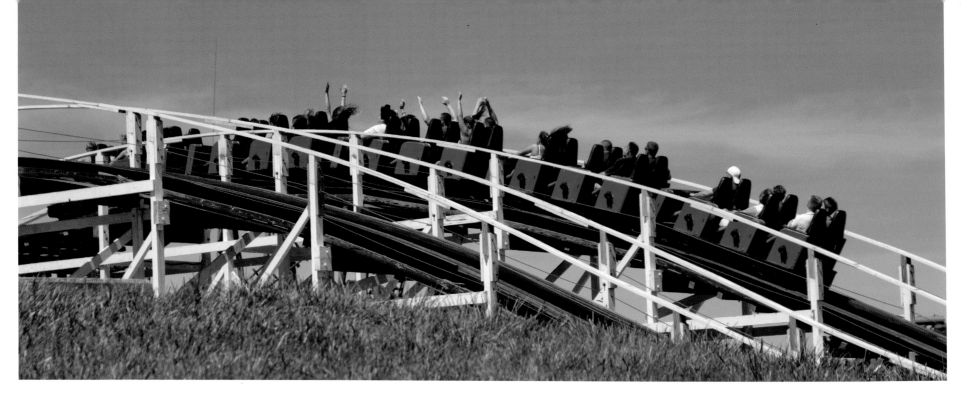

Racer™ is a classic out and back woodie.

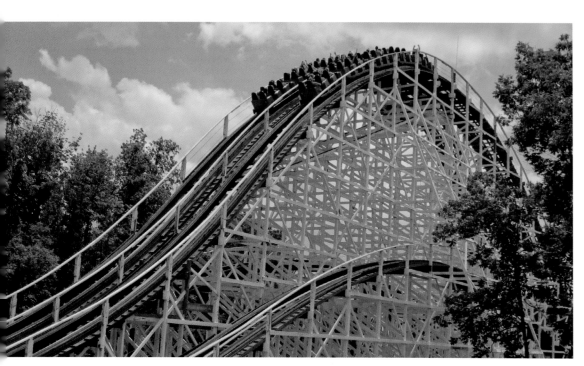

Trains used to regularly race side by side, but nowadays they rarely sync up.

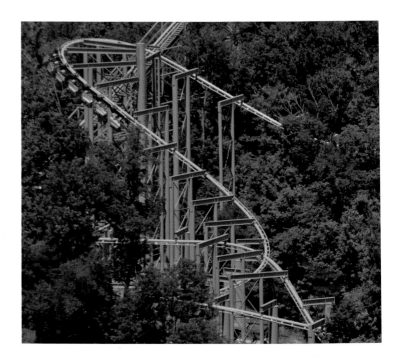

It's a long walk to the station, but Flight Deck™ is special in that it is one of the few remaining suspended roller coasters.

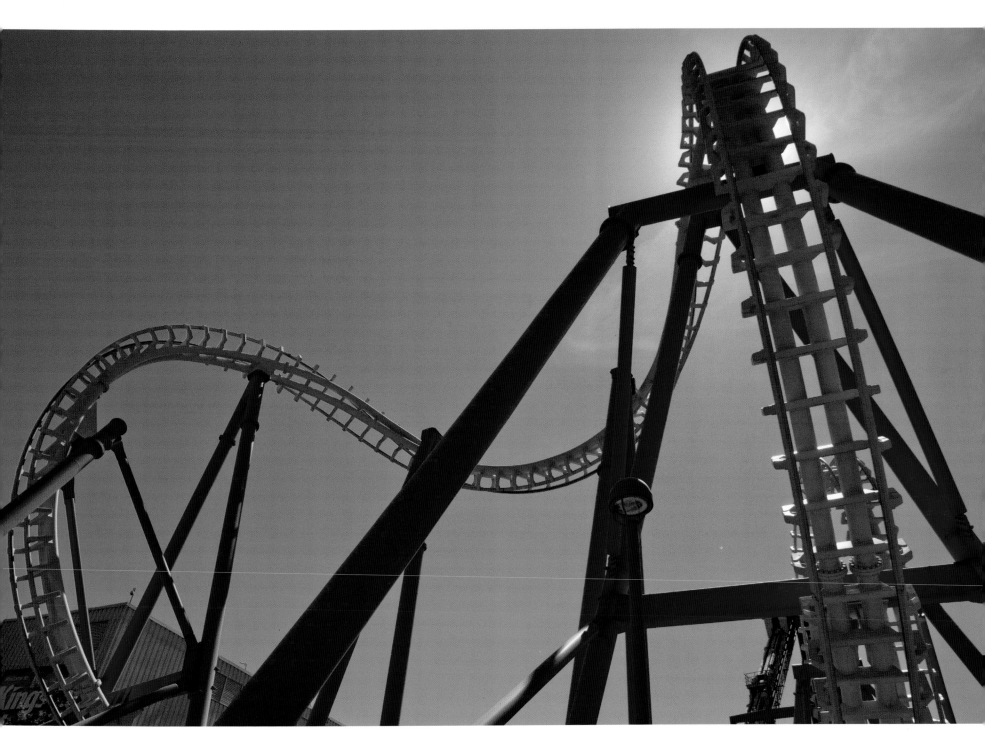

Invertigo™ is a boomerang-style roller coaster with a twist—riders hang below the track.

The Beast™

OPENING DATE: April 14, 1979
DESIGNER: Al Collins, Jeff Gramke
BUILDER: Charlie Dinn
MAX HEIGHT: 110 feet (141-foot drop)
LENGTH: 7,359 feet
MAX SPEED: 65 mph
DURATION: 4:10
INVERSIONS: 0

The length, 7,359 feet, is not a typo. The Beast is the longest wood roller coaster in the world. But this ride is much more than a number. Using the terrain to its advantage, this ride rips through the woods, providing the most visceral coaster experience anywhere. The unrelenting fury of this ride is capped by the best ending of any coaster in the world: a trip through the double helix. Riders are thrust into what appears to be a rickety wooden tunnel, rumbling around the helixes in ecstatic turbulence. Park yourself in the front seat for the best ride and hope the trim brakes don't sap too much of the speed. Rides just don't get much better than this.

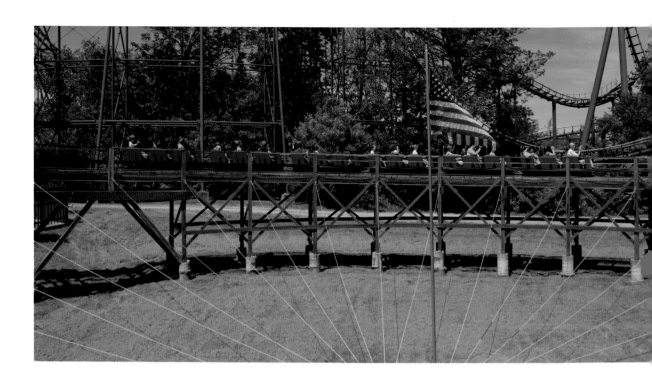

TOP: Rounding the turn to the lift hill, these riders are in for a treat.
BOTTOM LEFT: With no real sense as to the layout of this beast, you feel like you are being whisked to some remote location.
BOTTOM RIGHT: The train heads toward one of the three underground tunnels.

FACING PAGE

This jittery photo expresses how frenetic this ride can be.

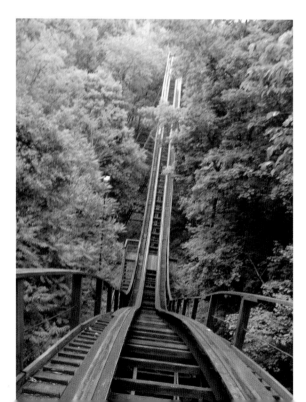

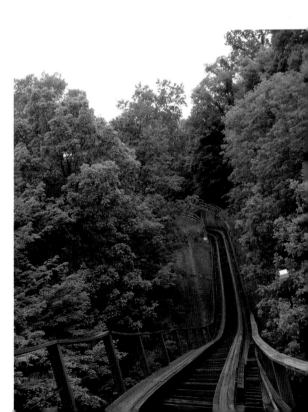

Vortex™

OPENING DATE: April 11, 1987
MAKE: Arrow Dynamics
MAX HEIGHT: 148 feet (138-foot drop)
LENGTH: 3,800 feet
MAX SPEED: 55 mph
DURATION: 2:30
INVERSIONS: 6

If any of the Arrow-made coasters can be considered art, it's this one. There are even places along the path beside the coaster that are designated for scenic picture taking. It's that pretty. And like nearly all Arrow coasters, the aging process hasn't been kind. If you enjoy inversions and don't mind being jostled, these coasters still deliver the goods.

FACING PAGE

TOP LEFT: The year it opened, it claimed a record for most inversions (6).
TOP RIGHT: This batwing element is the final inversion before heading back to the station.
BOTTOM RIGHT: The trains have that distinctive Arrow styling to them.

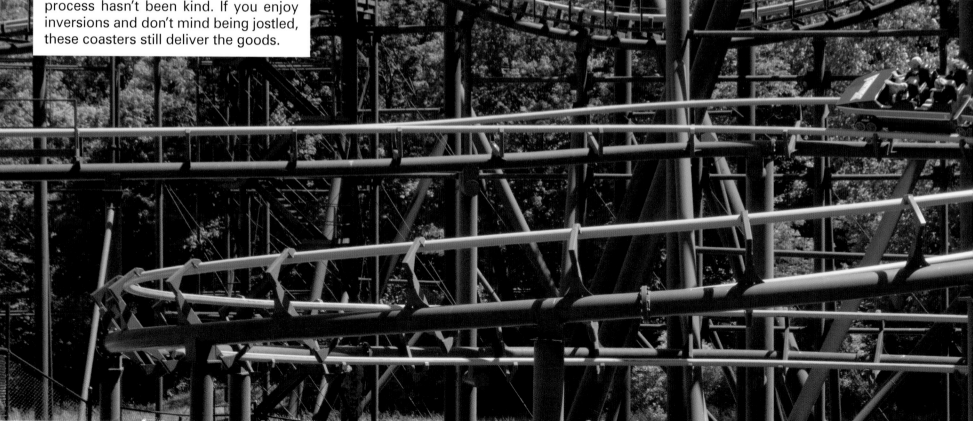

This upward helix is used to bleed off energy from the train before it arrives back at the station.

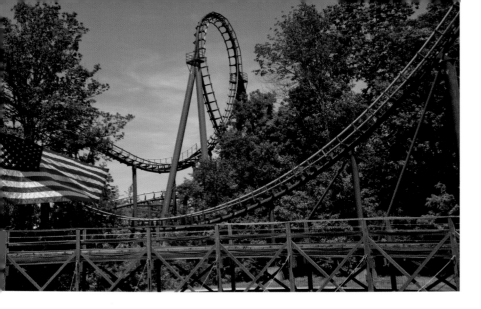

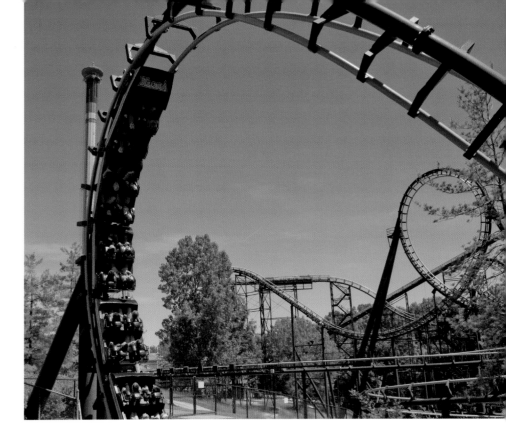

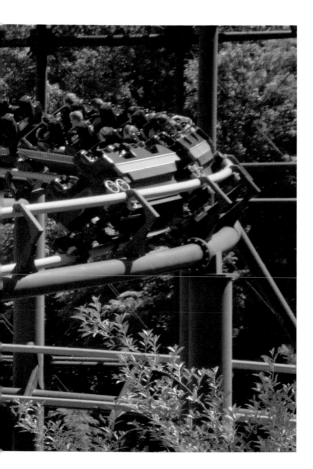

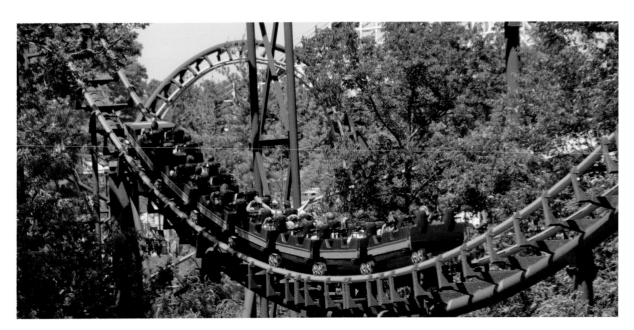

Diamondback™

OPENING DATE: April 18, 2009
MAKE: Bolliger & Mabillard
MAX HEIGHT: 230 feet (215-foot drop)
LENGTH: 5,282 feet
MAX SPEED: 80 mph
DURATION: 3:00
INVERSIONS: 0

Snaking through the interior of the park with its unique V-shaped seat configuration (which resembles a snake scale pattern), this relative of Six Flag's Nitro™ and Busch Garden's Apollo's Chariot™ exhibits all the grace and fluidity that one would expect from a B&M (Bolliger & Mabillard) mega coaster. It's a gentle giant that is tall and long featuring sublime airtime. For the best riding experience, ride near the front.

FACING PAGE

TOP LEFT: The unique V-formation seating provides ample room for every rider.
BOTTOM LEFT: Its beauty is particularly evident at dusk.
TOP RIGHT: Hooks on the back of the last car dig into the pond, creating a spectacular rooster-tail wake.
BOTTOM RIGHT: Diamondback snakes through the interior of the park, flying over walkways.

A train rushes through the hammerhead turn.

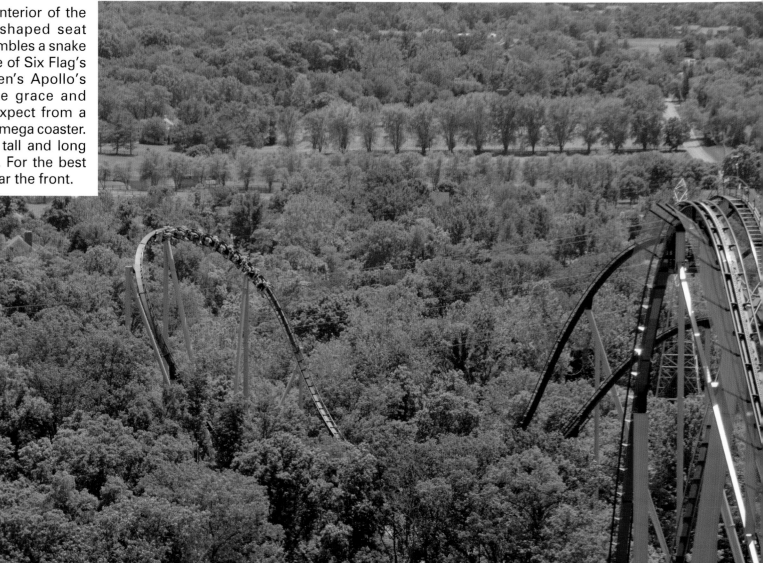

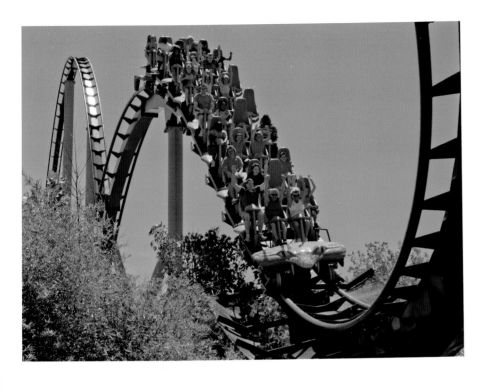
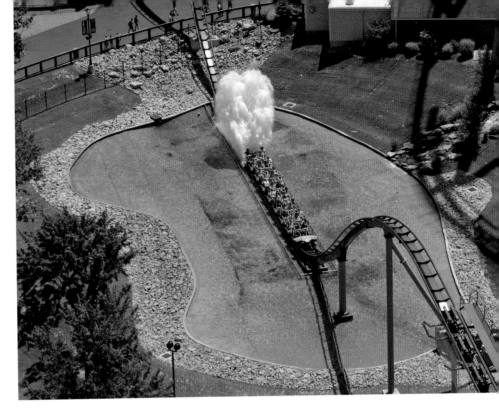
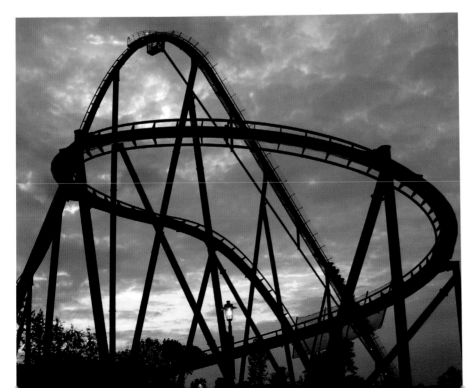
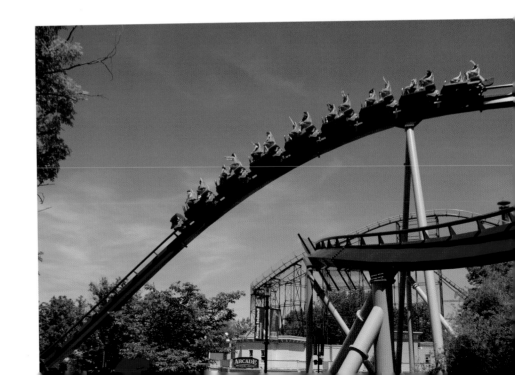

Son of Beast™

OPENING DATE: May 26, 2000

CLOSING DATE: June 16, 2009

DESIGNER: Ing.-Büro Stengel GmbH, Roller Coaster Corporation of America

MAX HEIGHT: 218 feet (214-foot drop)

LENGTH: 7,032 feet

MAX SPEED: 78 mph

DURATION: 2:20

INVERSIONS: 0 (previously 1)

Unlike its father, Son of Beast's fury was uncontrollable and it had to be put down. It was the tallest, fastest wooden coaster on the planet. It was the longest coaster with a loop and the only wooden coaster with a loop, which was made of steel (they weren't *that* crazy). It was a hide-the-women-and-children kind of ride. It is arguably the most beautiful coaster structure ever conceived. But they forgot one thing: People had to ride it. At first it was tolerable, but then something happened and the son lashed out. Maybe it was jealous of its father stealing the limelight. No one knows. They tried to placate it by removing the menacing loop and shortening the trains, but it would have none of it. They even replaced the trains with lighter ones. Still it bucked and gnashed its teeth. Today it remains chained and caged. Will it ever be tamed?

FACING PAGE

LEFT: They took The Beast's helix and made it bigger and badder.

RIGHT: Then they mocked the Gods by putting a loop in it.

Almost the entire ride is viewable from the Eiffel Tower replica.

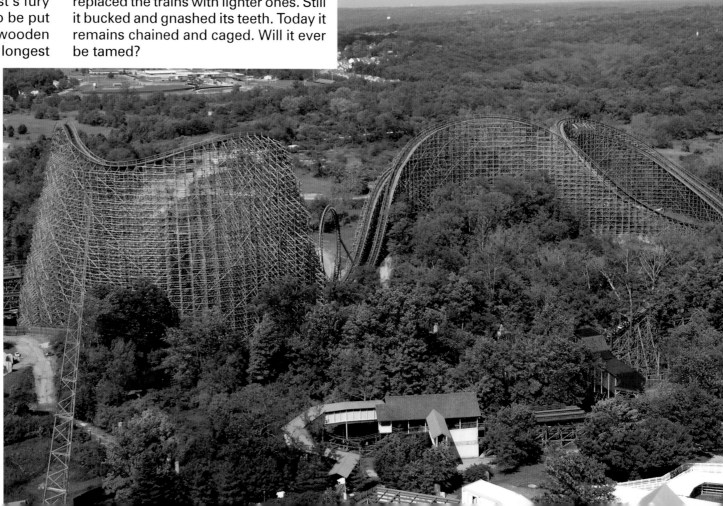

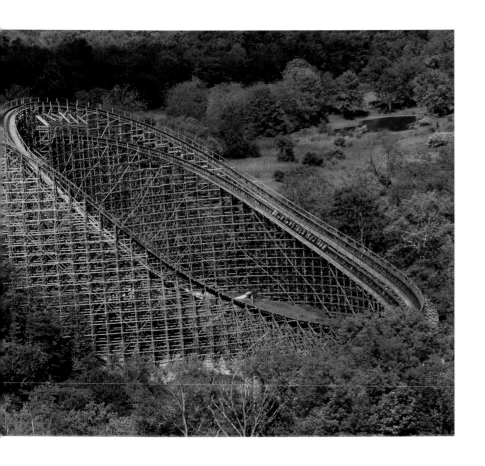

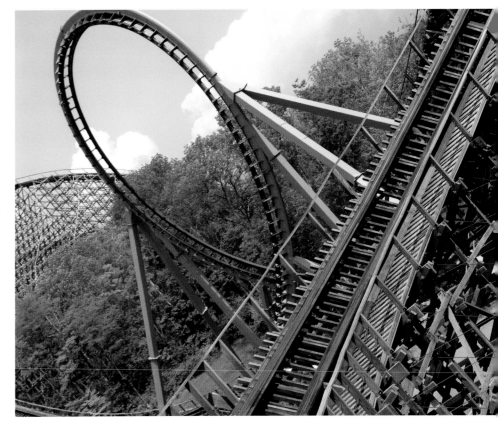

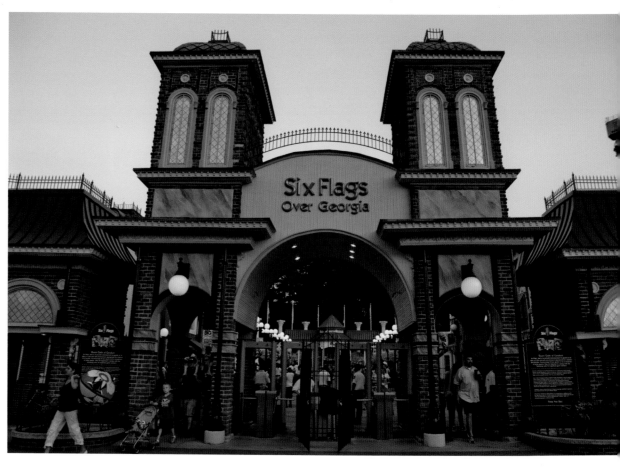

The main entrance to the park.

Six Flags Over Georgia

Austell, Georgia

Six Flags Over Georgia is the second Six Flags park and one of three Six Flags parks founded by Angus G. Wynn, the original developer behind the Six Flags parks. Unlike many other Six Flags properties, this one seems to have distinctive character. Interesting visual pieces seem to spring up behind every corner. Besides being well groomed, the park is home to several roller coasters that any park would be glad to have. Dahlonega Mine Train™ might be the best mine ride in the country. Unfortunately, the park doesn't have many high-capacity rides, so be sure to visit outside of the peak times of the year if you want to maximize ride time and enjoyment.

Built into a hillside, the many trees provide at least
some protection from the scorching Georgia sun.

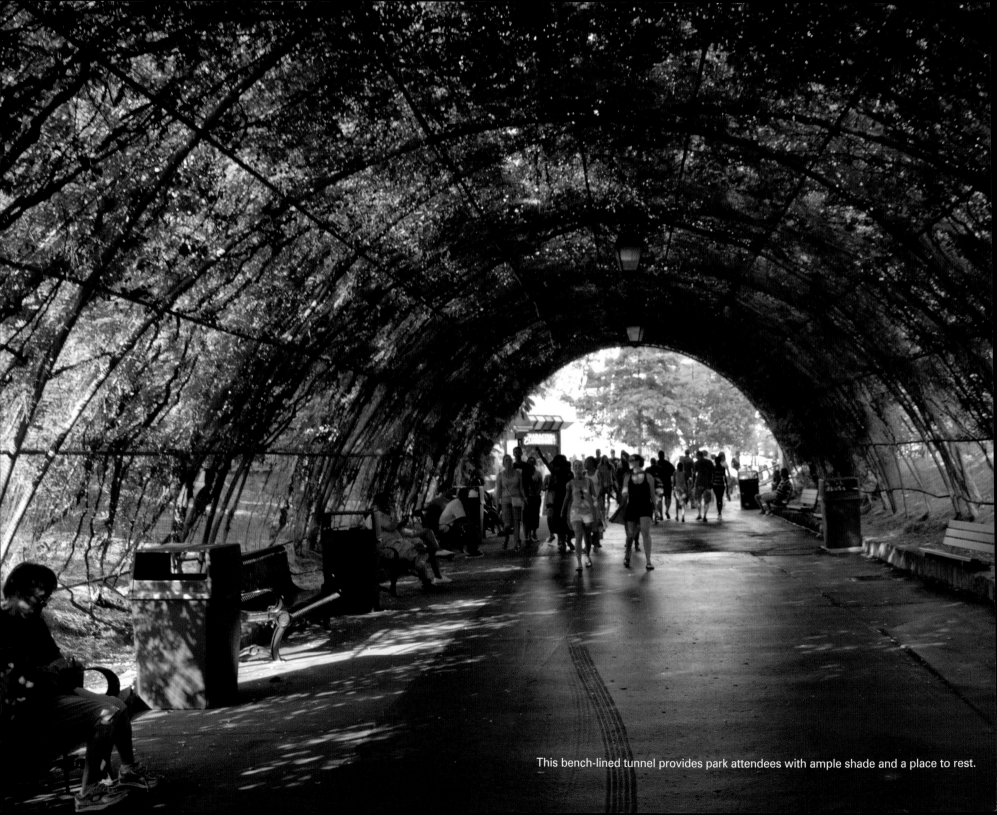
This bench-lined tunnel provides park attendees with ample shade and a place to rest.

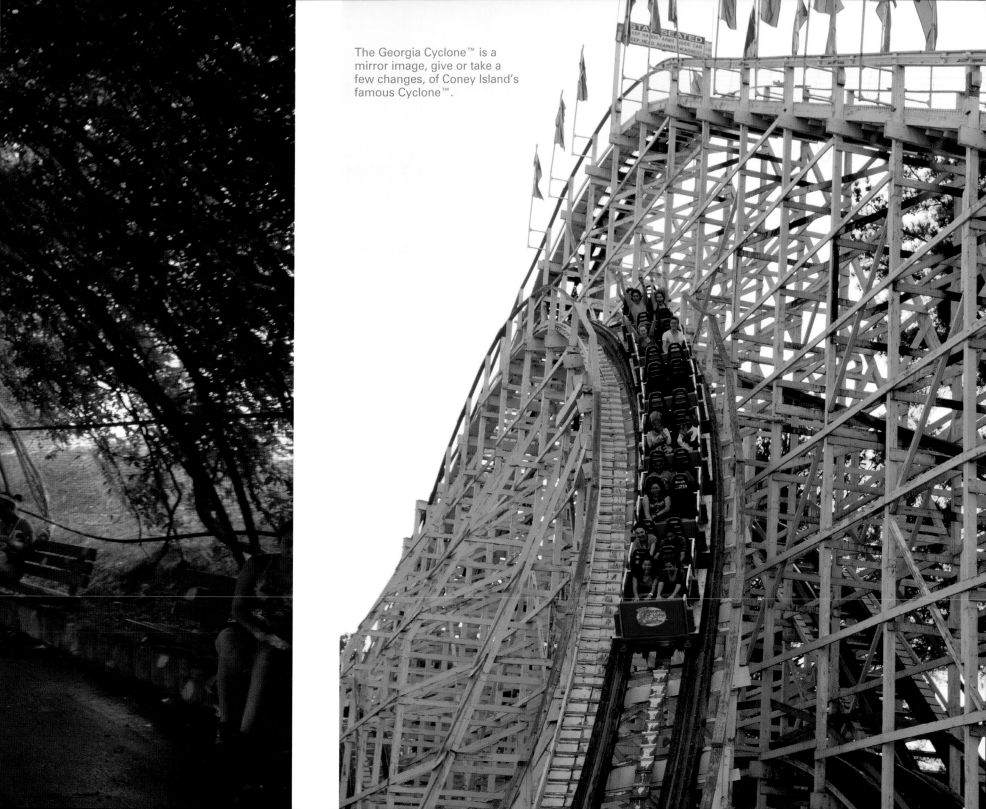

The Georgia Cyclone™ is a mirror image, give or take a few changes, of Coney Island's famous Cyclone™.

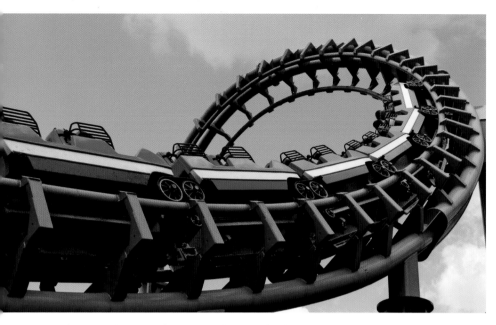

Arrow trains traveling on a Vekoma track is an unholy union of pain and misery. Fortunately, recent improvements have elevated Ninja™ from a bruise machine to a multi-looper that will merely knock you around a little.

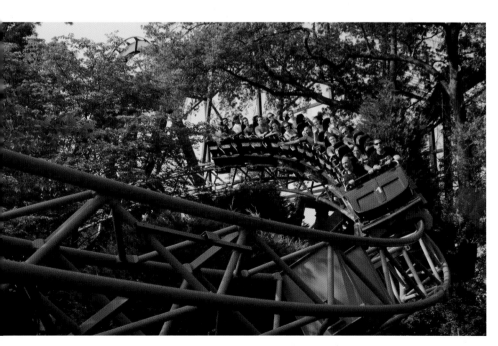

Opened in 1978, Mindbender might be the best old steel coaster anywhere; it routinely cracks top-20 lists to this day.

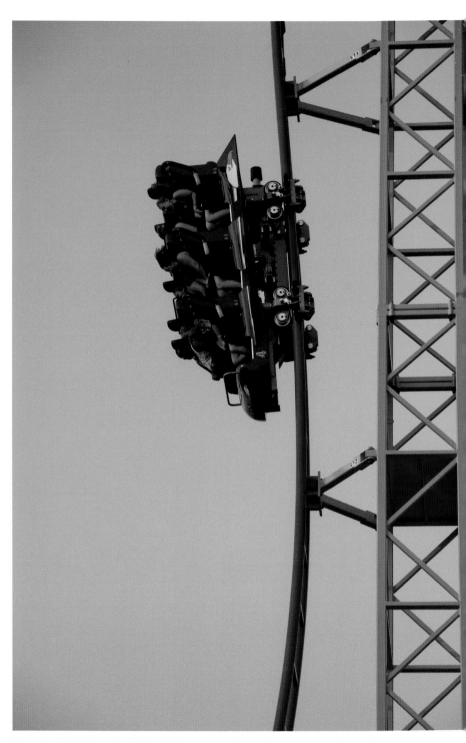

New in 2011, Daredevil Dive™ features a drop of more than ninety degrees.

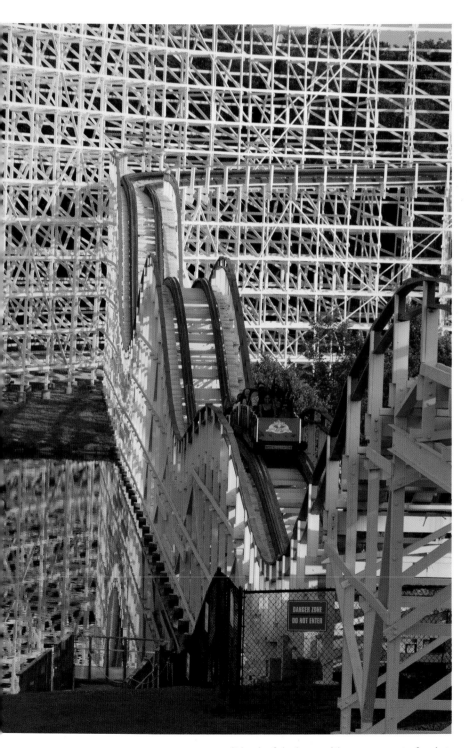

It looks fabulous with a new coat of paint.

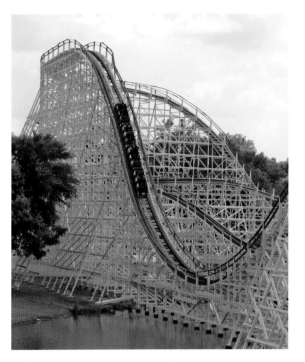

Great American Scream Machine™ opened as the tallest, fastest roller coaster in the world in 1973.

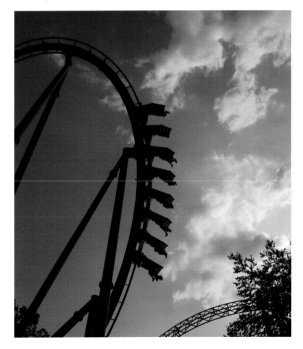

This is the sixth of the nine Batman: The Ride™ coasters sprinkled throughout the Six Flags parks.

Superman: Ultimate Flight™

OPENING DATE: April 6, 2002
MAKE: Bolliger & Mabillard
MAX HEIGHT: 106 feet (100-foot drop)
LENGTH: 2,759 feet
MAX SPEED: 51 mph
DURATION: 2:00
INVERSIONS: 2

This was the first B&M flying coaster in the United States. It differed from previous flying coasters in that it raised riders into flying position instead of laying them on their backs, like the Vekoma models. This sped up the loading process, but not by much. Instead of taking a full week to progress through the line, now it only takes two days, three tops. Ride this one right after the park opens unless you enjoy wilting in the Georgia sun.

The entrance is well themed and provides a great view of the coaster in action.

FACING PAGE

LEFT: The pretzel loop was introduced with this coaster and it is the star of the ride.

RIGHT: Empty seats aren't a welcome sight when you've already waited a lifetime in line.

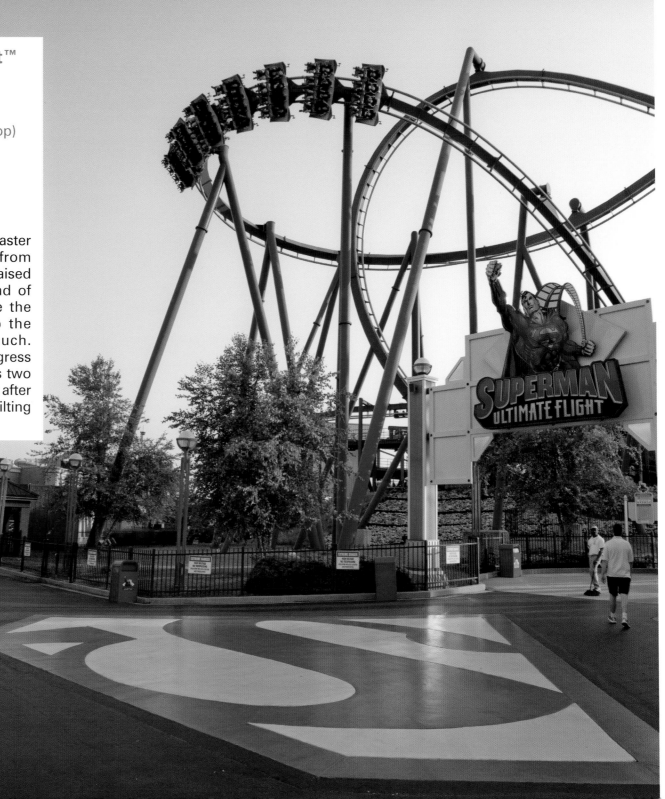

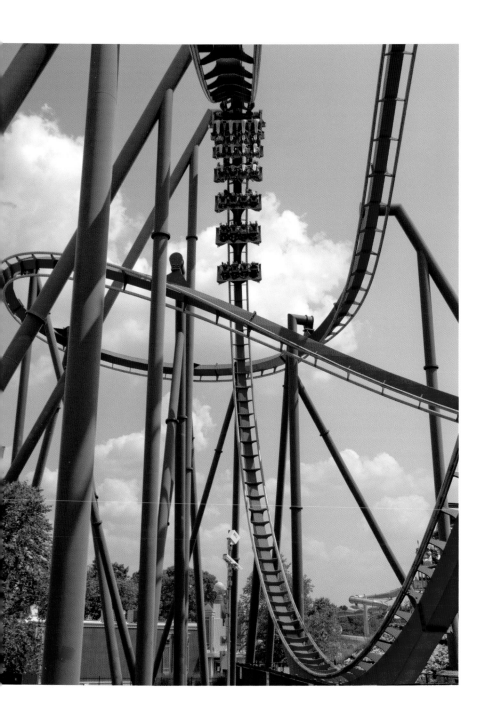

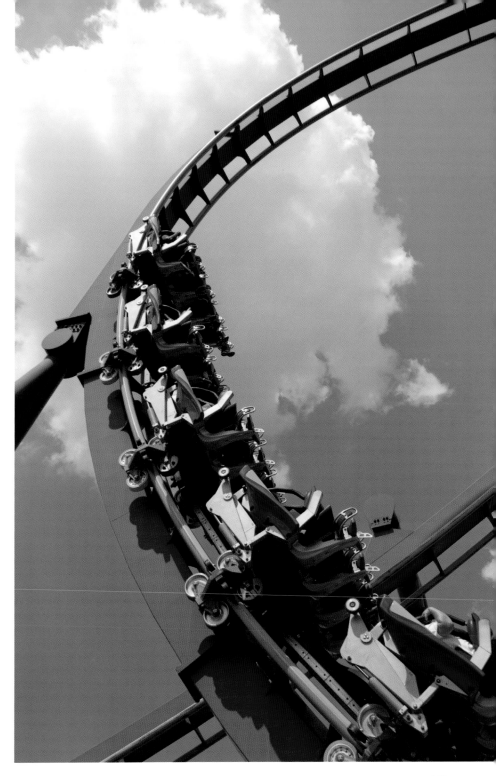

Georgia Scorcher™

OPENING DATE: May 1999
MAKE: Bolliger & Mabillard
MAX HEIGHT: 107 feet (101-foot drop)
LENGTH: 3,000 feet
MAX SPEED: 54 mph
DURATION: 1:24
INVERSIONS: 2

FACING PAGE

LEFT: Riding a loop while standing is one of the better coaster sensations.
RIGHT: It's not the tallest or the fastest, but tell that to these lucky riders.

The train turns around before tackling the second half of the track.

Georgia Scorcher is Six Flags Over Georgia's stand-up coaster and is the last newly constructed stand-up roller coaster anywhere (Green Lantern™ at Six Flags Great Adventure was a relocation from another park). The ride is featured prominently as you make your way into the park, and as stand-ups go, it's pretty good. For some reason, however, the idea of a stand-up roller coaster is markedly better than its execution. Maybe that's why no one has commissioned a new one since 1999.

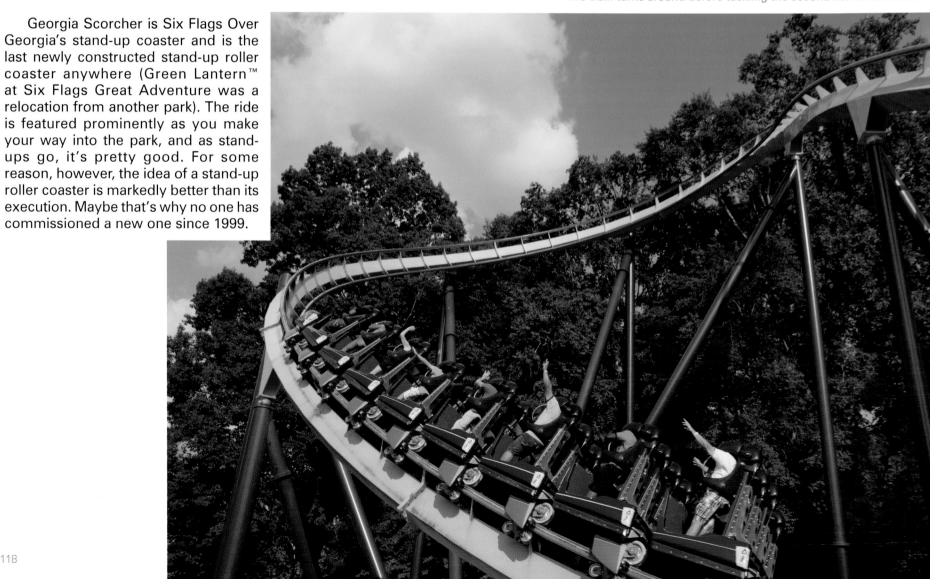

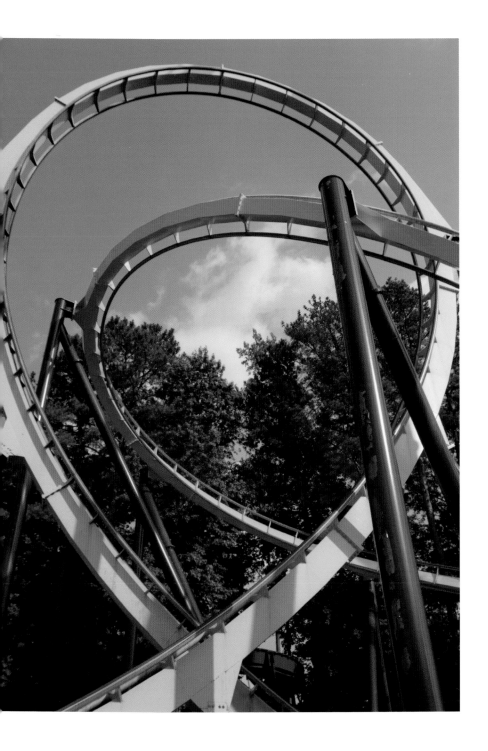
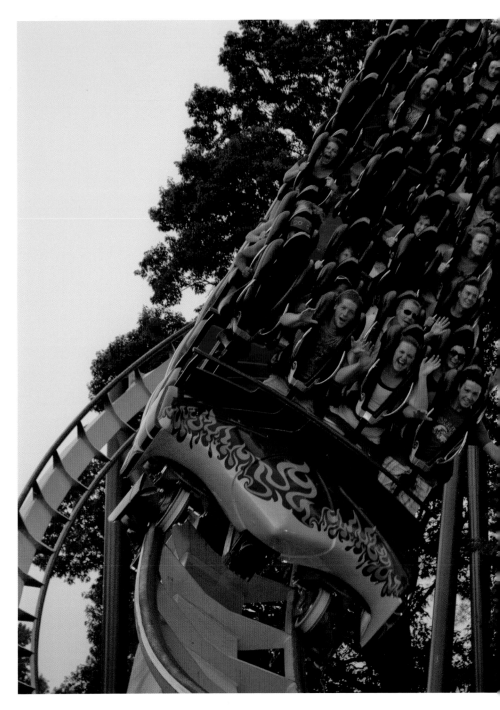

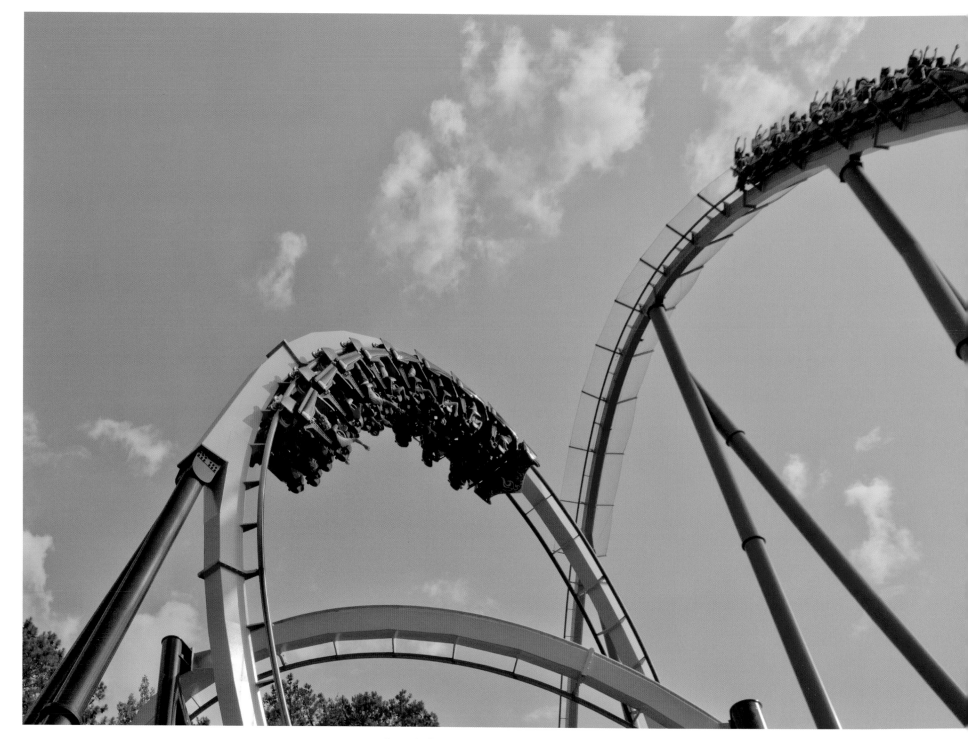

Georgia Scorcher and Goliath are close enough together that sometimes the stars line up and you get this.

Goliath™

OPENING DATE: April 1, 2006
MAKE: Bolliger & Mabillard
MAX HEIGHT: 200 feet (175-foot drop)
LENGTH: 4,480 feet
MAX SPEED: 70 mph
DURATION: 2:45
INVERSIONS: 0

B&M mega coasters are popping up everywhere, and with good reason. They combine a great coaster experience with a swiftly moving line. What's not to love? In a park filled with rides with long wait times, Goliath should have been a godsend. Ironically, it has a longer than average wait time for a mega coaster. That's not to say it's a death march. It's just not as fast as similar rides like Six Flags Great Adventure's Nitro.

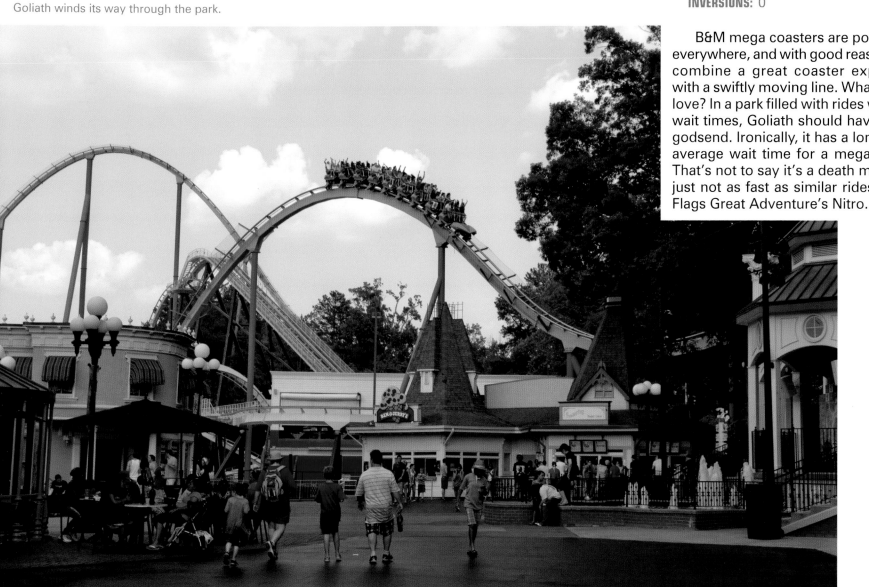

Goliath winds its way through the park.

Riders will leave their seats on the many air-time-filled hills like this one.

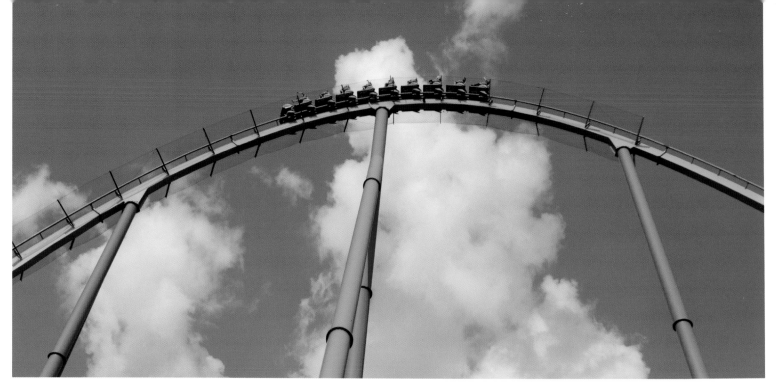

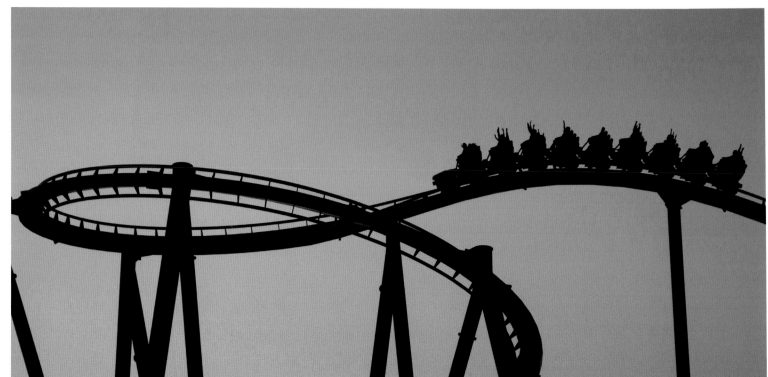

This 540-degree downward spiral propels riders toward the final hills of the ride.

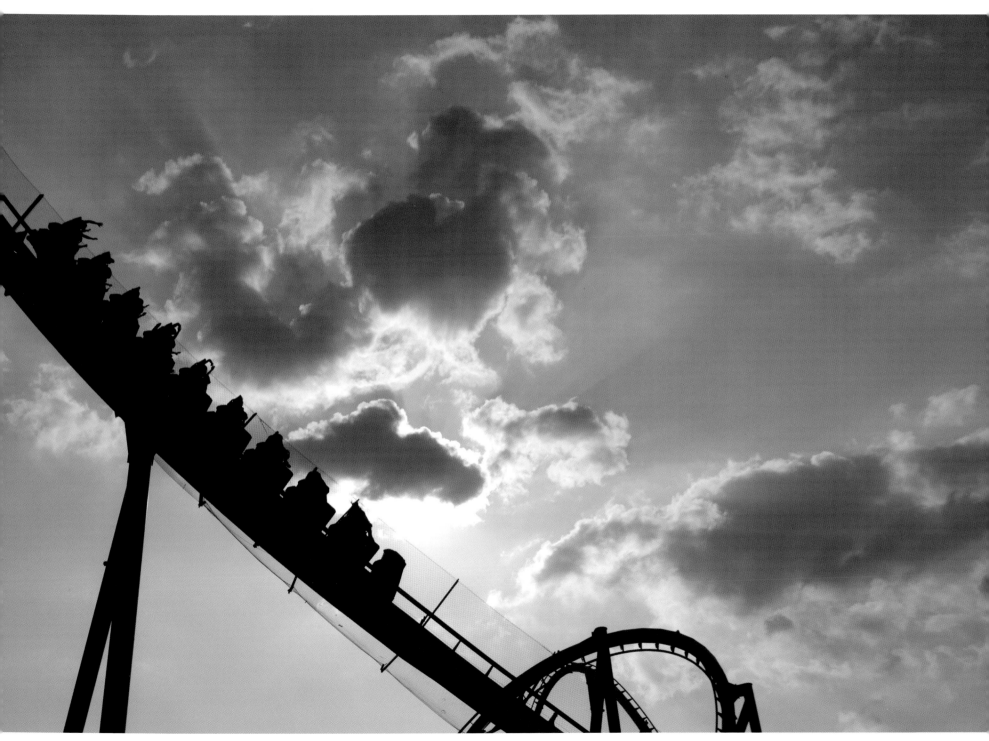

Goliath is the most beautiful and photogenic roller coaster in the park.

The midway provides a picturesque view of the park.

Kings Dominion

Doswell, Virginia

Being only an hour from Busch Gardens Williamsburg, this park is a perfect one, two punch (one, two, three punch if you want to include the relatively nearby Six Flags America). Built as a sister park to Kings Island, the two parks share a similar layout and a one-third scale replica of the Eiffel Tower. This unassuming park is home to twelve legitimate adult coasters.

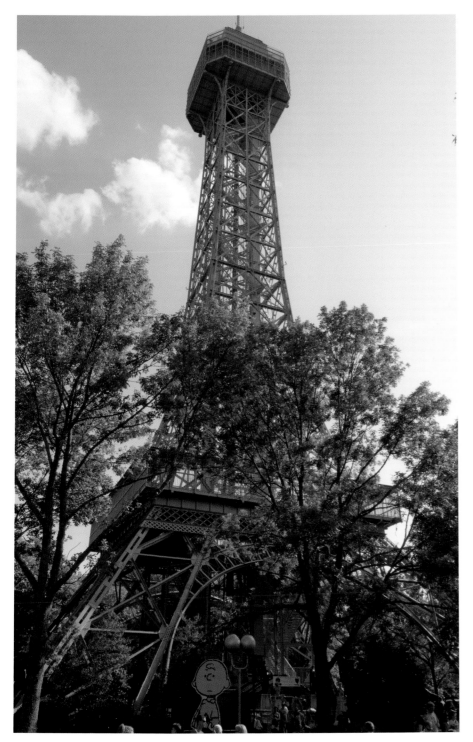

During the Halloween season, they will sometimes dye the water in the main pool and fountains blood red.

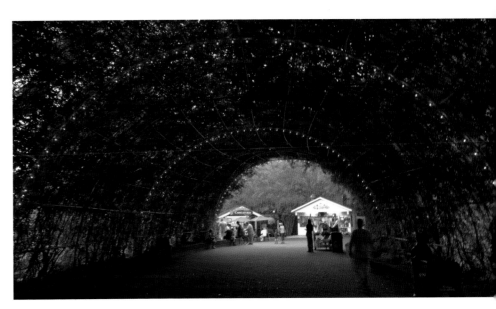

The Eiffel Tower replica acts as the park's central hub.

This foliage tunnel lights up beautifully at night.

Avalanche™ is a delightful toboggan coaster that is fun for both young and old.

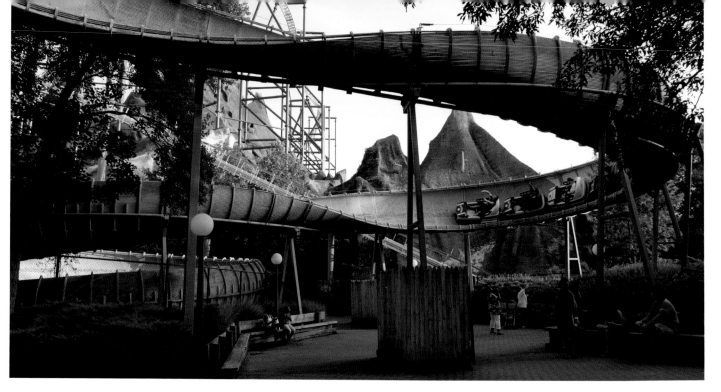

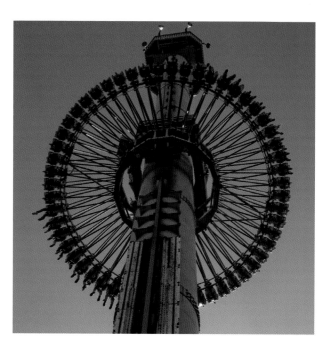

Drop Tower: Scream Zone™ has the longest drop of any tower in the world at 272 feet.

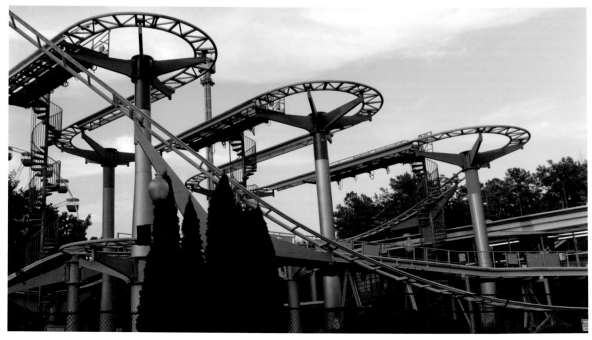

Ricochet™ is a wild-mouse coaster on steroids.

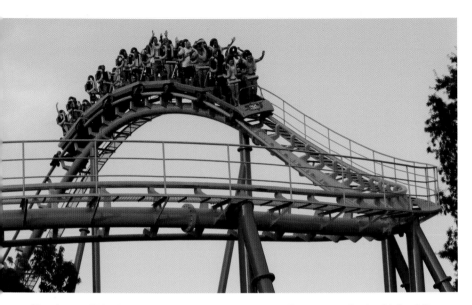

Shockwave™ is the oldest operating stand-up roller coaster in the United States.

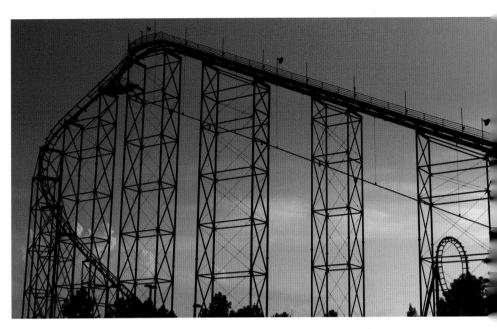

Anaconda™ is Kings Dominion's looping Arrow coaster that opened in 1991.

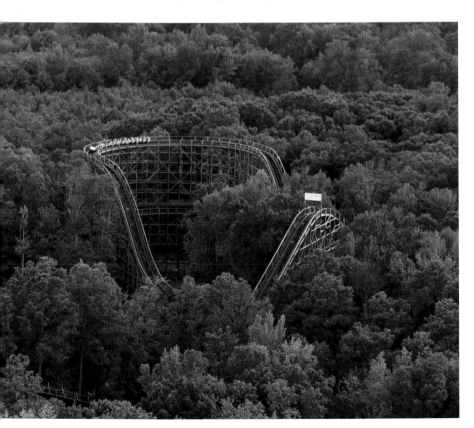

Grizzly™ is a great romp through the woods.

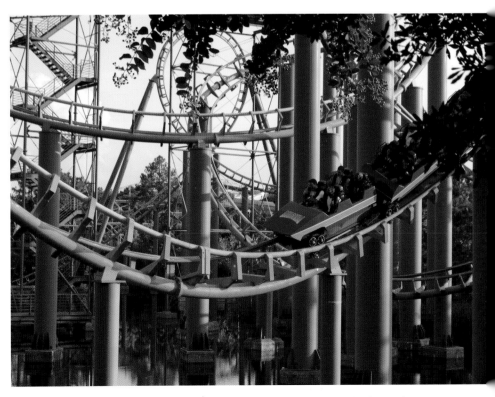

Built mostly over water, it's the most visually interesting coaster in the park.

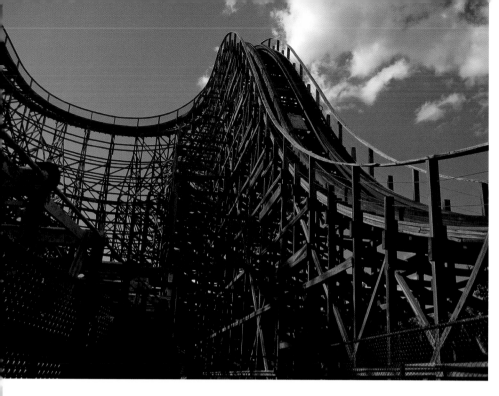

Hurler™ was originally a Wayne's World themed roller coaster, but had most references stripped after Paramount sold the park to Cedar Fair.

It may not be the best ride, but it sure looks pretty at sunset.

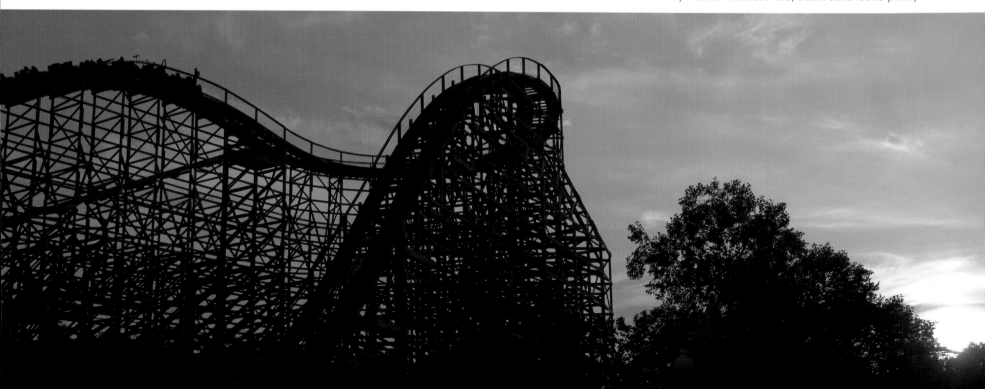

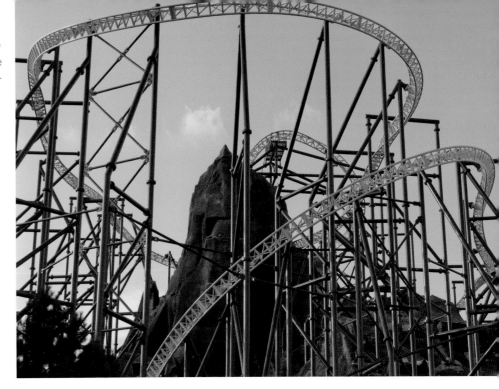

Volcano: The Blast Coaster™ launches riders out of the mouth of the volcano.

The track proceeds around the volcano's opening, almost like a giant trail of smoke.

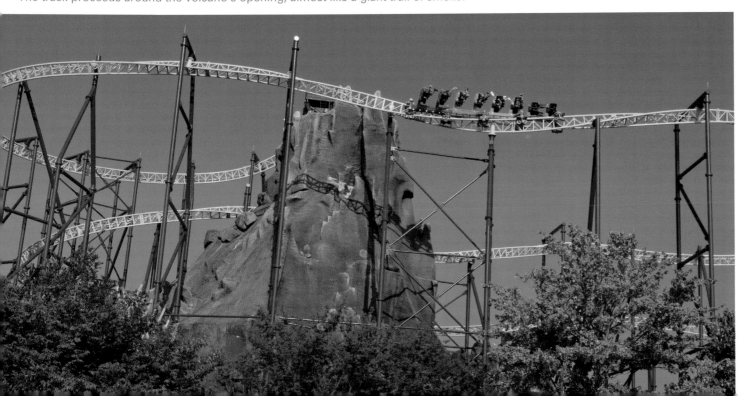

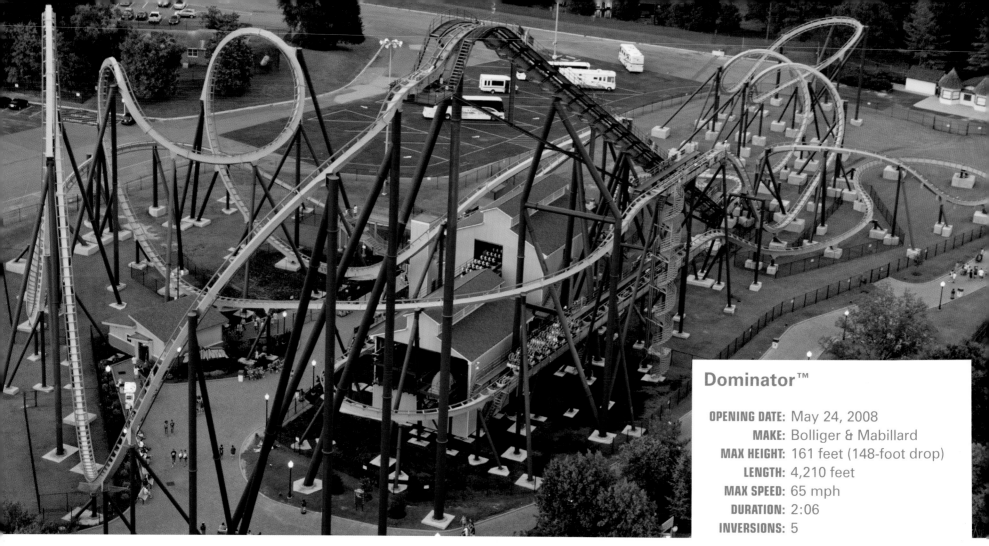

All 4,210 feet are stuffed into a relatively small space.

FACING PAGE

TOP LEFT: One of the world's biggest vertical loops.

BOTTOM LEFT: Riders exit the station on a narrow footbridge.

RIGHT: This cobra roll isn't exactly small either.

Dominator™

OPENING DATE: May 24, 2008
MAKE: Bolliger & Mabillard
MAX HEIGHT: 161 feet (148-foot drop)
LENGTH: 4,210 feet
MAX SPEED: 65 mph
DURATION: 2:06
INVERSIONS: 5

Formerly Dominator™ at Geauga Lake® (Cedar Fair), which was formerly Batman: Knight Flight™ at Geauga Lake (Six Flags), this ride has a lot of history. Even with all of its name and location changes, it remains the world's longest floorless coaster with the world's second largest vertical loop by diameter. It might be a little rough for some, but there is no doubting the heart of this monster. It has a wonderful collection of acrobatic elements that keep riders breathless.

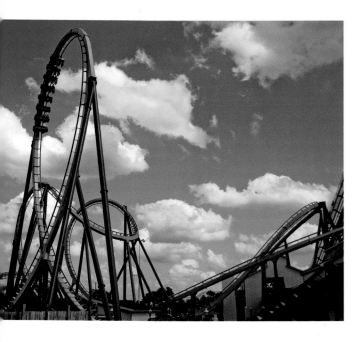

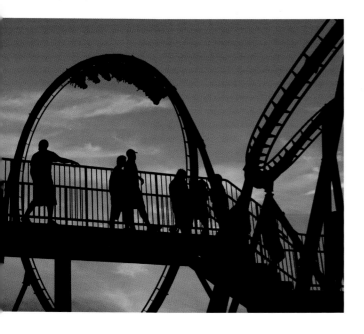

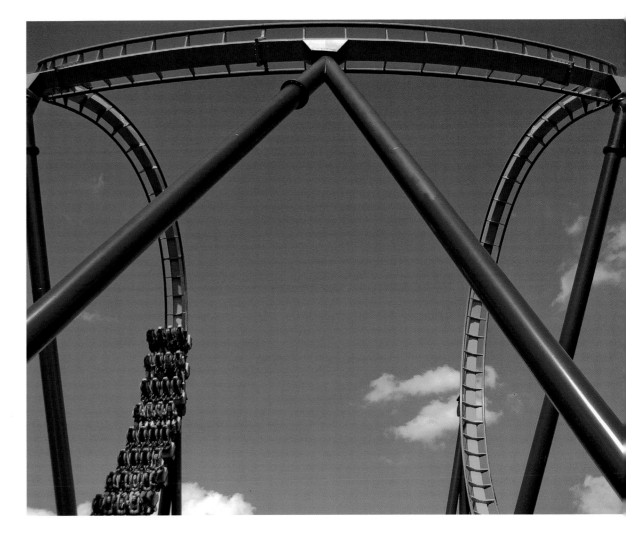

Intimidator 305™

OPENING DATE: April 2, 2010

MAKE: Intamin AG

MAX HEIGHT: 305 feet (300-foot drop)

LENGTH: 5,100 feet

MAX SPEED: 90 mph

DURATION: 3:00

INVERSIONS: 0

Like Carowind's Intimidator, this one is also named after legendary NASCAR driver Dale Earnhardt's nickname. It's only the third non-launch coaster in the world to eclipse 300 feet. This monster towers over every other ride in the park. The first drop generates such wicked g-forces that riders sometimes greyout as the train pulls out of the first dip. It's an interesting, not-all-together-pleasant sensation. Are these the kinds of g-forces NASCAR drivers routinely battle? Regardless, the speed attained in that first hill makes for a wonderful dash to the finish line.

FACING PAGE
TOP: Riders zoom around a series of tight twists and turns towards the end of the ride.
BOTTOM LEFT: The train is fashioned to emulate a race car—down to the harness that secures every rider.
BOTTOM RIGHT: It's a fast ride up the towering 305-foot lift hill.

The lift hill and crest only have three points of support.

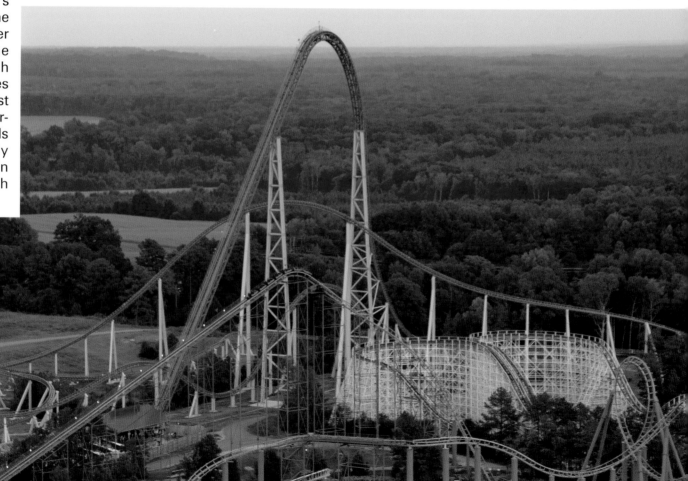

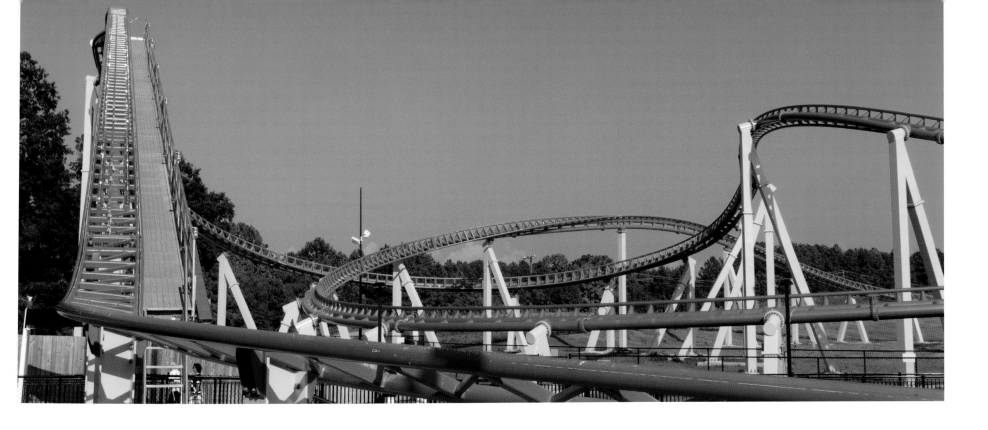

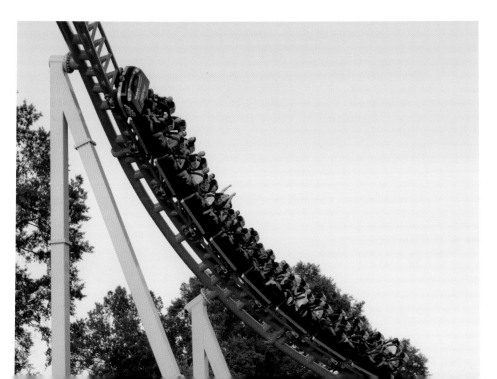

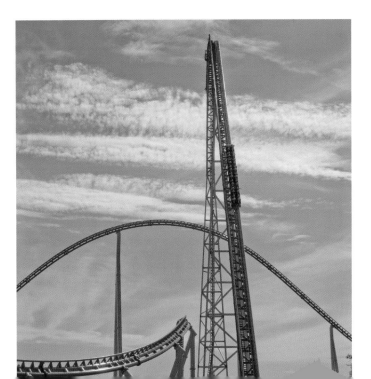

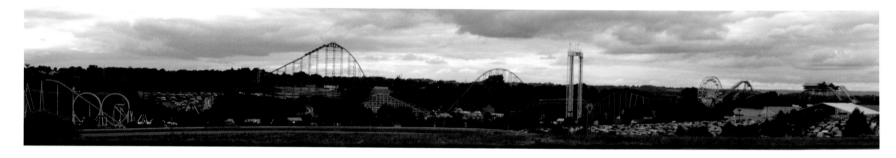

This panorama shows an older layout of the park before Laser™ was removed and Possessed™ was installed.

Dorney Park & Wildwater Kingdom

Allentown, Pennsylvania

Dorney Park's roots go all the way back to the late 1800s, when it was a trout hatchery and summer resort. But it didn't get its first roller coaster, currently named Thunderhawk™, until 1923. After many ownership changes, Dorney Park is now the property of Cedar Fair, LP. There aren't many roller coasters, so be sure to take advantage of the water park if you want to maximize your dollar.

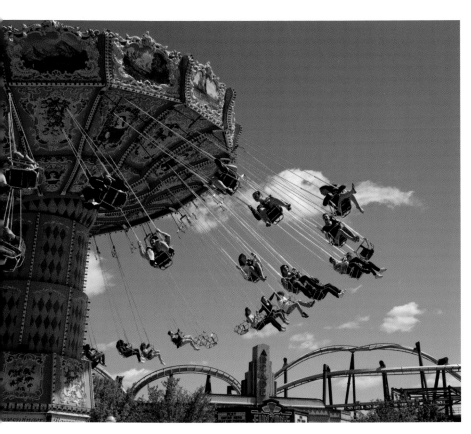

Park guests enjoy the Wave Swinger™.

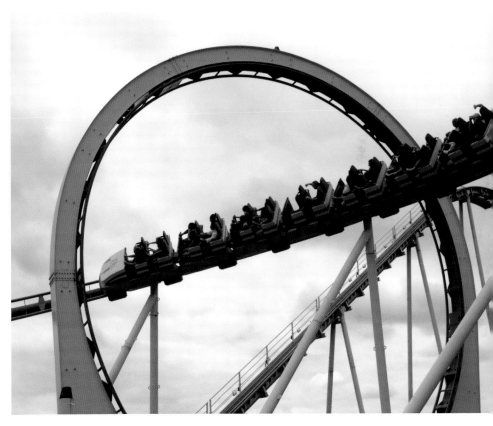

Gone but not forgotten: Laser was modular in design and looked like a carnival ride created by a mad scientist.

FACING PAGE

LEFT: The first half of the coaster's cobra roll.

RIGHT: Riders exit the zero-g roll.

The train is released down the first hill.

Hydra The Revenge™

OPENING DATE: May 7, 2005
MAKE: Bolliger & Mabillard
MAX HEIGHT: 95 feet (105-foot drop)
LENGTH: 3,198 feet
MAX SPEED: 53 mph
DURATION: 2:35
INVERSIONS: 7

This ride has a story behind it. At the location where Hydra stands today used to be another roller coaster. It was a woodie called Hercules™ (nicknamed "Jerkules" because of its tendency to bruise your soul). In mythology, Hercules was tasked to kill the Hydra, so when Dorney Park replaced Hercules, the story was that the Hydra came back, exacted revenge on Hercules, and took his place in the park.

The ride features a slow, 360-degree roll as the train leaves the station. As with all floorless coasters, Hydra features many acrobatic feats and has a smooth, enjoyable ride.

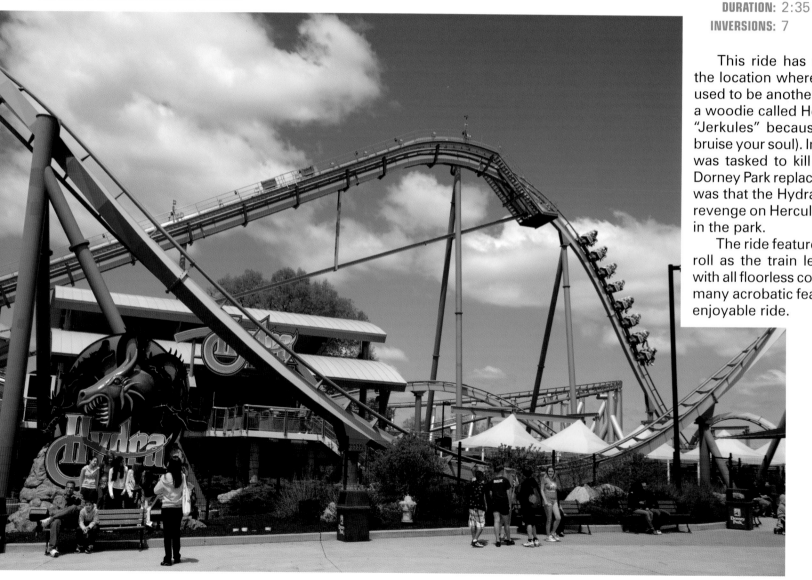

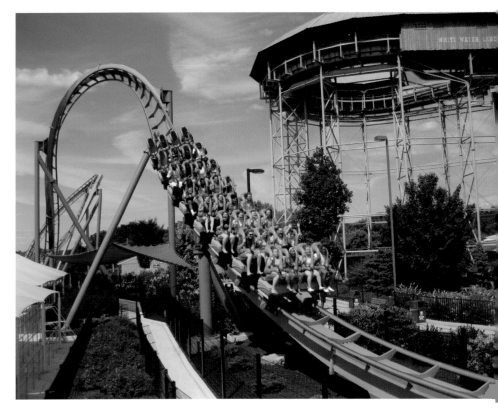

Thunderhawk

OPENING DATE: 1923

BUILDER: Philadelphia Toboggan Coasters, Inc.

MAX HEIGHT: 80 feet (65-foot drop)

LENGTH: 2,767 feet

MAX SPEED: 45 mph

DURATION: 1:18

INVERSIONS: 0

This is the first coaster the park ever had, and it's still operating. That should tell you all you need to know. Thunderhawk snakes through one of the few wooded areas in the park. This well-maintained ride is fairly smooth and a nice chaser after riding Steel Force™.

FACING PAGE

LEFT: In the shadow of Steel Force, it'd be hard not to get an inferiority complex.

TOP RIGHT: Grab a seat near the back and get ready for some airtime.

BOTTOM RIGHT: This odd little hill is directly after the first drop. You don't see that too often.

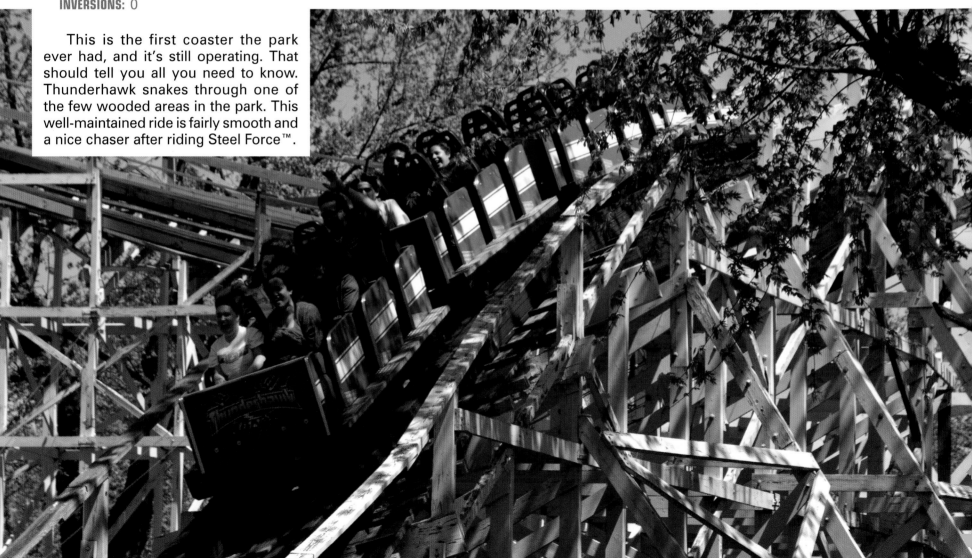

A train descends a hill in the back section of the track.

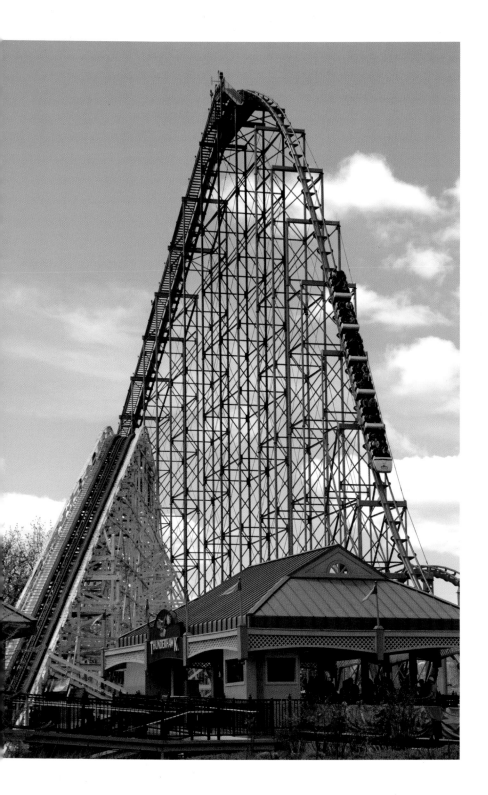

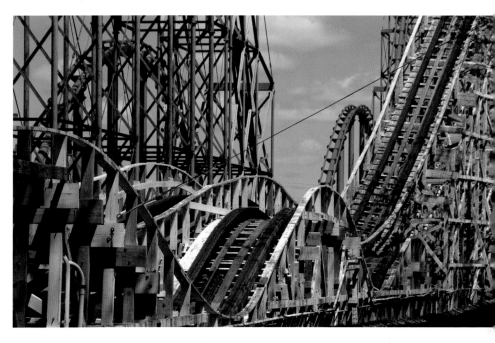

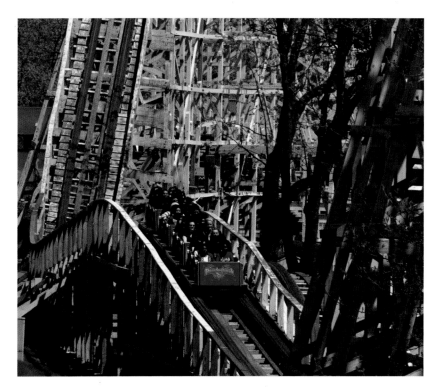

You can even take a relaxing stroll right through the middle of the coaster.

Talon™

OPENING DATE: May 5, 2001
MAKE: Bolliger & Mabillard
MAX HEIGHT: 134 feet (120-foot drop)
LENGTH: 3,110 feet
MAX SPEED: 58 mph
DURATION: 2:01
INVERSIONS: 4

This inverted coaster is no slouch. The first three elements (loop, zero-g roll, and Immelmann loop) will leave you a little dizzy, but the rest of the ride involves a pleasing array of rolls and turns to even things out. This little dynamo of a coaster could be the best ride in the park, but don't tell that to Steel Force.

FUN FACT: The track and supports are filled with sand to keep the ride quiet (The same is true for Hydra).

FACING PAGE
LEFT: Here the train passes through an inclined spiral.
RIGHT: Riders swoop down from the lift hill heading towards the loop.

There are acrobatic elements at nearly every turn.

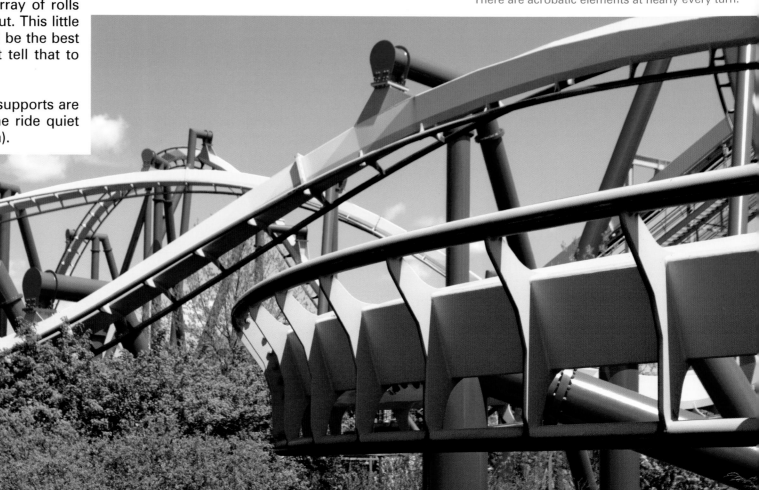

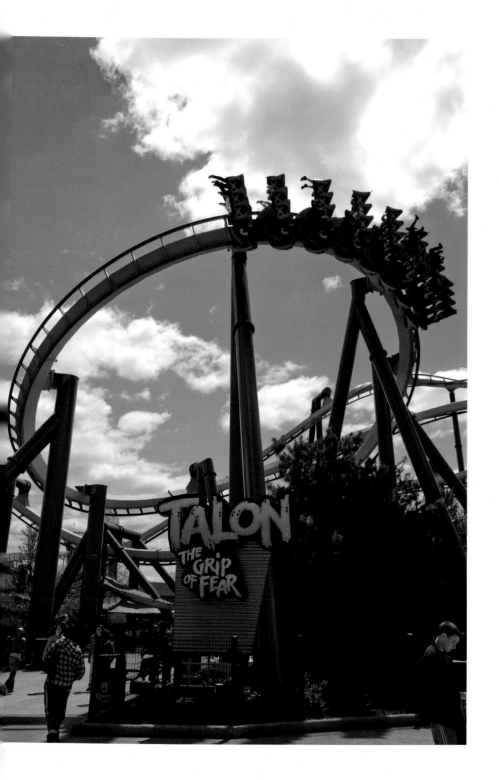

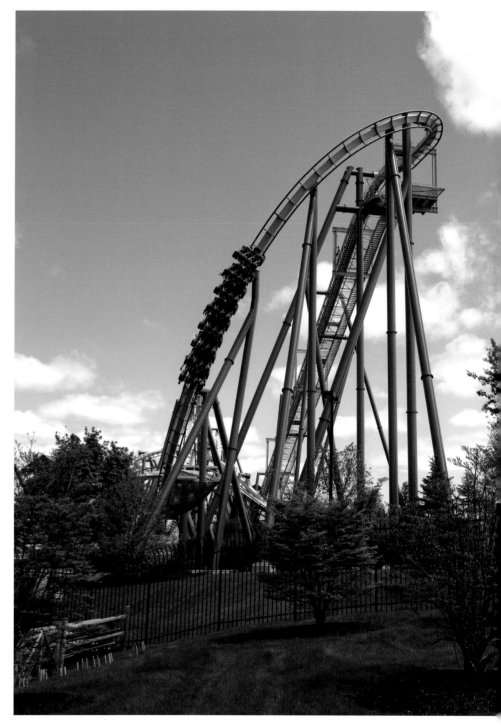

Steel Force

OPENING DATE: May 30, 1997
DESIGNER: Steve Okamoto
BUILDER: Morgan
MAX HEIGHT: 200 feet (205-foot drop)
LENGTH: 5,600 feet
MAX SPEED: 75 mph
DURATION: 3:00
INVERSIONS: 0

This coaster is the premier ride at Dorney Park. It's the longest roller coaster on the East Coast and the ninth longest steel coaster in the world. Fifteen years old and still silky smooth, it routinely places in the top twenty in steel coasters. If you can't make it out east then check out Mamba™ at Worlds of Fun® in Kansas City, Missouri. It's eerily similar.

FACING PAGE

TOP: This huge hill is not even the tallest.
BOTTOM: The train rockets up before entering the 510-degree downward helix.

The downward helix as seen from the service entrance to the park.

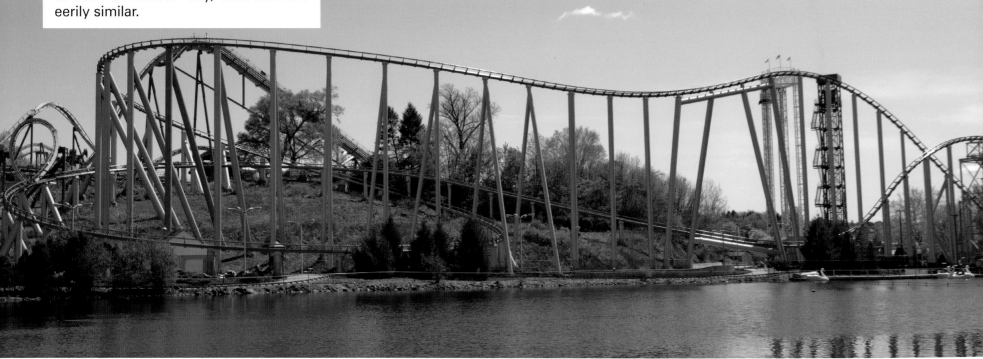

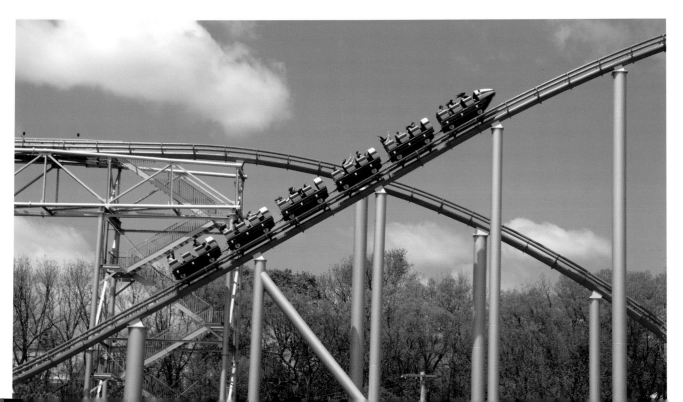

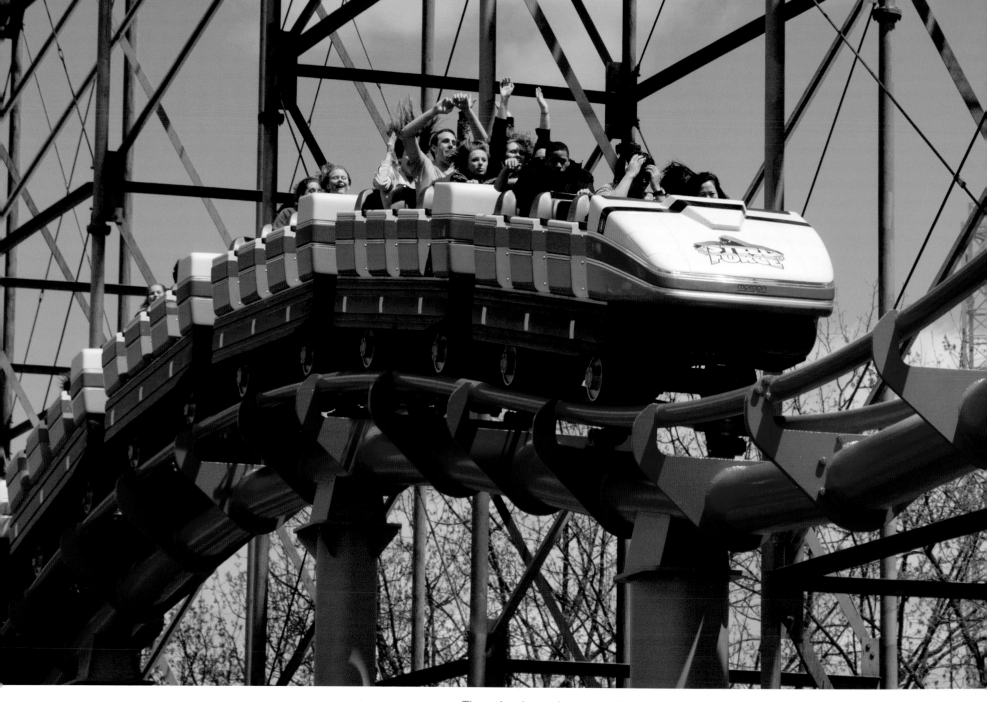

The trains themselves are bulky, but there are three of them and the line moves at a quick pace.

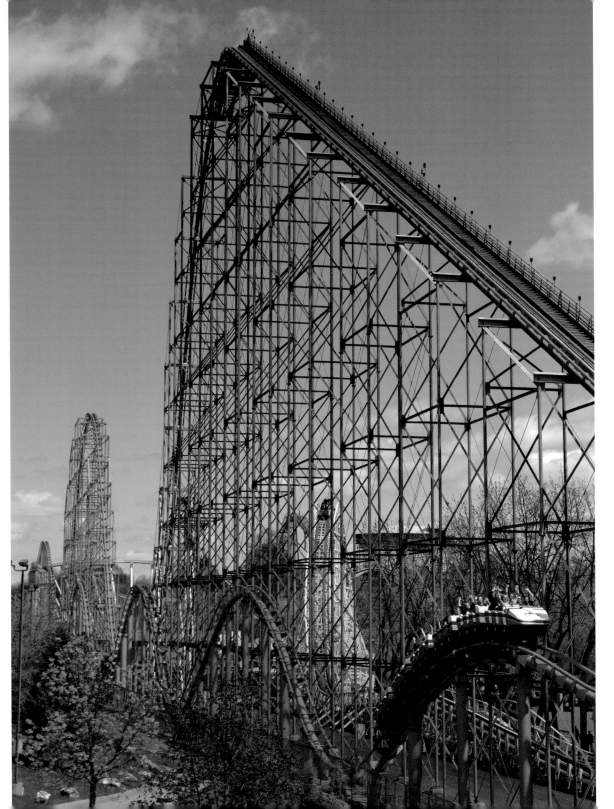

The bunny hills provide
great contrast to the
enormous lift hill.

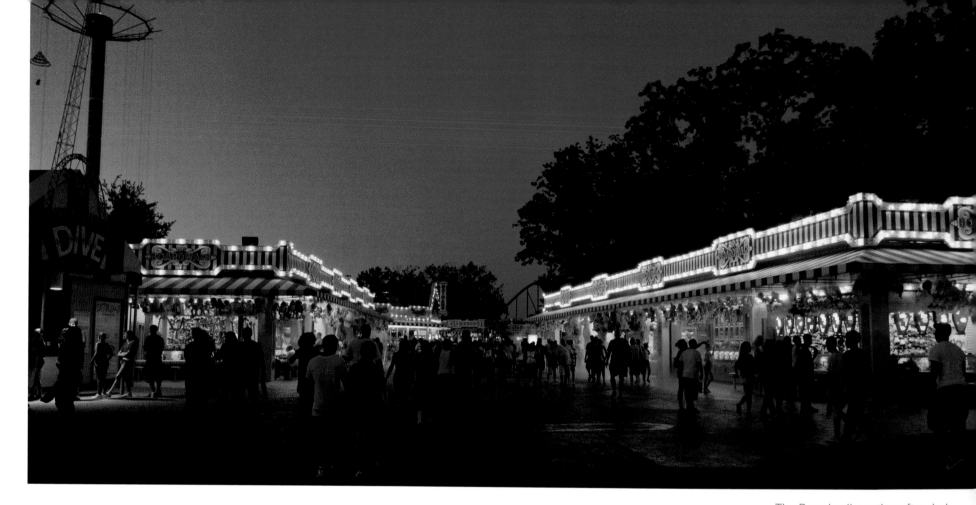

Six Flags Great Adventure

Jackson, New Jersey

This is the big daddy of the East Coast. It has one of the best steel coasters in the world. It has one of the best wood coasters in the world. It has the tallest and fastest coaster in the world. Mix in a rich assortment of other rides and you have a coaster rider's dream. It's massive, even without the spacious drive-through safari.

Big Wheel™ opened as the world's tallest Ferris Wheel in 1974.

The fort acts as an anchor for the Dream Street Skyway™ and as a home to the park's oldest roller coaster, Runaway Mine Train™.

They pull out all the stops for Fright Fest™. Crowds are humongous during weekend nights in October.

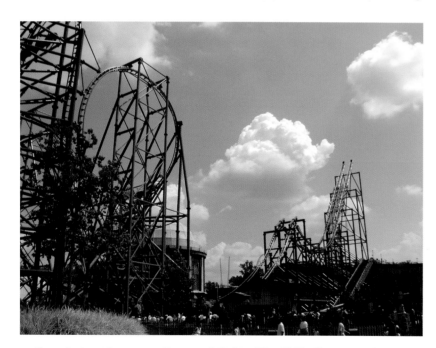

Gone but not forgotten: Batman & Robin: The Chiller™ was a twist on the traditional boomerang style coaster.

Gone but not forgotten: Super Teepee was a souvenir shop in the western themed part of the park.

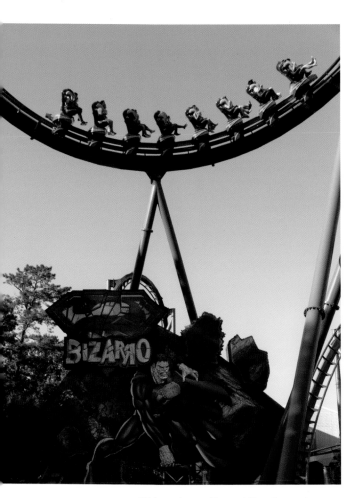

This cobra roll straddles the entrance.

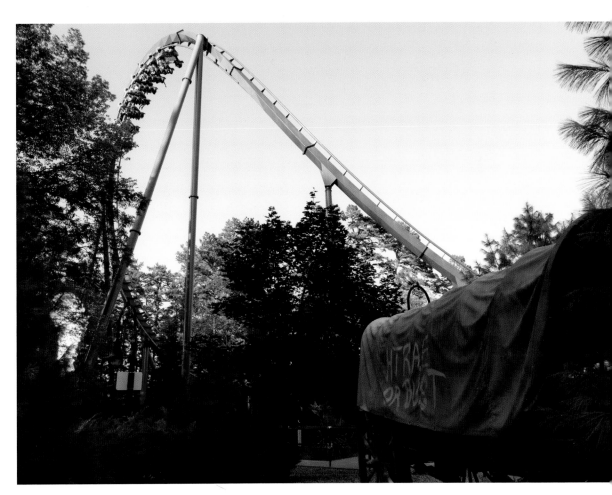

Bizarro™ was the world's first floorless coaster.

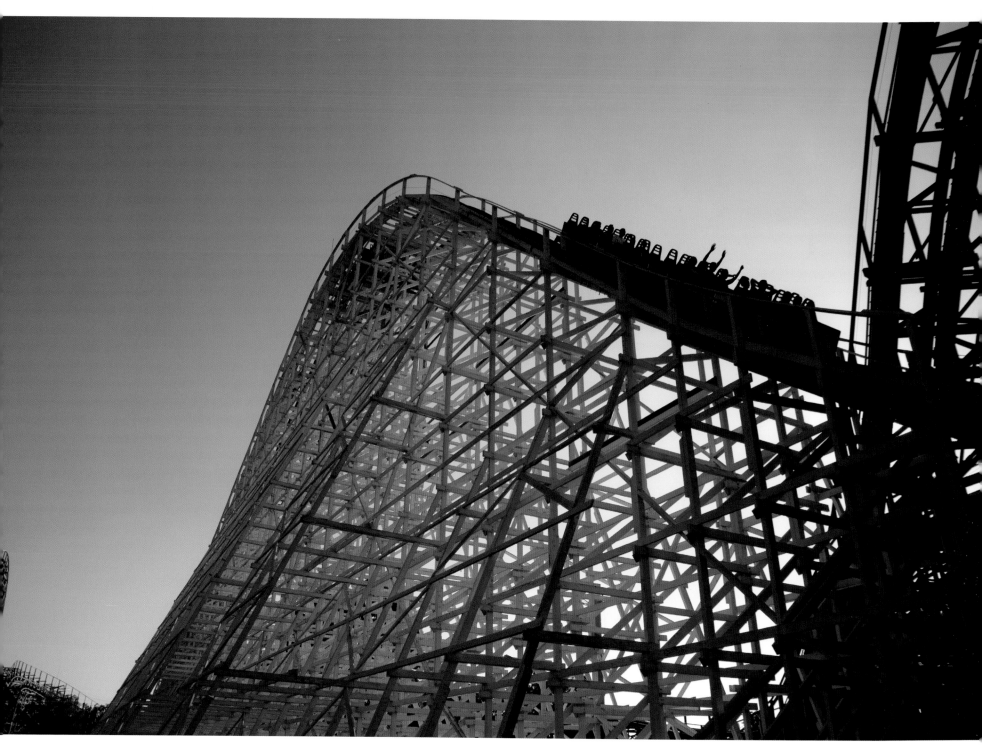

Rolling Thunder™ is the park's oldest wooden roller coaster.

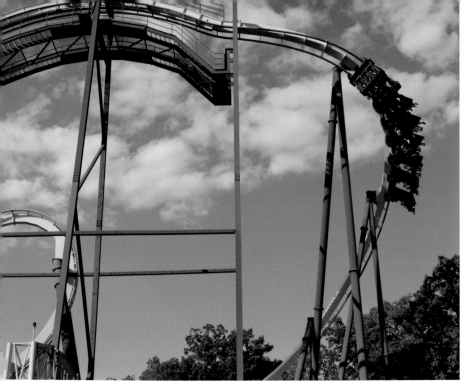

This was the second Batman:The Ride™ to open at a Six Flags park. It debuted in 1993.

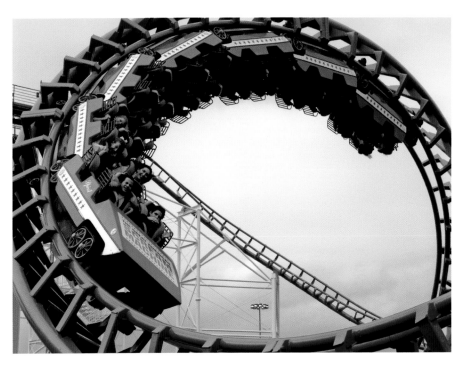

Gone but not forgotten: Great American Scream Machine™ was introduced in 1989.

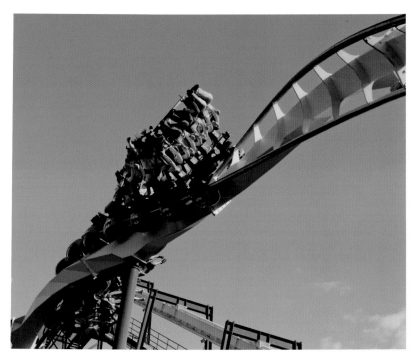

Riders enter the zero-g roll after the first loop.

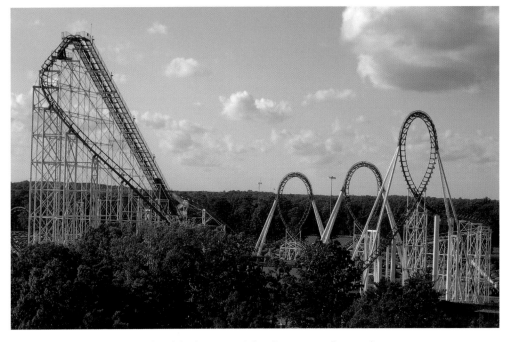

It is regarded by some as the ride that saved the then struggling park from closing permanently.

Nitro™

OPENING DATE: April 7, 2001
MAKE: Bolliger & Mabillard
MAX HEIGHT: 230 feet (215-foot drop)
LENGTH: 5,394 feet
MAX SPEED: 80 mph
DURATION: 2:20
INVERSIONS: 0

Year in and year out, this steel coaster is voted among the very best in the world. Its speed, undulating hills, and centrifuge-like, 540-degree helix near the end combine to make it one of the pure joys to be found anywhere. The open seating makes it easy to float around, weightless, as the train crests each hill. When the park has three trains running, the line moves at a brisk pace. If Nitro is your ride of choice, make your way to it at opening time—most other riders will be flocking to El Toro™ and Kingda Ka™.

FACING PAGE

TOP LEFT: Nitro is located at the edge of the park next to Congo Rapids.
TOP RIGHT: Grace and elegance: two words that define Nitro's beauty.
BOTTOM: As night falls it takes on an iconic form.

A train drops down the second hill heading towards the third.

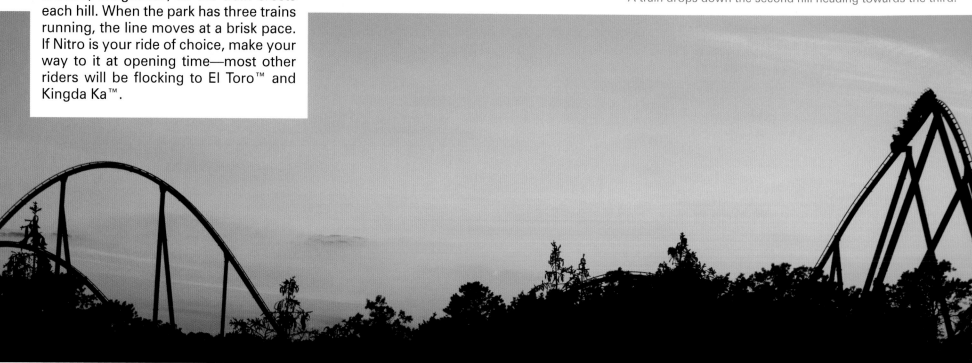

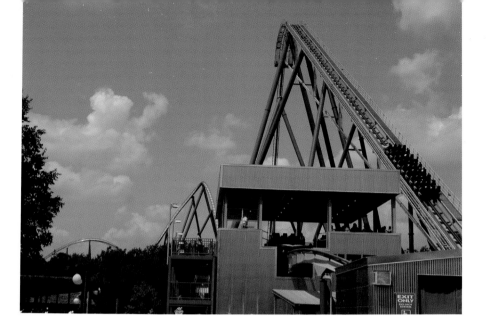

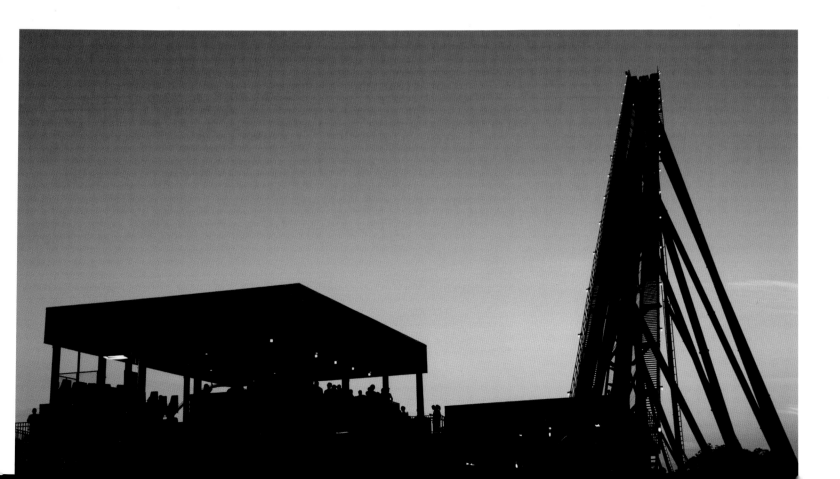

Superman: Ultimate Flight™

OPENING DATE: April 17, 2003
MAKE: Bolliger & Mabillard
MAX HEIGHT: 106 feet (100-foot drop)
LENGTH: 2,759 feet
MAX SPEED: 51 mph
DURATION: 2:06
INVERSIONS: 2

This is the second of three Superman: Ultimate Flight flying coasters to open at Six Flags parks. Six Flags Over Georgia had the first and Six Flags Great America® has the third. It's a fine ride if you don't have to wait long for it. Head for it first thing after the park opens to avoid a long line. It doesn't take long for the queue to balloon to more than an hour wait.

FACING PAGE

TOP LEFT: The pretzel loop can be seen in the center of that nest of track. It is the signature element of these B&M flyers.
BOTTOM LEFT: Guests ride facing toward the ground.
RIGHT: The blue, red, and yellow color scheme is visually striking.

The station and lift hill are easily seen from the parking lot.

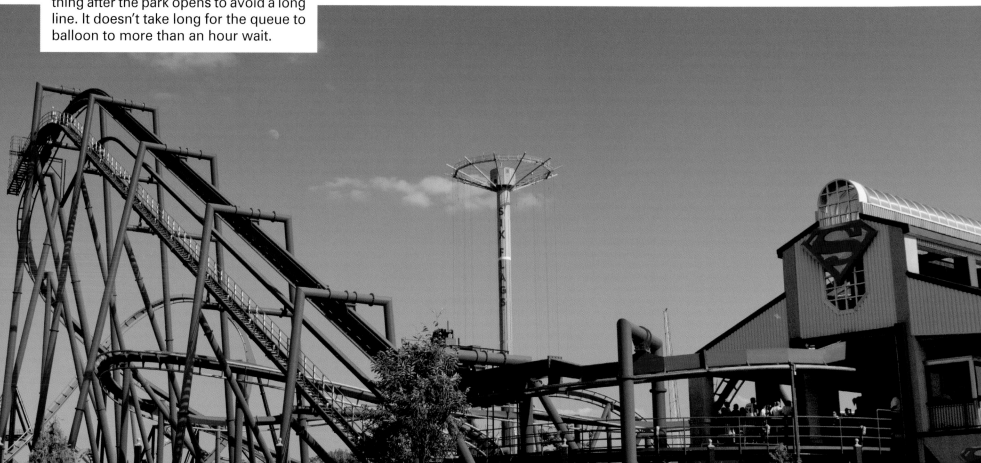

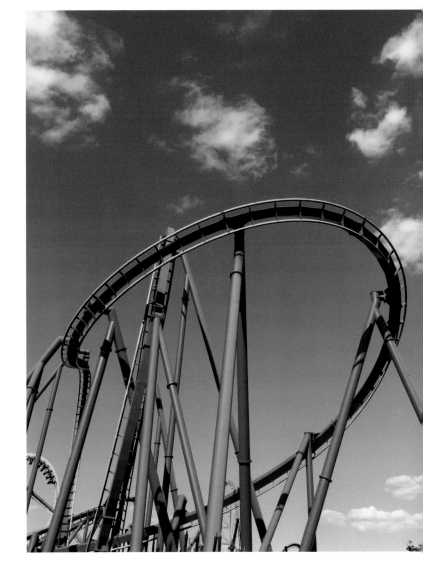

FACING PAGE

LEFT: The theme of the ride centers on an airport with riders boarding in a hangar.
RIGHT: The train enters a corkscrew.

The train conquers one of five inversions.

Green Lantern™

OPENING DATE: May 25, 2011
MAKE: Bolliger & Mabillard
MAX HEIGHT: 154 feet (144-foot drop)
LENGTH: 4,155 feet
MAX SPEED: 63 mph
DURATION: 2:30
INVERSIONS: 5

This stand-up was previously named Chang™ at the now-closed Six Flags Kentucky Kingdom® and replaced Great American Scream Machine™. When it originally opened in 1997, it set multiple records for stand-up roller coasters in height, drop, and speed. It was closed in 2009 and moved to Six Flags Great Adventure in 2011.

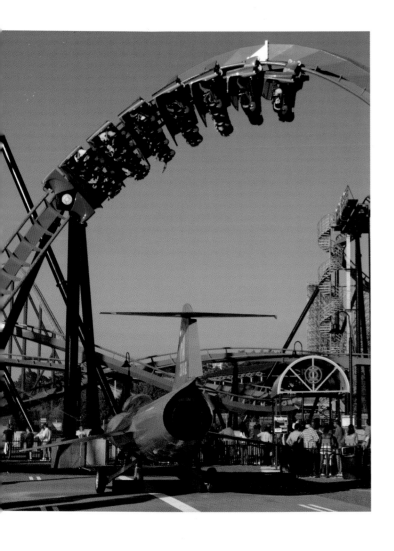
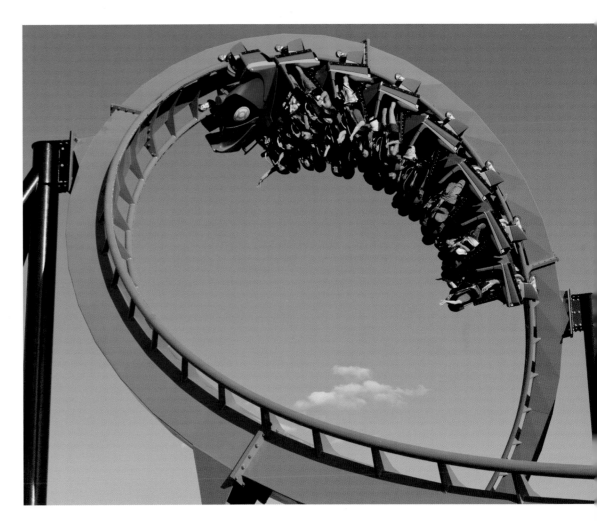

LEFT: The final hill is the biggest difference between Kingda Ka and Cedar Point's Top Thrill Dragster.

RIGHT: Zero to 128 mph in 3.5 seconds is an experience that is not to be missed.

The small train provides contrast to this massive structure.

Kingda Ka

OPENING DATE: May 21, 2005
MAKE: Intamin AG
MAX HEIGHT: 456 feet (418-foot drop)
LENGTH: 3,118 feet
MAX SPEED: 128 mph
DURATION: 0:28
INVERSIONS: 0

This ride is Top Thrill Dragster's bigger brother. The monstrous 456-foot tower makes it the tallest roller coaster in the world. Until recently, it was the fastest in the world at 128 miles per hour. Either way, the blistering launch accelerates riders to eyeball-popping speeds in mere seconds. An eyewear retainer is your best friend on this ride, as unsecured glasses aren't permitted. Also, if you are tall, the second row is almost as good as being in front because the second row is slightly elevated, offering taller riders an uninterrupted view.

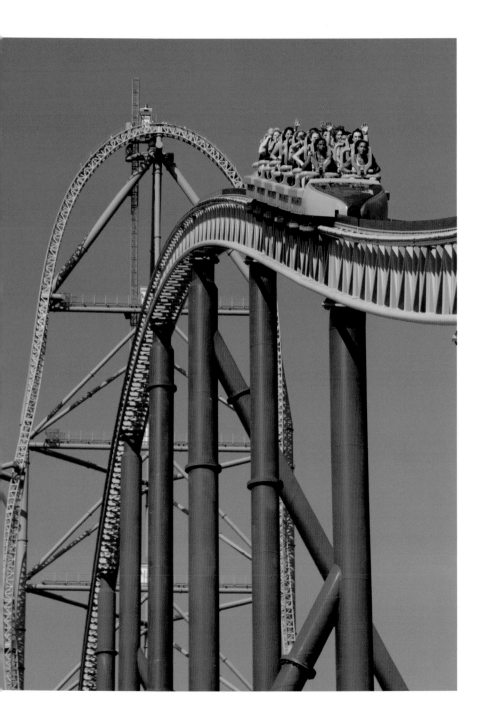

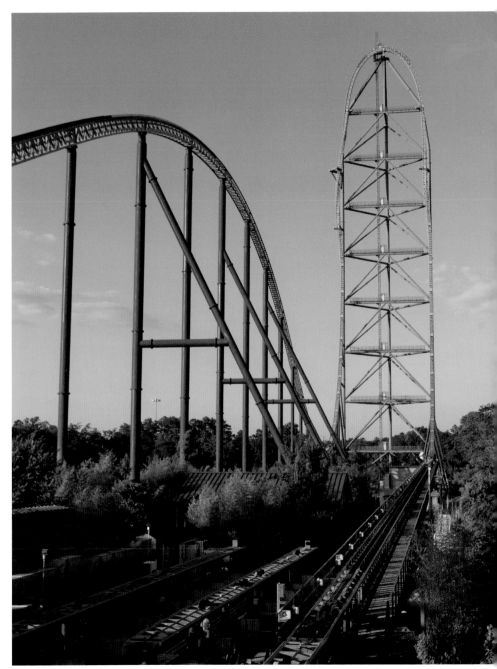

El Toro

OPENING DATE: June 11, 2006
MAKE: Intamin AG
MAX HEIGHT: 181 feet (176-foot drop)
LENGTH: 4,400 feet
MAX SPEED: 70 mph
DURATION: 1:35
INVERSIONS: 0

Considered one of the top coasters in the world, El Toro delivers an experience like no other. It's perhaps the smoothest wood roller coaster anywhere. Don't let that fool you, this one is ferocious. Riders are essentially stapled firmly into position, because the train feels like it wants to buck you right off the ride as it crests hills at breakneck speed. This "ejector air" adds an unparalleled thrill as you are constantly yanked back into your seat. The ride concludes with a twisting, snaking dash through Rolling Thunder's infield. It's a great cap to a near-perfect ride. If there is any criticism, it's the length. Why does it seem that the best things in life last but an instant?

TIP: If you ride it first thing and it seems a little slow and underwhelming, give it a second chance later on when the wheels are hot. It can make a world of difference.

FACING PAGE

TOP LEFT: The track was laser cut in a factory instead of cut by hand on-site, creating the smoothest woodie you will likely ever ride.

TOP RIGHT: When it opened, El Toro had the steepest drop of any wooden coaster on the planet (76 degrees).

BOTTOM LEFT: It has an out-and-back shape in the beginning, before its fantastic, turbulent finish.

BOTTOM RIGHT: Riders plunge down the second hill.

It looks gentle, but the ejector air is anything but tranquil.

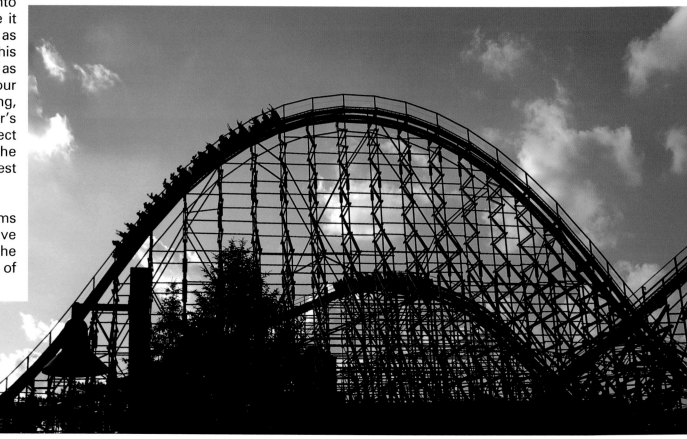

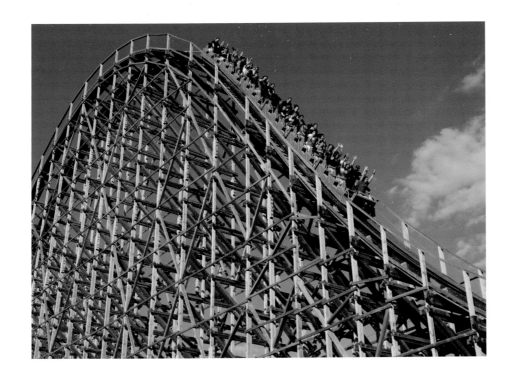
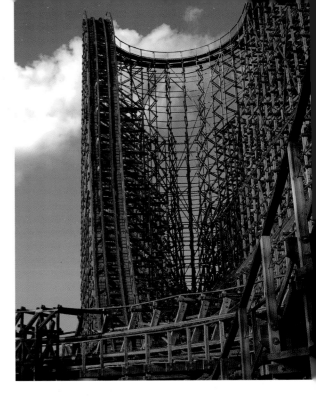
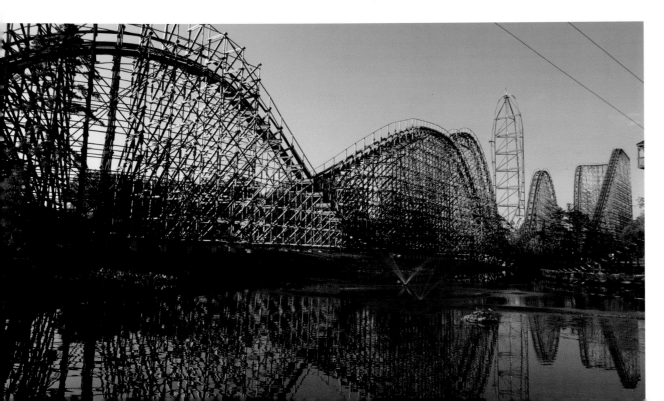
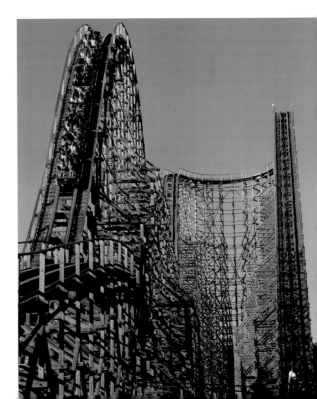

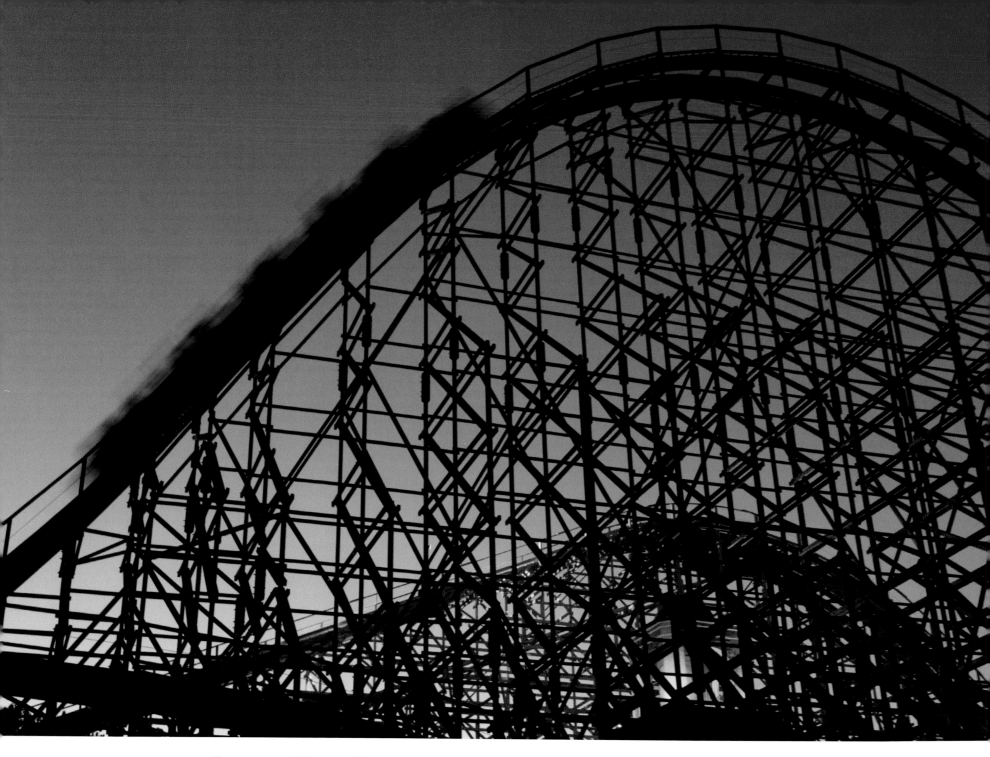

If you want to ride more roller coasters like this one, be prepared to travel. The only other ones are in Germany, Switzerland, and South Korea.

Best of the Rest

All good things must come to an end, and my time with you draws to a close. I hope you enjoyed the pictures. My apologies if I wasn't able to include your favorite coaster. As a consolation, I'm including a few of the pictures I couldn't include in the main section of the book for one reason or another.

Universal Studios Island of Adventure®
Orlando, Florida

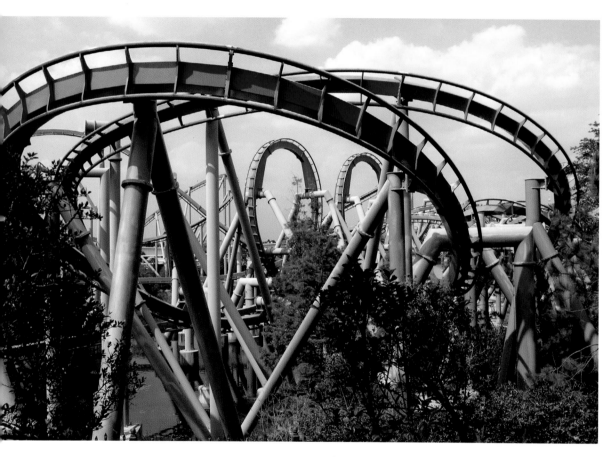

Dueling Dragons™ was an excellent inverted dueling coaster. It is now called Dragon Challenge™ for The Wizarding World of Harry Potter™ section of the park.

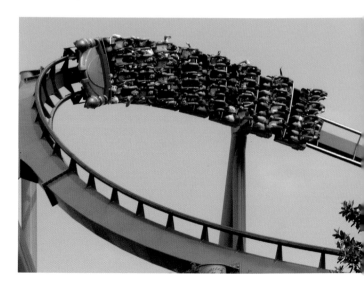

Incredible Hulk™: the launch up the lift hill is memorable.

Worlds of Fun®
Kansas City, Missouri

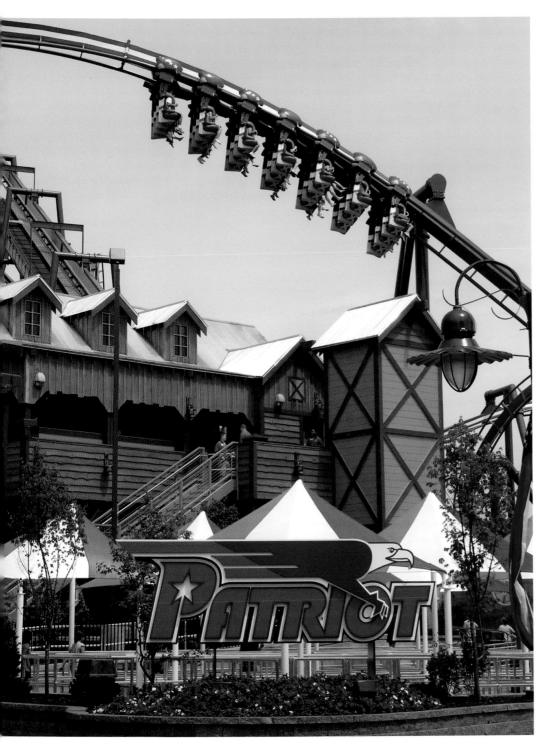

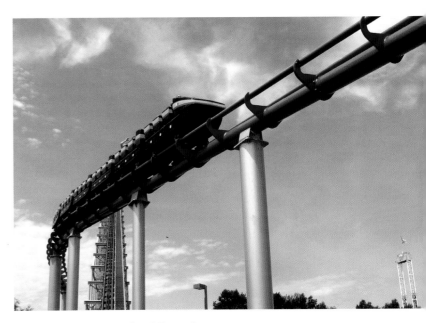

Mamba: it's a lot like Steel Force from
Dorney Park and Wild Water Kingdom.

Patriot™, a good little inverted coaster that is silky smooth
(or at least was the year it opened in 2006).

Valleyfair®
Shakopee, Minnesota

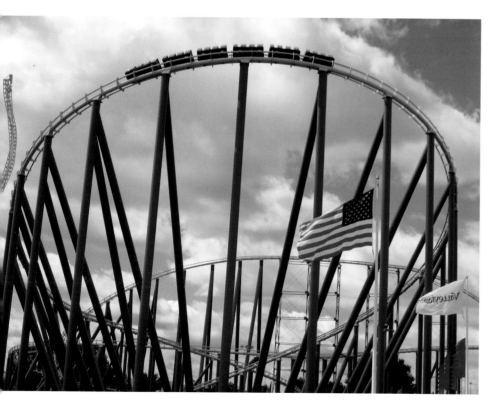

Wild Thing™ is also reminiscent of Steel Force, but not a near copy like Mamba.

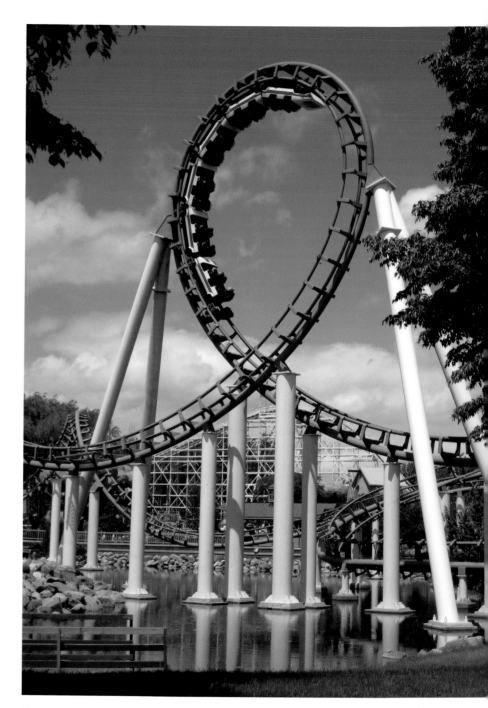

Corkscrew™ was the only all-steel roller coaster in the state of Minnesota until 1996.

Busch Gardens Tampa®

Tampa Bay, Florida

Kumba™ had the first-ever diving loop in a B&M coaster.

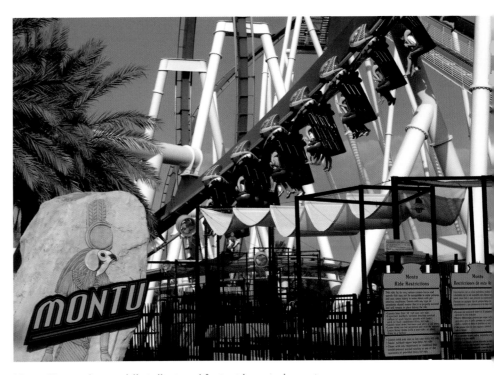

Gwazi™ is a dueling wooden coaster that holds a record for most fly-bys (coasters near-miss each other six times).

Montu™ was the world's tallest and fastest inverted coaster when it opened in 1996.

Six Flags Magic Mountain®
Valencia, California

Goldrusher™ was the first roller coaster at Six Flags Magic Mountain.

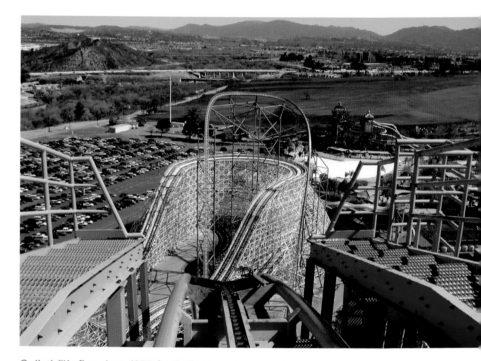

Goliath™'s first drop (255 feet) dives underground.

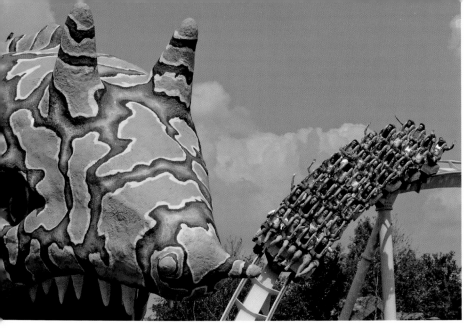

Sea World Orlando®

Orlando, Florida

Kraken™ was the first floorless coaster
in the southern United States.

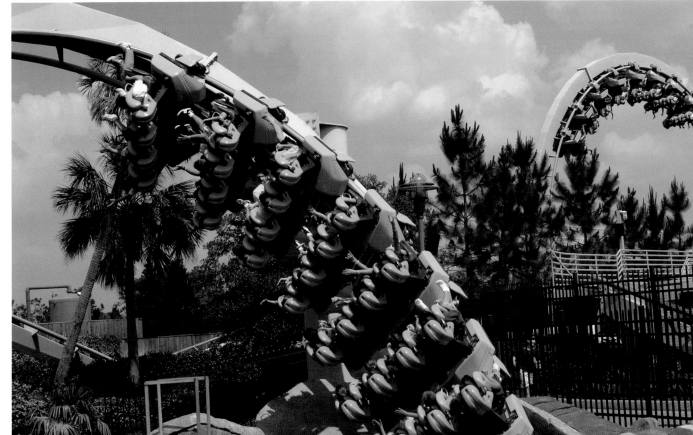

Two of Kraken™'s seven inversions.
Photo is a composite of two different shots.

Dollywood®
Pigeon Forge, Tennessee

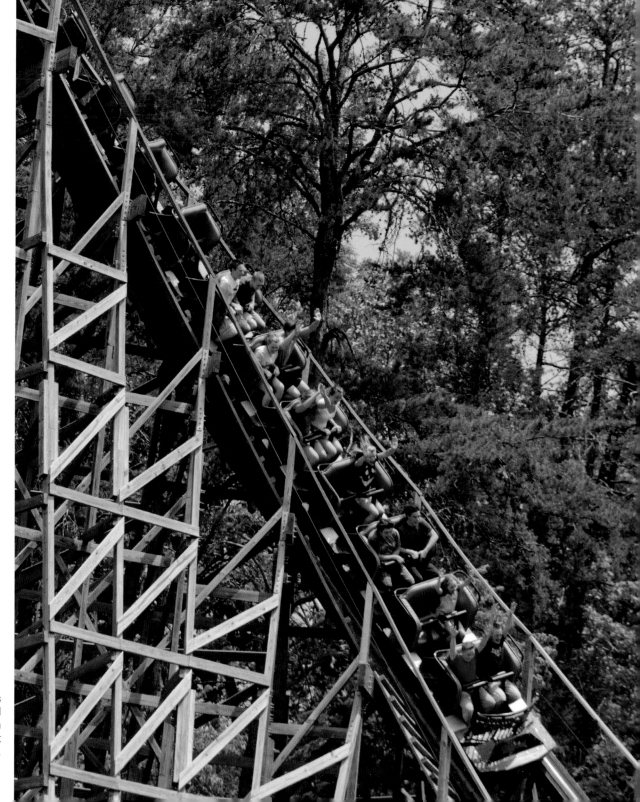

Thunderhead™ is perhaps the best wood coaster in the south and one of the best woodies anywhere.

Six Flags St. Louis®

St. Louis, Missouri

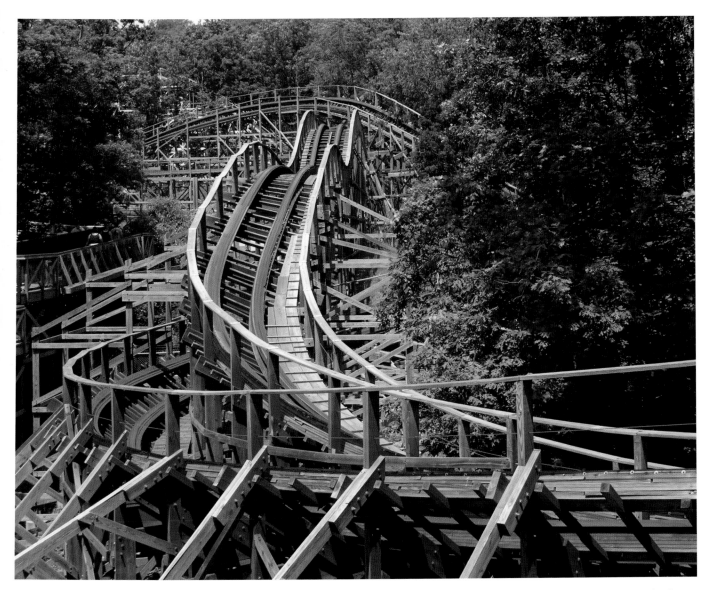

Boss™ is a bit of a rough ride, so sit near the front.

Holiday World and Splashin' Safari®

Santa Claus, Indiana

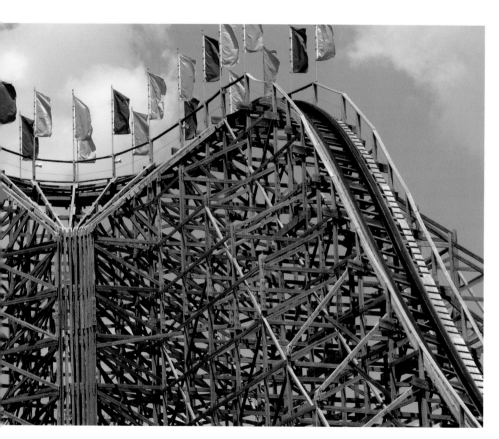

The Legend™: you've got to ride it a few times before you can recognize its brilliance.

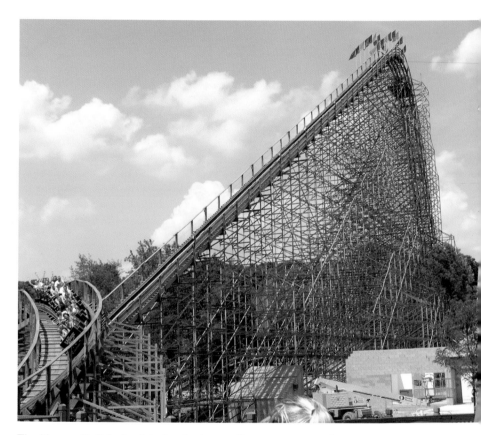

The Voyage™: it just might be the best roller coaster anywhere.

Bibliography

Busch Gardens, SeaWorld Parks & Entertainment, Aug. 5, 2011. (http://buschgardens.com)

Cedar Fair LP, Aug. 12, 2011. (www.cedarfair.com)

Dollywood Company, Aug. 16, 2011. (www.dollywood. com)

Holiday World & Splashin' Safari, Aug. 12, 2011. (www. holidayworld.com)

Kennywood, Palace Entertainment, Aug. 12, 2011. (www. kennywood.com)

Knoebels Amusement Resort, Aug. 13, 2011. (www. knoebels.com)

Marden, Duane. Roller Coaster Database, Nov. 27, 2011. (www.rcdb.com)

Sea World Orlando, SeaWorld Parks & Entertainment, Aug. 5, 2011
 (http://seaworldparks.comen/seaworldorlando)

Six Flags Theme Parks Inc., Aug. 12, 2011. (www.sixflags. com)

Universal Studios Islands of Adventure, Universal Orlando Resort, Nov. 27, 2011.
 (www.universalorlando.com/theme-parks/islands-of-adventure.aspx)

Index

Afterburn, 54, 55
Alpengeist, 92, 93, 94, 95
Anaconda, 127
Apollo's Chariot, 89
Avalanche, 126
Batman: The Dark Knight, 43
Batman & Robin: The Chiller, 150
Batman: The Ride (SFGAdv), 153
Batman: The Ride (SFOG), 115
Batwing, 65
Beast, 102, 103
Big Bad Wolf, 89
Bizarro (SFGAdv), 151
Bizarro (SFNE), 48, 49, 50, 51
Blue Streak, 18, 19
Boss, 173
Carolina Cobra, 56
Carolina Cyclone, 57
Cedar Creek Mine Ride, 10, 11
Corkscrew (CP), 17
Corkscrew (Valleyfair), 168
Cyclone (SFNE), 46, 47
Dare Devil Dive, 114
Diamondback, 106, 107
Dominator, 130, 131
Dueling Dragons, 166
El Toro, 162, 163, 164
Firehawk, 99
Flashback, 42

Flight Deck, 100
Gemini, 14
Georgia Cyclone, 113
Georgia Scorcher, 118, 119, 120
Gold Rusher, 170
Goliath (SFMM), 170
Goliath
 (SFOG), 120, 121, 122, 123
Gotham City Gauntlet Escape
 from Arkham Asylum, 41
Great American Scream Machine
 (SFGAdv), 153
Great American Scream Machine
 (SFOG), 115
Green Lantern, 158, 159
Griffon, 90, 91
Grizzly, 127
Gwazi, 169
Hurler (Carowinds), 53
Hurler (Kings Dominion), 128
Hydra The Revenge, 136, 137
Incredible Hulk, 166
Intimidator, 61, 62, 63
Intimidator 305, 132, 133
Invertigo, 101
Iron Dragon, 8, 9
Jack Rabbit, 75
Joker's Jinx, 70, 71

Kingda Ka, 160, 161
Kraken, 171
Kumba, 169
Laser, 135
Legend, 174
Loch Ness Monster, 96, 97
Magnum XL-200, 22, 23
Mamba, 167
Mantis, 20, 21
Maverick, 15
Mean Streak, 24, 25
Millennium Force, 26, 27, 28, 29
Mind Eraser (SFA), 65
Mind Eraser (SFNE), 44, 45
Mindbender, 114
Montu, 169
Nighthawk, 58, 59, 60
Ninja, 114
Nitro, 154, 155
Patriot, 167
Phantom's Revenge, 78, 79
Phoenix, 34, 35
Racer (Kennywood), 76, 77
Racer (Kings Island), 100
Raptor, 17
Ricochet, 126
Roar, 65
Rolling Thunder, 152
Runaway Mine Train, 149

Shockwave, 127
Sky Rocket, 80, 81
Son of Beast, 108, 109
Steel Force, 144, 145, 146, 147
Superman: Ride of Steel
 (SFA), 72, 73
Superman: Ride of Steel
 (SFNE), 49
Superman: Ultimate Flight
 (SFGAdv), 156, 157
Superman: Ultimate Flight
 (SFOG), 116, 117
Talon, 142, 143
Thunderbolt
 (Kennywood), 82, 83
Thunderbolt (SFNE), 42
Thunderhawk, 138, 139, 140, 141
Thunderhead, 172
Top Thrill Dragster, 16
Twister, 36, 37, 38, 39
Volcano: The Blast Coaster, 129
Vortex (Carowinds), 54
Vortex (Kings Island), 104, 105
Voyage, 174
Wicked Twister, 12, 13
Wild One, 66, 67, 68, 69
Wild Thing, 168
Wildcat, 16